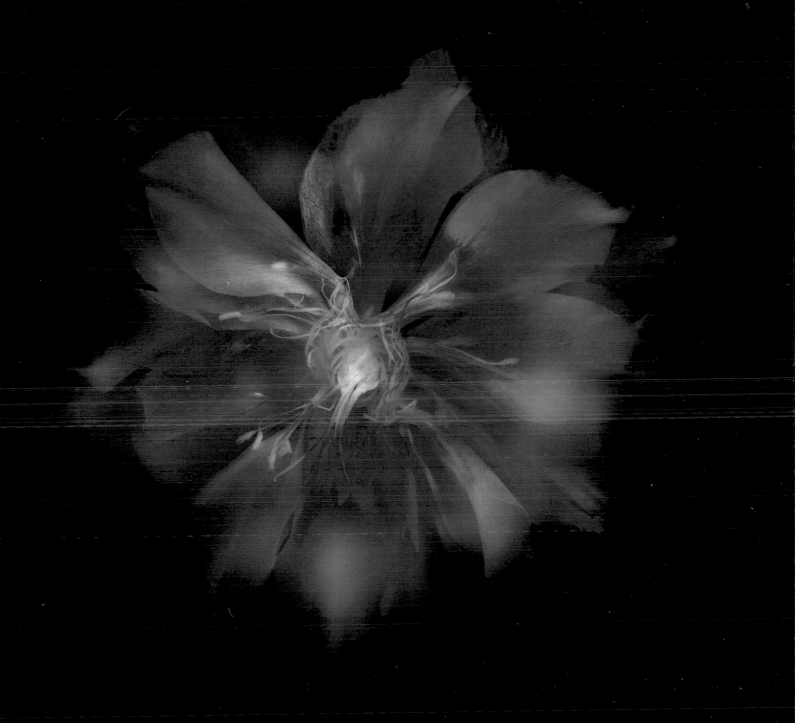

Focal Press is an imprint of Elsevier

30 Corporate Drive, Suite 400, Burlington, MA 01803, USA
Linacre House, Jordan Hill, Oxford OX2 8DP, UK

Library of Congress Cataloging-in-Publication Data
Davis, Harold, 1953-
 The Photoshop darkroom / Harold Davis, Phyllis Davis.
 p. cm.
 Includes index.
 ISBN 978-0-240-81259-5 (pbk. : alk. paper)
 1. Photography--Processing. 2. Photography--Special
effects. 3. Computer graphics. 4. Adobe Photoshop.
I. Davis, Phyllis, 1963- II. Title.
 TR287.D423 2010
 771'.4--dc22
 200902625

British Library Cataloguing-in-Publication Data
A catalogue record for this book is available from the
British Library.

ISBN 978-0-240-81259-5

For information on all Focal Press publications, visit
our website at *www.focalpress.com*

10 11 12 13 5 4 3 2

Printed in China

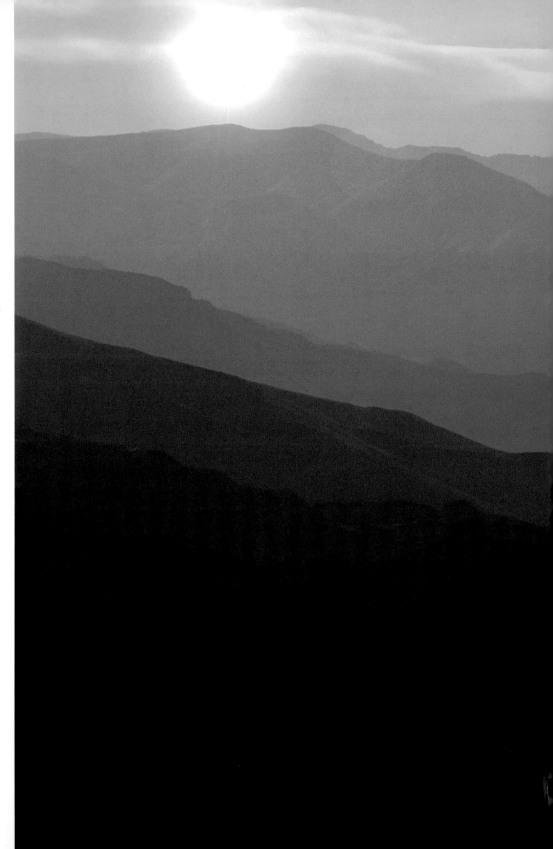

The Photoshop® Darkroom

Creative Digital Post-Processing

Harold Davis
Phyllis Davis

AMSTERDAM • BOSTON • HEIDELBERG • LONDON
NEW YORK • OXFORD • PARIS • SAN DIEGO
SAN FRANCISCO • SINGAPORE • SYDNEY • TOKYO

Focal Press is an imprint of Elsevier

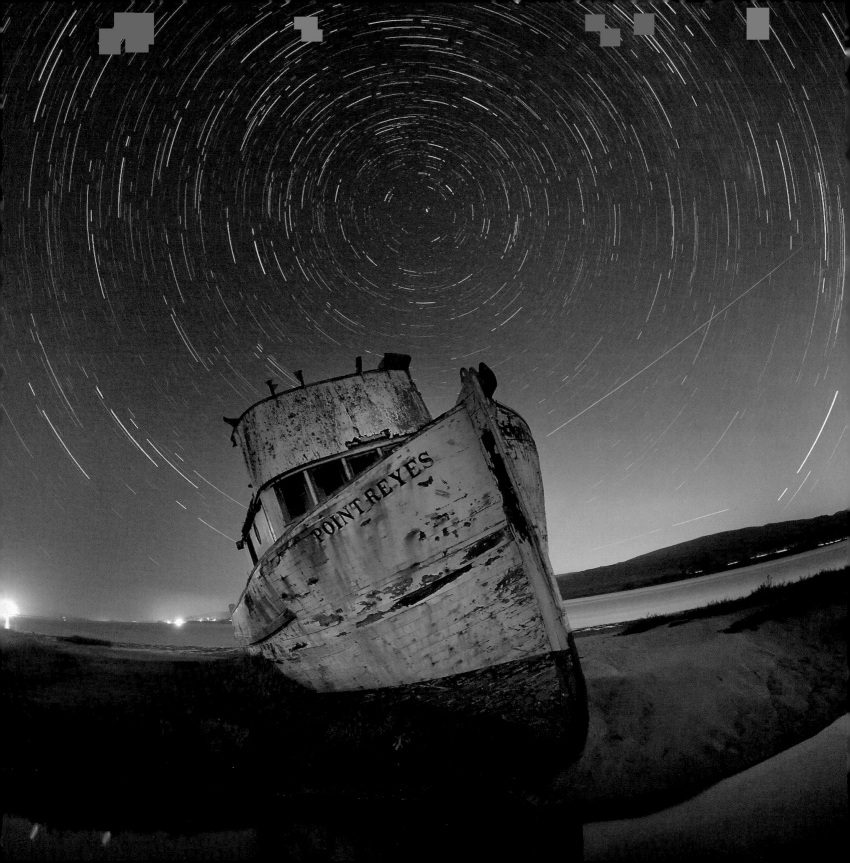

Contents

>> Introduction

Art, being bartender, is never drunk. —Randall Jarrell

Working in the darkroom I'd marvel at the moments of magic: the image unfolding under the light of the enlarger, and appearing from nothing on the paper in the tray of developer. The magic when I process a digital image is comparable— but, for me, more powerful.

The Photoshop Darkroom shares these revelations with you: the great moments in which an apparently mundane or dark capture comes alive. Digital photography is one part photography and one part software alchemy: creative post-processing.

A digital photographer who misses the opportunities that come after the photo is taken loses much of the power of the new medium. Therefore, a goal of *The Photoshop Darkroom* is to provide a framework of fundamental techniques you can use to enrich your creative work.

Ansel Adams compared his work to musical composition, saying his photographic negatives were the score and his prints the performance. With a digital photo, the RAW negative is the score, and how you post-process is the performance. *The Photoshop Darkroom* will jump start you on your journey towards peak post-processing performances.

Make no mistake: *The Photoshop Darkroom* is for photographers. Photoshop is a tool, just like the enlarger and chemicals in an old-fashioned darkroom.

Unlike some Photoshop books, in *The Photoshop Darkroom* I don't care about Photoshop except as a tool. Our concern is solely the ultimate image.

This is not a book about the latest bells and whistles in Photoshop. Almost everything I explain can be done with older versions of the program.

Depending on the version of Photoshop and operating system you are using, your functionality and appearance may change a bit from that shown in this book, although the fundamental techniques that I present will not vary.

There's always more than one way to do anything in Photoshop. I make no claim that my way is the only way, or the best: only that my way works. Hopefully, seeing my way will spark your creativity.

In *The Photoshop Darkroom* I am blessed with the perfect co-author (who also happens to be my wife). Like me, Phyllis believes that before explaining something, one has to fully understand it.

For us, a book that encourages learning is about the student's work, not the teacher's. We will have done our job if this book gives you the techniques you need and the creative inspiration to have fun while making potent digital imagery.

Harold Davis

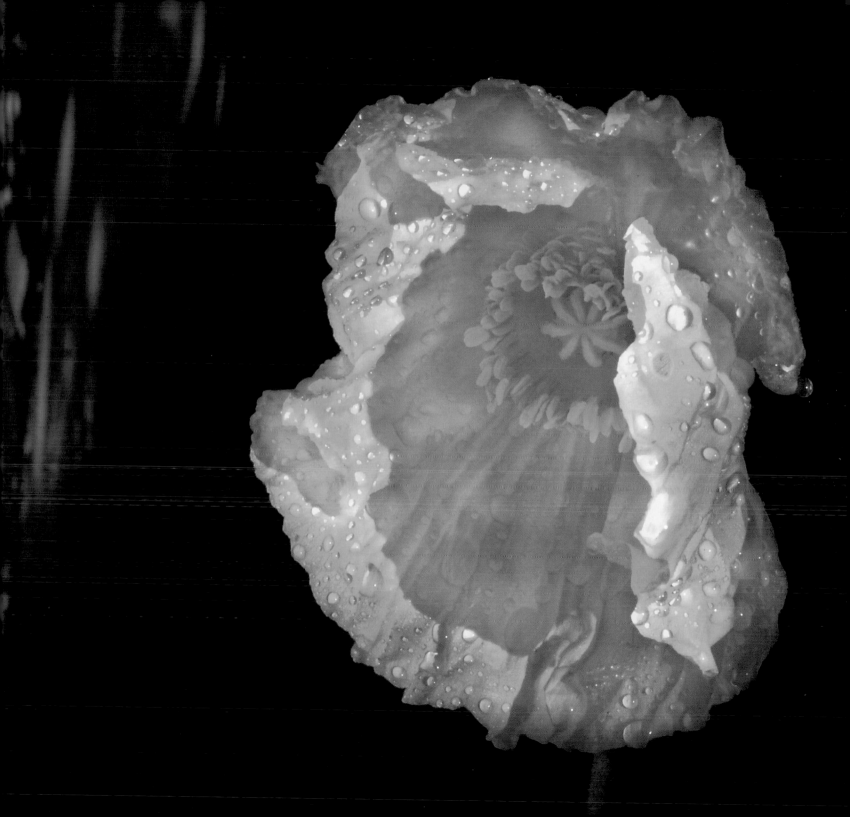

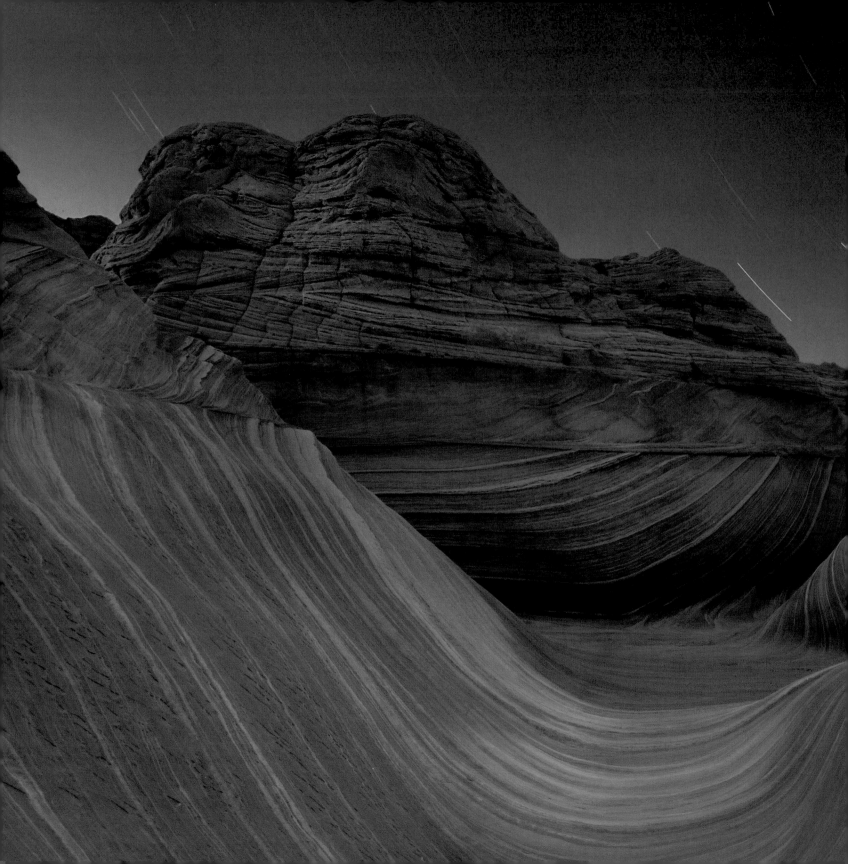

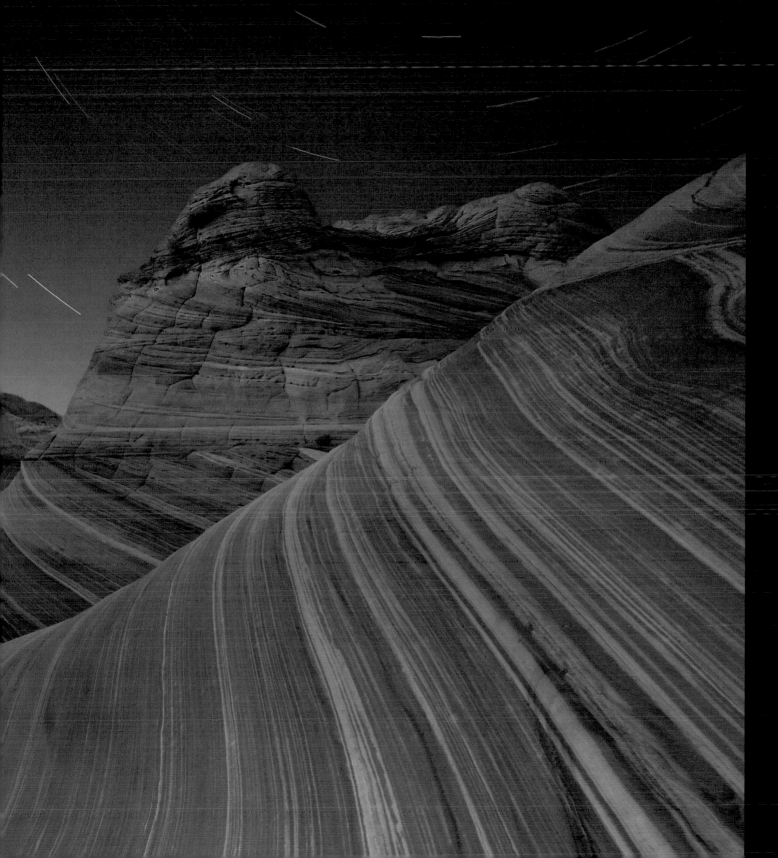

From Score to Performance

›› Input devices: Cameras and scanners

What devices can you use?

Before you can work in the Photo-shop darkroom, you need some-thing to process—in other words, an image. The usual way you get an image is to take a photo with a camera.

But, think about what a digital cam-era really is: it is a special purpose computer with a lens on the front and a sensor in the back. However, that sensor really is a special pur-pose scanner just in the same way that the computer in the camera is a special purpose computer.

What you also need with a digital camera is a way to save the files that result from the camera's cap-ture. Usually, this is a memory card.

There's no reason you always have to use a camera. If you have a flatbed scanner (and this can be an inexpensive one—nothing fancy), you can also use it to scan and capture images.

Getting ready for scanning

Before using a scanner, make sure the glass scanning surface is as clean as possible. Anything that is on the glass will show up in your scan.

Make a black box and put it over the object you are scanning to keep as much ambient light out as possible.

You should also know that there is no depth of field to speak of, so the object that you scan can't be very tall.

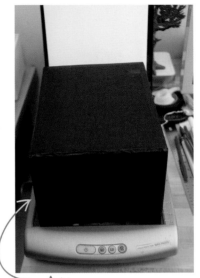

An iris ready for scanning

A black box placed over the iris keeps ambient light out

If you're an artist with a tablet and stylus, you could also draw the image you want

"ARTS & CRAFTS" PROJECT

Make your own black box

At an art supply store, buy a piece of black foam board that is 1/4" thick, black masking tape, and an X-Acto knife for cutting the foam board (be careful!).

At home, cut four pieces for the sides of the box: two that are 5" x 8" and two that are 5" x 11". Then cut one piece for the top that is 8" x 11".

Use the black masking tape to put the box together.

Scanning objects

In Photoshop, choose File ► Import, and select the scanner from the list.

Use the scanner's software to do a preview scan, cropping in as close as you can to the object. Since the files created by the scanner are very large, you don't want too much extra black area around the object.

Choose the highest bit-depth and resolution possible (the scanner's software will tell you if you have selected a setting that is too high for the size of the area that is to be scanned). You'll probably end up with something like 48-bit color at 3200 ppi for an image that is a few inches in either dimension.

Your scanner's software might let you adjust the exposure histogram and curves. If you would like, adjust these settings.

Once you have everything as you want it, scan the image. The unnamed image will appear in Photoshop, ready for you to save it.

You need to make sure your scanner's software is properly installed before you can use it in Photoshop

For more about histograms, turn to page 19. Check out pages 194–197 to find out about curves

File	
New...	⌘N
Open...	⌘O
Browse...	⌥⌘O
Open As Smart Object...	
Open Recent	►
Device Central...	

Import	►
Export	►
Automate	►
Scripts	►
File Info...	⌥⇧⌘I
Page Setup...	⇧⌘P
Print...	⌘P
Print One Copy	⌥⇧⌘P

Variable Data Sets...
Video Frames to Layers...
Anti-aliased PICT...
PICT Resource...
Annotations...
EPSON Perfection 1660...
HP Scan Pro (TWAIN)...

Choose your scanner from the Import menu

You could also combine a flatbed scan with a photograph using layers and painting. Turn to page 50 for more about painting on layers.

This iris was scanned at 3200 ppi with 48-bit color

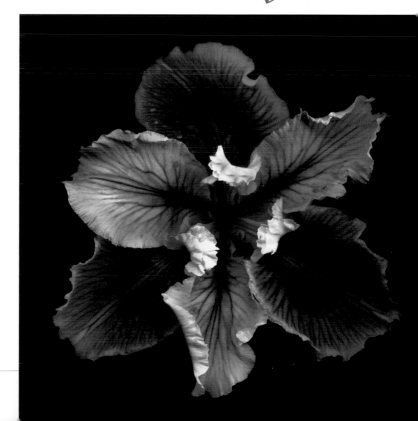

❯❯ Working in RAW

In film photography, Ansel Adams (who was a pianist as well as a photographer) said that the negative was the score and the print was the performance. In digital photography, the RAW capture is the score and the post-processing is the performance.

What is a RAW capture?

A digital RAW file is a complete record of the data captured by the sensor. What makes the concept of RAW a little confusing is that it is a general concept in the sense that there is no one single RAW file format—each camera manufacturer implements the concept somewhat differently. For that matter, the different camera manufacturers name their proprietary RAW files differently: for example, Canon's RAW format files are designated .CRW and .CR2, and Nikon's RAW format files have a .NEF file suffix.

To restate this, each man-ufacturer's RAW file format amounts to an unprocessed record of the sensor data from a capture encoded into a file.

Note: Adobe has helped to sponsor the open source Digital Negative (DNG) format, which is a manufacturer-independent RAW format. A number of cameras now directly support DNG, instead of or in addition to a proprietary RAW file format. Some photographers like to archive their RAW files in the DNG format, an option that is made more attractive because Adobe makes a RAW file to DNG conversion tool available for free. Note on the Note: My personal recommendation is to archive a copy in the native RAW format of your camera; you may also decide to archive in DNG, but you shouldn't trash your original files.

If you only saved JPEG files, this is what you would get. The post-processed RAW file is over here

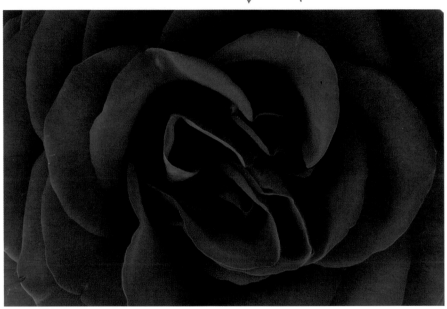

Why do you want to shoot in RAW?

If you set your camera to shoot in JPEG, the most common option other than RAW, you are accepting the computer-in-the-camera's idea of how to process your photo for color, white balance, contrast, noise, and so on. Even worse, you are throwing away all the data in your image except that single JPEG rendition. There's a vast range of exposure and color data in every RAW file that gets trashed forever when the capture is saved as a JPEG. Finally, the JPEG format compression itself involves some data loss.

Is there any downside to shooting in RAW?

RAW files do take up more space than JPEGs, although for a serious photographer this should not be the most important concern, particularly since data storage has become much less expensive in recent years.

In addition, RAW files are *potentiality*: they are not ready to go. They need to be converted to some other format (such as Photoshop's PSD, TIFF, or JPEG) before they are usable.

How do you work in RAW?

Set your camera to shoot in RAW. It's that simple, although usually the default (even for fancy DSLRs) is JPEG.

Most cameras have an option where each capture is done in RAW and converted to JPEG at the same time. This is great because you have a JPEG ready for immediate use (the only downside is that the JPEG file takes a little extra space on your memory card).

When you set your camera to capture in RAW, you should choose the highest bit depth possible (this will depend on your camera). If your camera has a color space setting, you should set this to a color space with as wide a gamut as possible to get an accurate display on the LCD. Usually this means selecting Adobe RGB rather than sRGB. (sRGB is a garbage lowest common denominator gamut designed for monitors and will limit the range of colors you have available.)

Why your camera doesn't show you the RAW truth

Particularly when you shoot RAW, the LCD version of the RAW capture that you can see on the little screen on your camera is actually a JPEG version of the image. This is what you would get if you had told the camera to save the image as a JPEG. It's not the actual RAW image. The camera has no way to show you the RAW image. And you have no idea, based on the camera's display, what you really have to work with. You need to open the RAW image in Photoshop to see what you really have.

The preview on your LCD, combined with the exposure histogram that your camera will show you, does give you some idea of the data available in the RAW file. (To find out how histograms work, turn to page 19.)

›› Case Study: Converting a RAW photo

STEP 1

Getting RAW files off your camera's memory card and onto your computer

The software for your camera will do this for you, BUT (here's the problem) it will also try to do other things for you at the same time—for example, not give you a choice about where files are saved. The software may also start to process and filter the files.

Surprisingly, few people realize that the memory card in a camera is just a virtual hard drive. What I do is use a *memory card reader* to transfer the images from the memory card to the computer.

To use a card reader: take the memory card out of your camera and put it in the card reader. The memory card then appears on your computer as a drive. (On the Mac it will show up on the desktop. In Windows, you will see it in Windows Explorer.)

Use the Finder on the Mac or Explorer in Windows to copy and paste the RAW image files into a properly named and located folder.

I don't use the software that came with my camera to get the files from the memory card onto my hard drive. Instead I use a memory card reader.

A memory card reader is an inexpensive device that can read flash memory cards and transfer their contents to a computer. If you would like to buy a card reader, you can type "memory card reader" into the Google search box to see a list of suppliers

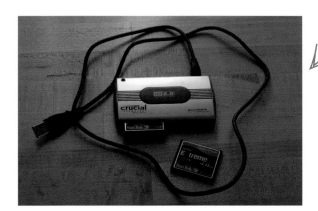

I use my computer's file system to copy and paste image files

Turn to page 24 for more about naming and locating image files and folders systematically

Adobe Camera Raw (ACR) Plug-in

Make sure you have the correct version of the Adobe Camera Raw (ACR) plug-in installed on your computer. Different versions of Photoshop use different versions of ACR and in some cases ACR doesn't get installed when Photoshop is installed. Go to www.adobe.com/downloads to find the most recent version of ACR for your version of Photoshop and operating system.

STEP 2

›› Opening your RAW file in ACR

This is the best thing to do

Bridge comes with Photoshop and is installed when you install Photoshop

In the folder where your image file is located, double-click on the image file and it will open in the ACR application window.

OR

Launch Adobe Bridge, locate the folder containing the image files, and look through your *similars*. All experienced photographers try to shoot similars of any subject they are interested in. These may have slightly different exposure settings, different composition, or may have changed over the course of time as light changed. Your first job is to look through these images in Bridge and find the one you want to work on.

After you find the image you want to work on, double-click on the image and it will open in the ACR application window.

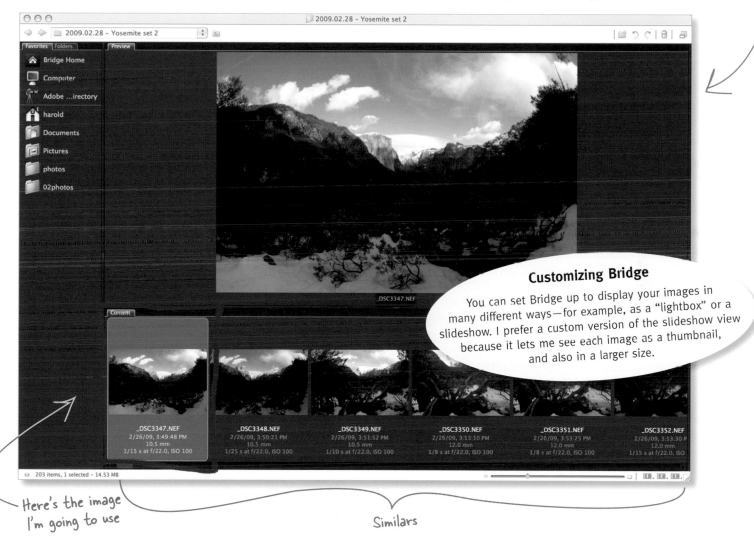

Customizing Bridge

You can set Bridge up to display your images in many different ways—for example, as a "lightbox" or a slideshow. I prefer a custom version of the slideshow view, because it lets me see each image as a thumbnail, and also in a larger size.

Here's the image I'm going to use

Similars

>> Using the ACR application window: Processing an image

STEPS 3-8

Turn to page 19 for more about histograms and exposure

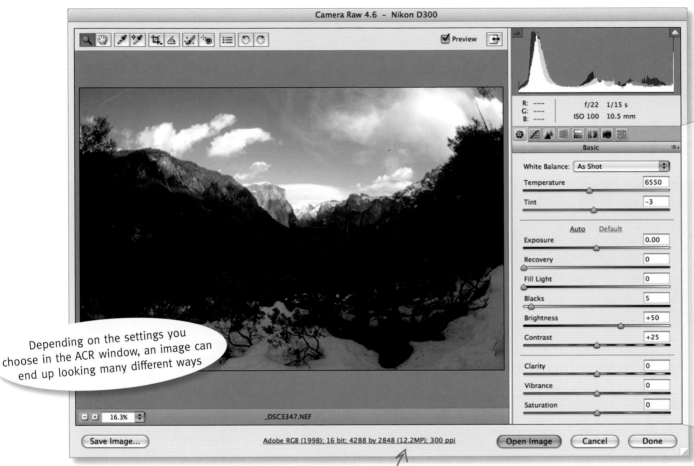

Depending on the settings you choose in the ACR window, an image can end up looking many different ways

Click here to access the Workflow Options dialog

Selecting resolution in the Workflow Options dialog

The best idea here is to accept the native resolution suggested by ACR (as shown with a check next to it). If there's a minus sign to the right of the resolution, this means that the setting down samples the image. You don't want to do this because you will lose image resolution. If there's a plus sign to the right of the resolution, this means that the image is up sampled.

There are certainly times when you do want to decrease or increase the size and/or resolution of an image. However, it's best to do this after you have finalized work on the image (not before).

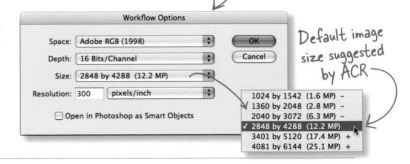

Default image size suggested by ACR

You can click these tabs to access other kinds of adjustments such as: Tone Curve, HSL/Grayscale, Split Toning, Lens Corrections, and Camera Calibration

This tiny button opens a fly-out menu that allows you to save and load image settings in a separate XMP file (more about this on page 23)

ACR opens with the image set with "As Shot" default values. It would look like the camera-generated JPEG.

Basic

White Balance:	As Shot
Temperature	6550
Tint	-3

Auto Default

Exposure	0.00
Recovery	0
Fill Light	0
Blacks	5
Brightness	+50
Contrast	+25
Clarity	0
Vibrance	0
Saturation	0

STEPS:

3

Use the Exposure slider to adjust how light or dark the image is (pages 18–19)

4

Adjust the white balance of the image using the Temperature slider (page 20)

You don't have to do steps 3–5 in any particular order

5

Use the Tint and Saturation sliders to adjust the color of the image (page 22)

Save the ACR image settings (page 23)

Open the image in Photoshop (page 23)

Save and archive the image using *Digital Asset Management* (pages 24–27)

>> Using the ACR application window: Adjusting exposure

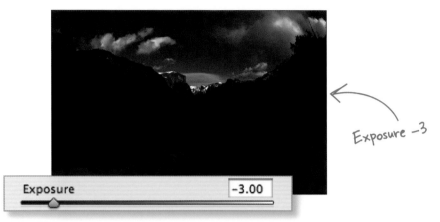

Exposure −3

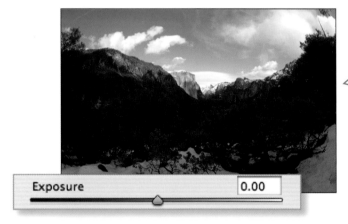

This is the exposure "As Shot" with the exposure slider untouched at 0

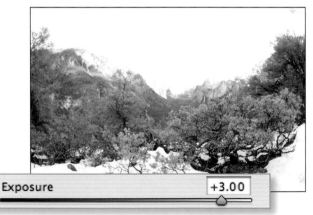

Exposure +3

RAW and exposure range

Within each RAW capture there is an exposure range from −4 f-stops to +4 f-stops. You primarily control this range using the Exposure slider. Often, not all of the entire range is usable. It will usually be too dark or too light at the extreme ends. In addition, in the darker settings there is a great deal of increase of noise in the image.

Photographers know that f-stops are not a linear scale. Each successive f-stop lets in half the light of the preceding f-stop. Therefore, the −4 to +4 f-stop range represented by the Exposure slider is enormous. This is a 2^8 range of potential exposure values: 256 times from darkest to lightest (although as noted not all of these values will be usable).

If there's one thing to point out as the immense power of a RAW capture, it's this vast range of potential exposure values included in every RAW file.

Setting the Exposure slider

Using the Exposure slider is pretty straightforward. When an image opens in ACR, the Exposure slider is set at zero with the image "As Shot." Moving the slider to the right increases f-stops and brightens the image. Moving the slider left decreases f-stops and darkens the image.

Keeping the Sneak Preview (over there) in mind (using multiple exposures of one image), think about how you want to expose an image. Do you want to process the image so the sky looks good or so the detail in the foreground is visible? You can do both!

Move the slider until the lights and darks of the image are where you want them. There is no specific number or formula that you need to use to get the right exposure. Just trust your eyes.

The histogram in the ACR window

The histogram that appears in the ACR window with an image shows how the light and dark values in the image are distributed when the image was shot. The left side of the histogram represents the darkest areas in the image, progressing across the histogram through the image midtones at the middle of the histogram to the lightest areas of the image on the extreme right of the histogram.

Since the image to the right (shown as it opened in the ACR window on page 16) is largely dark, the histogram that appears in the ACR window with the image is largely bunched over on the left side.

An average correct exposure (such as your camera would generate on Auto) would produce a histogram with a mountain in the middle like this one.

The reason that I tend to expose with histograms that are pushed to the left is that it is easier to rescue underexposed areas of a photo than it is to save blown-out highlights (even though darker images do tend to have more noise).

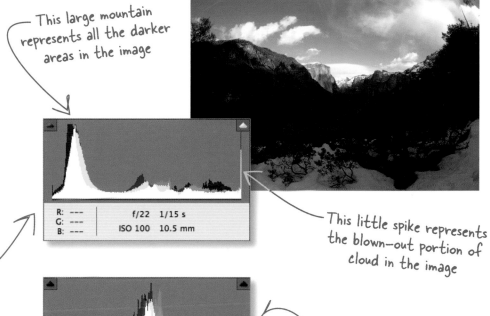

This is the image "As Shot" as it first appears in the ACR window

This large mountain represents all the darker areas in the image

This little spike represents the blown-out portion of cloud in the image

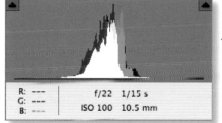

This histogram shows an average exposure like you would get when your camera is on Auto

Sneak Preview

It's possible to combine several exposures from a single RAW capture using multi-RAW processing, greatly increasing the dynamic range of the composite image. For example, you can have an image that shows both detail in a dark shadowed area and bright sun on a mountainside. Take a look at pages 30–67 to learn more about multi-RAW processing.

The Fill Light, Blacks, and Brightness sliders

There are other sliders on the ACR window that impact overall exposure—the apparent overall lightness and darkness of an image.

In addition to the Exposure slider, I often use three other sliders to control the range of darkness and lightness in an image. They are: Fill Light, Blacks, and Brightness.

Increasing the Fill Light by moving the slider to the right brightens shadow areas. You can increase or decrease the overall strength of the dark areas in an image using the Blacks slider. The Brightness slider increases or decreases the amount of brightness in an image.

STEP 4

Don't worry about in-camera white balance settings! Leave it on Auto!

›› Using the ACR application window: Adjusting white balance with the Temperature slider

White balance and your camera

When you set the white balance in your camera, you are telling your camera the color temperature of the light source used to illuminate your subject. The color temperature of light is expressed in degrees Kelvin. For example, 5500 degrees Kelvin is usually the color temperature of daylight towards the middle of the day.

There are two points here. The first is that measuring the color temperature of light is not a simple issue as you will often have light from a variety of sources. In addition, light changes. Daylight towards early evening is very different from daylight in the middle of the day. Without a color spectrometer, you can't really measure color temperature accurately.

The second point is that cameras have an Auto white balance setting. This lets the camera measure the light and do the best it can.

Whatever white balance setting was used to shoot the picture (whether the camera was set on Auto white balance or not) is what shows up in ACR as the default "As Shot" value.

Despite white balance being a huge bugaboo for many photographers, what you set it to in the camera doesn't really matter much because it is completely adjustable in ACR after the fact. The only two things your in-camera white balance affects are the appearance of the image on the LCD screen of your camera and the setting of the image when it first opens in ACR.

Using the Temperature slider

I suggest using the Temperature slider to make the colors in the image appealing and the way you would like them. Some folks justify this adjustment by saying that they are recreating the scene as it appeared to them, but you don't really need an excuse. Don't worry about the technicalities of accurate temperature measurement and white balance.

When the white balance of Tungsten is selected from the drop-down list, the color temperature is set to 2850 degrees Kelvin. The image becomes very blue.

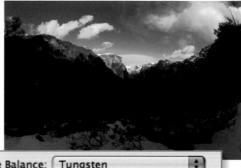

The image "As Shot" is 6550 degrees Kelvin.

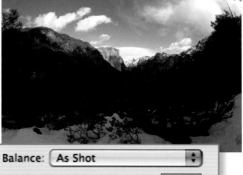

With a color temperature setting of 15,000 degrees Kelvin, the image gets very yellow.

Color temperature and your camera

The camera's measurement of the color temperature of light assumes that the light is being reflected off an 18% neutral gray surface. If there is a situation where you need to accurately measure color temperature and white balance, then you should include an 18% neutral gray card (available from photo suppliers) in one of your captures. You can then use the White Balance Tool in ACR to find the exact color temperature by clicking on the neutral gray card in the image.

Here's a seat-of-the-pants trick: if you don't have a neutral gray card (perhaps you are photographing on the top of Mount Everest), any area that is close to the 18% neutral gray value will do in a pinch.

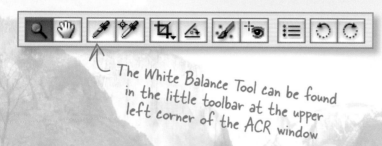

The White Balance Tool can be found in the little toolbar at the upper left corner of the ACR window

This is 18% gray

Using Flickr to stay organized

After I finish processing images, I take an additional step that is somewhat unusual. I make sure to upload a low resolution version to Flickr (any other photo file sharing service would work as well). Then, I tag each photo with pertinent words or phrases. I can now use the excellent search facilities available on Flickr and the web to find my tagged images. Once I've located an image on Flickr, I can use the date it was uploaded to locate the high resolution source files in my archive. For more about managing your image files and *Digital Asset Management*, take a look at pages 24–27.

How long does it take to process a photo?

When I give workshops, people are sometimes stunned to hear that it can take me hours and even days to process a single photo. This amount of time cannot be justified in a production environment. However, if you look at what you're doing as a creative and artistic endeavour, then it's not really a great deal of time to spend per image.

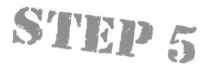

STEP 5

>> **Using the ACR application window:**
Adjusting color with the Tint and Saturation sliders

Using the Tint and Saturation sliders

The Tint and Saturation sliders are the main controls that you have to adjust the overall color of an image.

The Tint slider should be used first because small adjustments of Tint have a dramatic impact. (Note that the Tint slider is located right next to the Temperature slider. If you select one of the White Balance presets from the drop-down list, it may set a Tint setting

as well as a Temperature setting.)

The Tint slider moves through a color spectrum from green on the left to magenta on the right. Often, I find that I use a Tint setting of about +10. But this is something that depends on the image and your taste. So, you should play with the Tint slider to see what impact it has on your image.

Once you have set the Temperature slider and the Tint slider, it's time to work with the Saturation slider. As

opposed to the Tint slider which changes the color spectrum in your image, the Saturation slider changes the apparent richness of the color spectrum in the image.

While it is all a matter of taste, it is worth noting that the Saturation slider can be overused. Sometimes heavily saturated imagery is done by choice to create a specific effect; however, this kind of saturation can look artificial and unnatural.

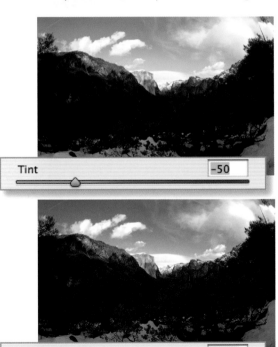

Once you have multi-RAW processing under your belt (pages 30–67), you can use variations in Tint settings so one area of the final composite image has one tint setting while another area has a different setting.

Using the Vibrance slider

The Vibrance slider works in a similar fashion to the Saturation slider but primarily operates on low saturation colors. The Vibrance slider doesn't

change colors that are already highly saturated. Much of the time, you'll want to move the Vibrance slider along with the Saturation slider. However, there are some situations where you'll want to

adjust the Vibrance slider without the Saturation slider—for example, increasing the saturation in a photo with people when you don't want to make skin tones look weird.

STEP 6

Saving your ACR settings

When you finish processing an image, make sure to save the ACR settings. That way, if you have another image you want to process in exactly the same way (or you want to open another copy of the same image), you can just load the settings instead of reinventing the wheel.

To do this, click the tiny button at the right of the ACR window and choose Save Settings from the fly-out menu.

In the Save Settings dialog that opens, select Basic from the Subset drop-down list, then click Save and save the file in the same folder where the image is (so you'll know where to find it again—ACR will try to make you save it in a general settings folder).

When you choose Save Settings, this dialog opens. I use the "Basic Subset" and then save the settings in the same folder with the image.

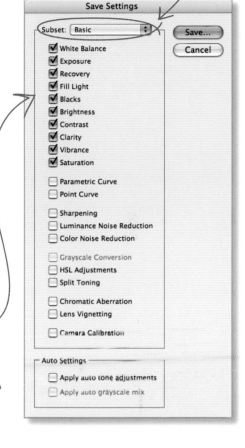

Click this tiny button at the right of the ACR window

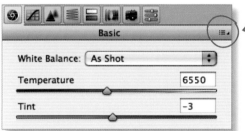

No matter how you open an image using ACR, Photoshop will not overwrite the RAW image

After you save settings, you can select Load Settings to apply them to another image or to a copy of the same image

STEP 7

Opening your image in Photoshop

Once you have all the sliders set the way you want them, it's time to open your processed image in Photoshop.

Don't just click the Open Image button, however. If you do that, all the original "As Shot" settings (the way the settings are when the image originally opens

in ACR) will be overwritten with the current slider settings.

What you want to do is open a copy of the image. To do this, hold down the Alt key and notice that the Open Image button at the lower right corner of the ACR window changes to Open Copy. Continue to hold down the Alt key while clicking Open Copy.

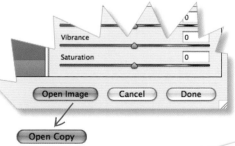

Hold down Alt key a[...] Image button changes t[...]

STEP 8

>> **Digital Asset Management (DAM): Saving your images**

Saving files logically

Sure, it's easy to select File ► Save in Photoshop to save the image file you just finished processing. But where are you going to put the file so you know where it is and know whether you have worked on it or not?

In this day and age it's really easy to get overwhelmed with digital information—tunes, videos, images, whatever. When you get inventive and creative with your images in the Photoshop darkroom, the number of versions can really explode. You'll need to set up a file structure that will always be in place so you don't lose images and so you can find various versions.

Over the years, I've created a workflow that lets me logically take care of archiving and versioning my digital files while I process them.

It's not important that you exactly follow my workflow, but it is important that you do have a workflow in place that you follow. If you use a workflow, then you'll be able to let your inspiration and creativity soar.

Organizing files and folders

Check out the folder structure shown in the Finder window below (if you're using a Windows machine, Window Explorer would look much the same with a tree-type file structure). Set up

something similar to keep yourself organized.

The scheme I use is to create a chronological hierarchy of folders by year. Within each year, each folder is named with the year, month, and date so they are listed chronologically. In addition, I add a few words to the folder name to describe what images are in the folder. This way, if I know the date when I took an image, I can find the related files. The descriptive words let me search by keyword, using a common tool like Finder on the Mac and Search on the main Windows taskbar.

Creating a comprehensive, organized folder structure like this is part of *Digital Asset Management* (DAM).

Here's how I have my folder hierarchy set up:

Main photo folder

Folders sorted by year

Folders named by date with a few descriptive words

Here are the RAW images. Also, two folders I always create: WIP for Work in Progress and Final for storing finished images.

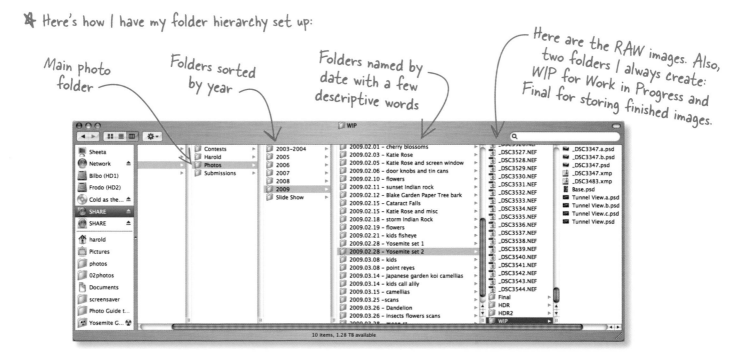

As you work through *The Photoshop Darkroom*, any step that contains a checkpoint will show this icon

✓ Checkpoint

Managing your image files

You may have heard a lot about non-destructive image editing. The idea of non-destructive editing is that your edits are created separately from the original file so that the original itself is never changed. Examples include the separate XMP file that ACR creates from a RAW original and adjustment layers in Photoshop. In these cases, the separate file or adjustment layer is a kind of gloss or annotation. You don't change the original; instead you provide instructions about how the original should be changed.

In some ways, the concept of non-destructive editing has things exactly right. You should never alter an original image file (it's actually quite hard to do this using Photoshop, because Photoshop saves your RAW files as PSD or TIFF files without the ability to overwrite the original file).

However, I don't find that editing with a base image and a stack of adjustment layers on top works for me, because some of the Photoshop

darkroom work I do is quite complex. It simply gets too complicated, and too slow once you have more than 10 layers or adjustment layers in any image stack.

Something needs to take the place of non-destructive image editing. The criteria of this something must meet four points:

1. The original has to be completely untouched

2. Every major step during editing has to be saved and archived

3. It should be possible to track the editing to understand how the results in any of the intermediate steps were obtained

4. No single file should get so big and complicated as to be difficult to work on. (This, of course, depends on the hardware you are using.) Also, as a practical matter, you probably don't want more than 10 layers in any image file.

My answer to this problem is a system of *checkpoints*. Every time I hit a major

step in the editing process, I save a version of the file. Usually the version is multi-layered. As a next step, I flatten the layers so I'm back to a single layer image and then I save a copy under another name. The internal layers (of the prior saved file) allow me to track my progress and let me go back to an earlier "checkpoint" if I need to.

For a typical image conversion, I end up saving 4 or 5 work-in-progress files. Each one of these files contains from 2 to 10 layers. The downside of this is that I take up more hard drive space than if I were using adjustment layers. As opposed to an adjustment layer, each regular layer doubles the image file size. If I was doing this with a single layer document, instead of 4 files with 5 layers, I'd end up with 1 file with 20 layers. The problem is that the 20 layer file, while being more flexible, is too much for most computers to handle nicely (it also doesn't give you a hard checkpoint in case you want to go back to a previous version).

I name the file that I save at each checkpoint with a sequential alphabet letter

›› Digital Asset Management: Protecting your images

Copyrighting images

Another part of Digital Asset Management is protecting your images so they are less likely to be used without your permission.

It is possible to add a watermark to your photos as a deterrent to theft. There are several methods you could use to add watermarks to your photos. But my own opinion is that the esthetics of watermarks are obnoxious enough that I don't do it.

However, there's no excuse for not marking your image as copyrighted in Photoshop. To mark an image as copyrighted, choose File ► File Info. On the Description tab of the File Info dialog, choose the Copyright Status drop-down list and select Copyrighted (by default this is set to Unknown). You should also add a web link in the Copyright Info URL text box. You should enter your name as the Author of the image. One other thing I always do is add my copyright notice to the Description text box.

Once you have entered your info, click OK. The title bar of the image will now show that it is copyrighted.

To add a copyright symbol (©) on the Mac, press Alt + G. For Windows, press Alt + NumLock + 0169

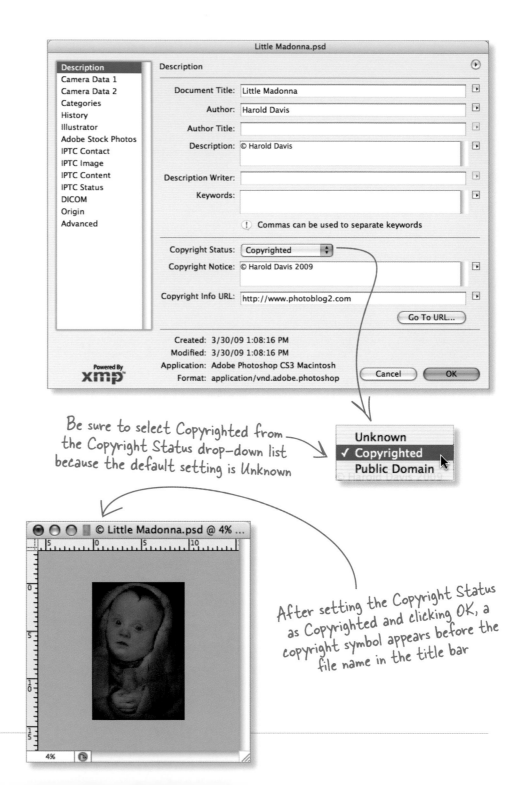

Be sure to select Copyrighted from the Copyright Status drop-down list because the default setting is Unknown

After setting the Copyright Status as Copyrighted and clicking OK, a copyright symbol appears before the file name in the title bar

⟩⟩ Digital Asset Management: Making sure your files don't get destroyed

RAID 5 is a good compromise between redundancy and safety

Archiving your files

There's no perfect way to archive any digital file. Contrary to what many people believe, CD-ROM and DVD disks are inherently unstable, generally rated with a shelf life of only 10 years.

The good news is that storage media is becoming a lot less expensive. A good thing indeed when you consider that digital photo files themselves are getting larger (some of my processed images are more than 1GB). When you work on a file in the Photoshop darkroom, you get multiple versions, often with increased file size (for instance, each layer in an image almost doubles the file size).

You should have at least 3 copies of every digital file you are archiving. Preferably, you should keep one copy off-site. I recommend network attached storage units in RAID 5 configuration like the Buffalo Technology unit shown here.

I have two of these units in my office for a total of 8TB of storage. However, they are filling up so I will be adding another two units soon.

This photo is the finished version of the one you've been seeing in this section since page 15. (Take a look at the original RAW capture in Bridge on page 15.)

I processed the same image twice in ACR—I made one version for the sky (ignoring the dark foreground) and the second version for the foreground (ignoring the blown-out sky). Then, I layered the two images in Photoshop and used a *layer mask* and *gradient* to blend the two versions together. This is called *multi-RAW processing*.

You can use these same layering techniques to enhance your photos. So turn the page and get ready to work, create, and play with multi-RAW processing in the Photoshop darkroom.

The Art of Imagination

>> Multi-RAW Processing: Expanding tonal range

Process the same photo
TWICE, (creating
2 images) in Adobe
Camera RAW (ACR)—
once for the sky and
once for the foreground

Combine the two images
as layers in Photoshop

Use layers, a layer
mask, and a gradient to
combine the two images

RAW capture "As Shot"

Processed for the sky

Processed for the foreground

›› Multi-RAW case study:
Combining two processed versions from the same capture

Why multi-RAW processing?

The true power, magic, and beauty of RAW processing happens when you do it more than once.

You found out that when you open a RAW file in ACR that there are many ways to change the exposure and color of an image (pages 16–23).

What would you say if you knew that you could change different parts of an image in different ways with incredible flexibility, ease, and pinpoint accuracy? That's what multi-RAW processing is all about.

Take the classical case: you are photographing a beautiful landscape with bright sunlight in the clouds and deep shadows in the rolling hills. There's no single exposure that will work for both the dark, shadowed hills and the bright sky. An exposure that averages the two, will give you "blah" results for both, but "blah" is not an option! What do you do?

The answer is to process the same capture twice in ACR—once for the sky and once for the hills—and then put the two exposures together using layers, a layer mask, and a gradient in Photoshop.

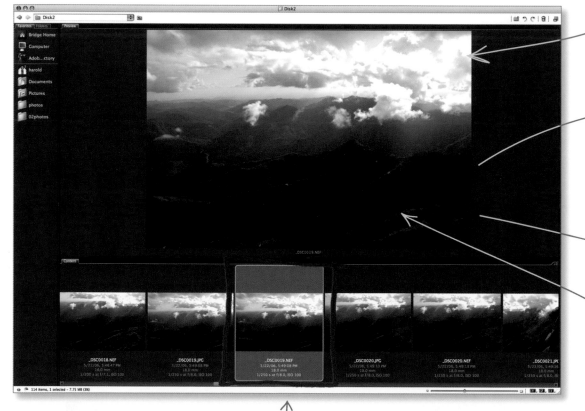

Some of the sky is blown-out

The hills in the foreground are too dark

This is the image I am going to multi-RAW process

>> Processing the same image twice in ACR

1 In ACR, use the Temperature, Tint, and Vibrance sliders to make the original image more attractively colored. Next, use the Exposure slider to set the exposure for the sky and let the hills go dark. Then, hold down the Alt key and open the image as a copy in Photoshop.

To find out more about opening an image as a copy, take a look at Step 7 on page 23

Version #1

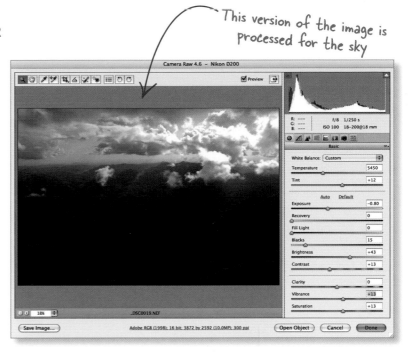

This version of the image is processed for the sky

2 Now the magic begins (I promise!). Go back to Bridge and double-click the *same* image again to open the same RAW file a second time in ACR.

This time, use the Exposure slider to make the hills in the foreground lighter, ignoring how bright this makes the sky. Next, use the Temperature, Contrast, and Saturation sliders to make the foreground more vibrant. Then, open the image as a copy in Photoshop.

Version #2

Next Step

At this point you have two versions of the same image open in different windows in Photoshop. The next step is to combine them in one image window (pages 34–35).

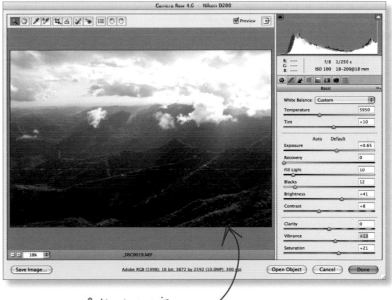

This version of the image is processed for the foreground

›› Combining the two versions as layers in Photoshop

Layers in Photoshop

Combining two versions—one specifically processed for the sky and one specifically processed for the hills—will create a composite image with a greater tonal range.

In Photoshop, when one image is placed on a layer over another image on a different layer, by default it will completely hide the layer underneath. Later on, a layer mask and gradient will be used to blend the two layers, letting the best of each image show.

⭐ Before going any further, save your work as a PSD file (this is the native Photoshop file format)

Here's how

1

Click on the version that was processed for the hills

When you click the image, it appears as a Background layer in the Layers palette

If you don't see the Layers palette, press F7 to open it.

2

On the Layer menu choose New > Layer from Background to make a regular layer and rename the layer "Hills"

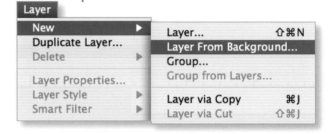

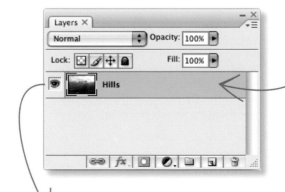

It's always a good idea to give each layer a name that lets you know what that layer is for

3 Now, go to the other window that is open in Photoshop and click the version that was processed for the sky. In the Layers palette, this version is also a Background layer. Use the same menu selection explained in step 2 to change the layer to a regular layer. Rename it "Sky."

4 Choose the Move tool from the Toolbox

5 Hold down the Shift key and use the Move tool to drag the Sky image onto the Hills image window. Release the Shift key only **after** you release the mouse button or the two versions won't be perfectly aligned.

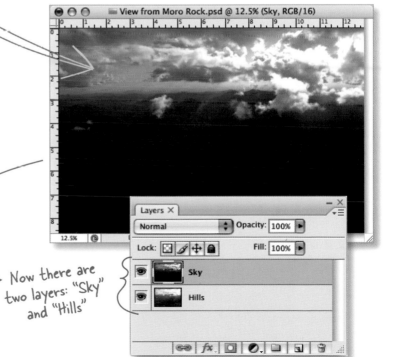

The two layers will be perfectly aligned IF the Shift key is held down when the "Sky" layer is moved on top of the Hills layer

Now there are two layers: "Sky" and "Hills"

Next Step

Use a layer mask and gradient to blend the two layers, letting the best of each layer show through (pages 36–38).

>> Add a layer mask

Hiding and revealing with layer masks

A layer mask is used to hide or show parts of a layer. At this point the "Sky" layer is completely hiding the "Hills" layer. Adding a layer mask that hides the "Sky" layer will let you see the "Hills" layer.

Here's how

1 Make sure the "Sky" layer is selected

2 On the Layer menu choose Layer Mask > Hide All

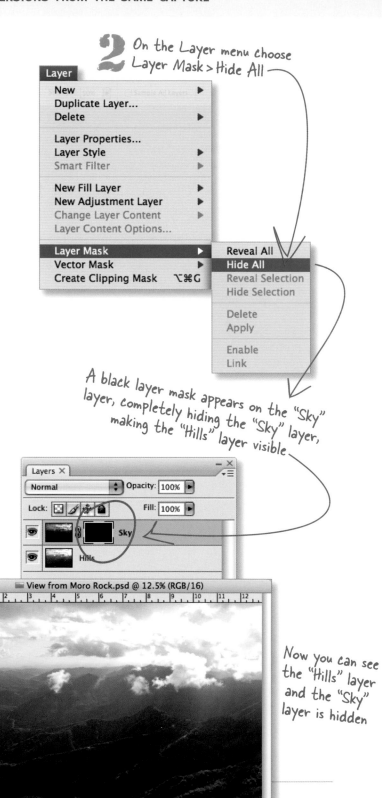

A black layer mask appears on the "Sky" layer, completely hiding the "Sky" layer, making the "Hills" layer visible

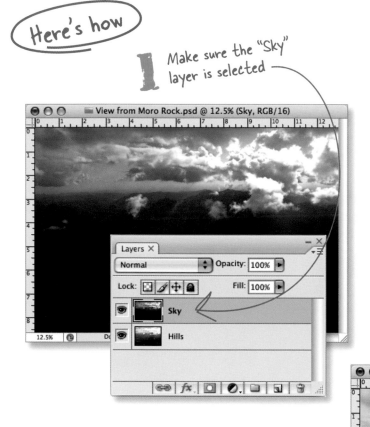

Now you can see the "Hills" layer and the "Sky" layer is hidden

Next Step

Draw a gradient on the layer mask so the best parts of each layer are visible (pages 37–39).

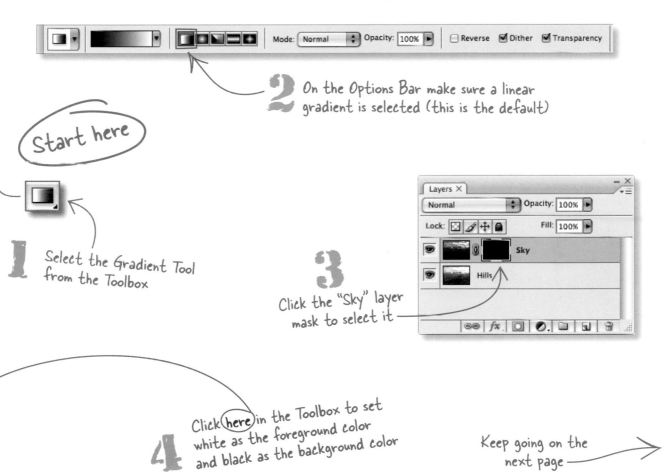

>> Draw a gradient on the layer mask

A gradient is an area that smoothly blends from one color to another, for example from black to white on a layer mask

Understanding layer masks

When working with a layer mask, remember that "white reveals and black conceals" the layer the mask is on. So any area on the layer mask that is white will reveal that area of the layer. Also, any area on the layer mask that is black will hide that area of the layer. Therefore, where the layer mask is black, the layer underneath shows, and where the layer mask is white, the layer underneath does not.

The gray areas in between will be less or more translucent depending upon whether they are closer to white (light gray) or closer to black (dark gray).

Drawing a gradient that blends from top to bottom, white to black on the Sky layer mask will make the vibrant blue sky from the "Sky" layer visible. It will also hide the lower portion of the "Sky" layer, making the hill area from the "Hills" layer visible. This will create a composite image with a larger tonal range in just a few seconds.

Start here

2 On the Options Bar make sure a linear gradient is selected (this is the default)

1 Select the Gradient Tool from the Toolbox

3 Click the "Sky" layer mask to select it

4 Click (here) in the Toolbox to set white as the foreground color and black as the background color

Keep going on the next page

›› **Draw a gradient on the layer mask, continued**

5 In the image window, click and drag the Gradient tool from top to bottom

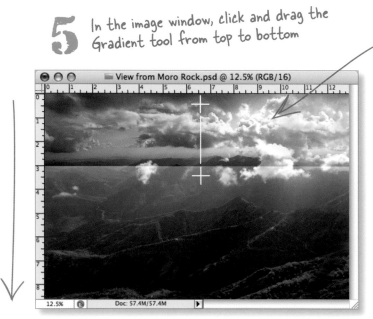

The top of the "Sky" layer appears in the image window after you release the mouse

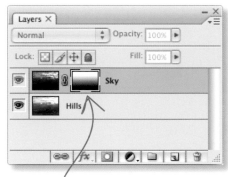

A white to black gradient appears on the layer mask icon in the Layers palette

UNDER THE HOOD

If you want to see the actual gradient you drew, open the Channels palette by selecting Channels from the Window menu. To take a look at the "Sky Mask," click the eye icon at the left of the "Sky Mask" channel to turn it on, and then click the eye to the left of the RGB channel to turn it off. The gradient will appear in the image window. For more about channels, take a look at page 153.

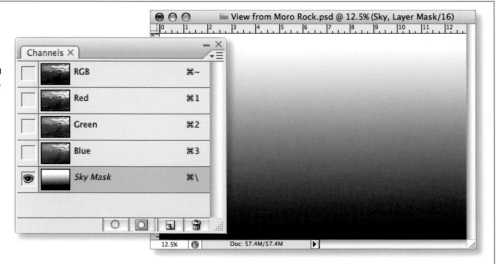

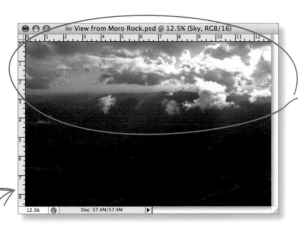

This is the version that was processed for the sky (the "Sky" layer)

Here's the finished image

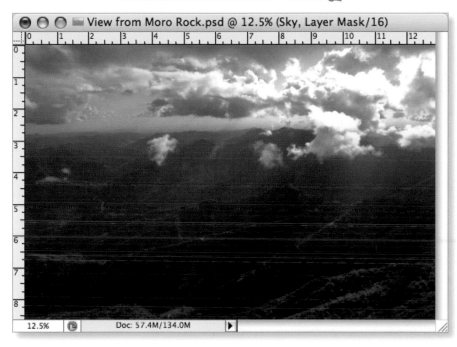

This version was processed for the hills (the "Hills" layer)

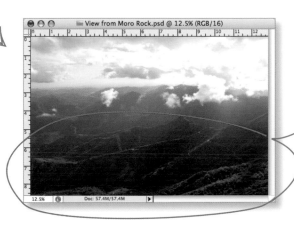

Hills

After adding the gradient to the Sky layer mask, the composite image has a larger dynamic range than the individual Hills and Sky versions. (To see a larger version of this finished image, turn to page 31.)

ONWARD & UPWARD

I find this more intuitively appealing and often works better for me except in the simplest examples

More multi-RAW processing

The example shown on pages 32–39 is one of the simplest demonstrations of the benefits and techniques of multi-RAW processing. Once you get the hang of it, it literally only takes seconds to rescue overly bright and dark areas of a landscape photo by combining two versions as explained.

It's pretty easy to see how you do this when you have a foreground that is overly dark and sky that is overly bright. But, many photographic situations are more complex than this. The good news is that multi-raw processing is powerful and flexible enough to rise to almost any occasion. For one thing, you're not limited to two versions on two layers. You could process an image any number of times, each time including it on a different layer with a layer mask.

Also, as you'll see in the next case study starting on page 42, it is possible to paint on layer masks. This gives a great deal more flexibility and pin-point accuracy about how much or how little you reveal on a given layer. If this sounds like a big deal, it is!

But wait! There's more...as you will see when you throw different *blending modes* into the soup (blending modes control how layers combine), the sky's the limit! A case study featuring this technique starts on page 62.

Have a plan!

It's a good idea to start out with a plan when you approach multi-RAW processing. You should start by pre-visualizing the end result you would like.

When I start multi-RAW processing, the most common scenarios I use are these two (both use layers and masking):

1. A three layer scenario that starts with a "background" layer that is generally the most attractive version of the image. Then, I add two layers on top that are partially masked—one layer adds in brighter areas and the other layer adds in darker areas.

2. A second approach that is also intuitively appealing is to start with a very dark version as the "background" (which is used for the brightest area in the image). I then add layers on top to mask in successively lighter versions, as many layers and masks as needed.

This second approach is shown in the next case study starting on page 42.

No-risk experimenting

I'm a great believer in planning in Photoshop. However, don't let your plan stop you from experimenting! If you're curious about what something will do, try it and see. You can always undo using my great friend the History palette. Also if you have established a system of checkpoints as shown on page 25, then it should be easy to get back to a previous version of your image.

Photoshop is a visual program. You can see what you get. Inspiration comes with improvisation. I urge you to experiment!

Another multi-RAW processing scenario

If you are trying for a high-key lighting effect (by photographing for transparency perhaps using a lightbox) and you are intentionally overexposing, then a good plan is to start with the lightest version of the image and layer on successively darker versions as you go along. The Rose Cone flower shown above and the Anemone to the left use this technique.

>> Multi-RAW Processing:
Selective exposure control

I LEARNED THAT A FAMILY of Great Horned Owls had moved into the eucalyptus forest in Claremont Canyon in the hills above the city of Oakland, California. So I spent a happy afternoon photographing the owl chicks in their nest. The photos were taken from the top of a small hill at the same height as the chicks. A very protective mother owl hovered in the background above the nest, while dad occupied a perch a few trees away.

Even though I was shooting with a long telephoto lens (600mm in 35mm terms) on a tripod, I knew that I would want to crop in on the image to exclude everything but the owls. I also wanted to make sure that the vibrant colors in the owl chicks' eyes and feathers were featured in the final image. It was time for multi-RAW processing using layer masks and the Brush Tool for pin-point accuracy.

My strategy in post-processing this image was to start with a good overall version of the RAW capture and then to layer in successively lighter versions for the eyes and feathers.

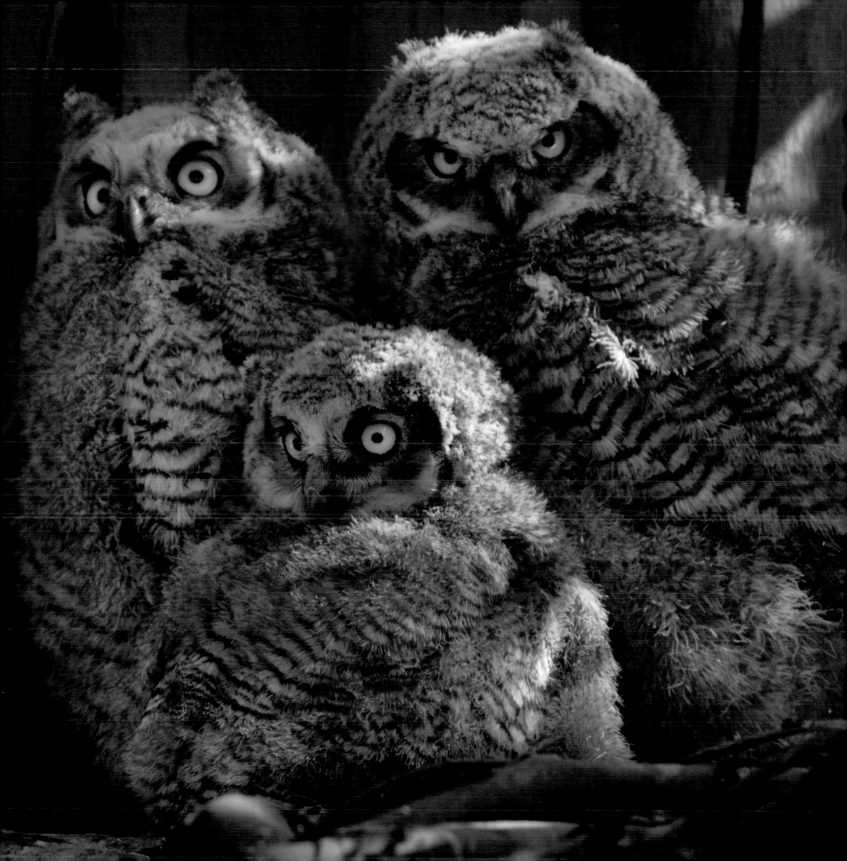

›› Processing the darkest version in ACR

Coming up with a strategy

Photographing these owl chicks was like photographing human kids—just as with children, it was hard to get the owls to all look at the camera at the same time!

To start post-processing the owls, I picked a capture that was sharp and with all three owls looking in my direction. If you check out the similars shown in Bridge below, you can see the owl chicks looking every which way.

My strategy for multiple processing this image in ACR was to start with the darkest layer and then put successively lighter layers on top, painting in the details using layer masks and the Brush Tool.

The first version of the image that I needed to process in ACR was the darkest version that was going to become the Background (bottom-most) layer in Photoshop. This version needed to have a good overall exposure. In addition, I used ACR to adjust the Temperature and Tint to give the image a warmer and brighter feeling.

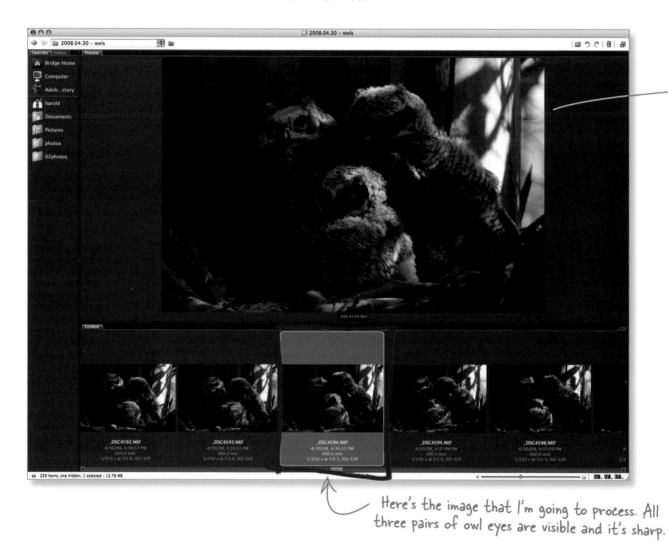

Here's the image that I'm going to process. All three pairs of owl eyes are visible and it's sharp.

The "As Shot" exposure

This is the way the image opens in ACR. You can see that the image is a bit dark, and this is confirmed by the histogram. The overall underexposure of this version of the capture fits in well with the plan to layer on successively lighter versions featuring the owls.

Leaving the background dark and making the owls lighter focuses the viewer's attention on the owls.

Image opens "As Shot" in ACR

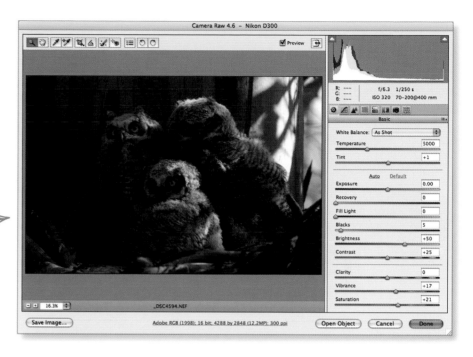

Color adjustments

By adjusting the Temperature and Tint sliders you can make the image warmer overall. I used these controls to make the image closer to the way that it actually looked in the late afternoon sun.

When you're done adjusting the image, open it as a copy in Photoshop (for info about this, look at step 7 on page 23).

I moved the Temperature up from 5000° to 5800°. 5800° is more or less the color temperature of late afternoon sunlight. (As afternoon progresses toward sunset, the color temperature goes up a bit more to around 6200°.)

I moved the Tint slider to the right to give the image a warmer tone.

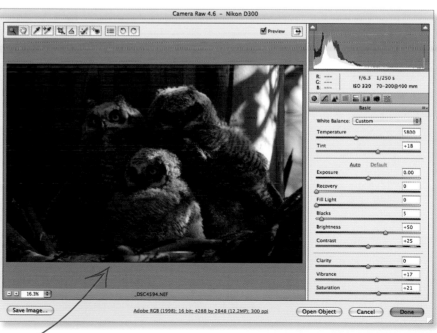

>> Processing a second version in ACR and layering the versions in Photoshop

Workflow

The idea is to add a lighter layer with a layer mask that hides the layer on top. Then, paint on the layer mask with the Brush Tool to reveal the portions of the layer you want.

The initial steps to set this up are described on pages 32–36. They are presented in overview here as well.

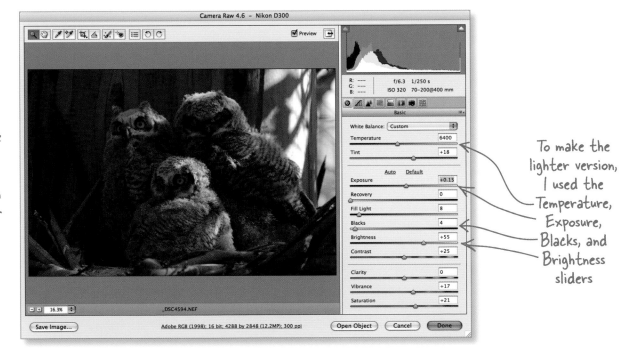

The image appears as the Background layer in the Layers palette in Photoshop

1 After opening the initial dark version in Photoshop, save it in a "WIP" (work-in-progress) folder as a PSD file. (To find out about creating work folders and saving images logically, turn to page 24.)

2 Go back to Bridge and double-click the same image again to open it in ACR. Now, make a lighter version of the owls with their bodies and feather detail in mind.

To make the lighter version, I used the Temperature, Exposure, Blacks, and Brightness sliders

3 Open this lighter version as a copy in Photoshop, and then change it from a Background layer into a regular layer named "Owls lighter". (To find out how to do this, turn to page 34.)

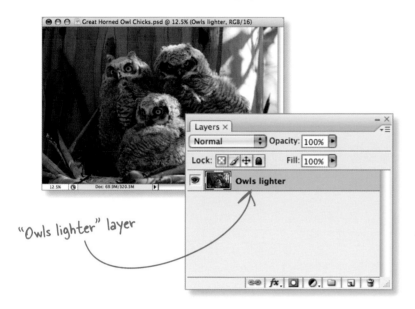

"Owls lighter" layer

4 Next, hold down the Shift key and use the Move Tool to drag the "Owls lighter" version from its image window into the image window containing the darker "Background," making two layers. (Turn to page 35 for directions on how to do this.)

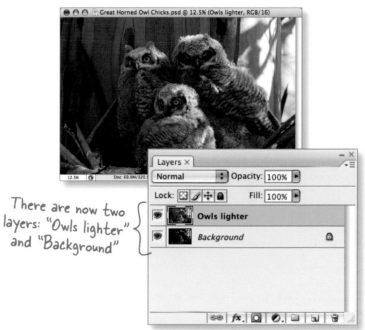

There are now two layers: "Owls lighter" and "Background"

5 Finally, make sure the "Owls lighter" layer is selected and add a layer mask, hiding the layer. (Take a look at page 36 to find out how to add a layer mask.) Save the file.

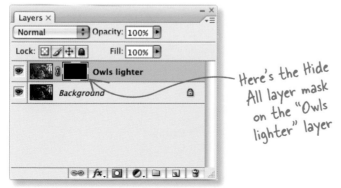

Here's the Hide All layer mask on the "Owls lighter" layer

What is open in Photoshop?

- There's a saved image with two layers, "Background" and "Owls lighter"

- The "Owls lighter" layer has a layer mask on it

- There's the lighter owl image (the second version open in its own image window). Don't close it; you're going to need it in a few minutes!

Next Step

Now that you have all the preliminaries finished, it's time to get the Brush Tool ready for painting on the layer mask (pages 48–49).

›› Getting the Brush Tool ready

Brush Tool settings

When I'm getting ready to paint on a layer mask, I usually use Brush Tool settings that slowly paint an area. If an area needs heavier coverage, I'll paint over it several times instead of using higher settings. Here are some of my thoughts about Brush Tool settings.

Brush Diameter: The width of your brush really depends on the area you need to paint. Don't make the mistake here, however, of being hasty. It's easy to look at an image and say "I want to blow out that area" and use a big brush that works fast. This will make for results that are a lot cruder than they ought to be.

Images look very different close-up and far away. To really do good, accurate brushwork, you need to see the impact at both kinds of magnifications. Most of the time you will want to do your work zoomed in, but you also want to check what it looks like further away.

Brush Hardness: You need to be aware that even a minimal percentage Hardness setting will leave an apparent visual line when painting. This might be good for something

like a pen and ink drawing, but for a photograph even minimal Hardness introduces a new visual element you don't necessarily want. Very occasionally, I raise the Hardness setting when I want to paint a new element into an image, but that's not something I do often. Painting with any kind of Hardness setting (except 0%) has to be done with great care. Most of the time I use a 0% Hardness setting because I don't want edges to show.

Brush Opacity: It's better to start with a lower Opacity setting and paint over an area several times instead of using a higher Opacity setting and painting once. Generally, for a typical multi-RAW adjustment, I use an Opacity setting of around 25%–30%.

Brush Flow: The settings for this feature really depend on your personal taste and input device—a stylus and tablet work pretty differently than a mouse. When I use a mouse, I almost always set the Flow to around 50%. This lets the Brush Tool do its thing, but slowly enough that I have some control. You need to experiment and find the right flow setting for your working environment.

Here's how

1

Select the Brush Tool from the Toolbox

Tablet or mouse?

Many people prefer to paint in Photoshop using a stylus and tablet rather than a mouse.

If you use a tablet and find that the plastic surface is too smooth, making you lose control when you draw, you can tape a piece of paper over the tablet to add friction to the surface.

2

On the left side of the Photoshop Options Bar, click (here) to open the Brush Preset Picker

Set the Opacity of the brush way down

Set the Flow of the brush (how much paint comes out) at around 50%

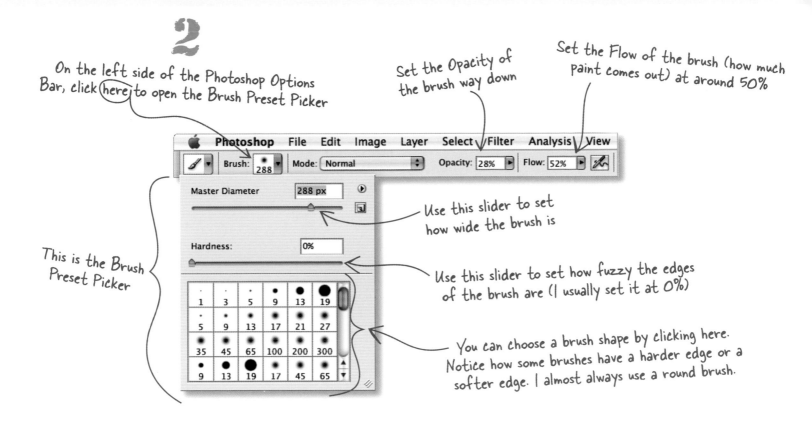

Master Diameter 288 px

Use this slider to set how wide the brush is

This is the Brush Preset Picker

Hardness: 0%

Use this slider to set how fuzzy the edges of the brush are (I usually set it at 0%)

You can choose a brush shape by clicking here. Notice how some brushes have a harder edge or a softer edge. I almost always use a round brush.

Setting the Brush Tool for control in the creative darkroom

When Photoshop is installed, the default Brush Tool cursor looks like this

While this little paintbrush is cute, it doesn't accurately show the diameter of the brush you are working with. I prefer to set the Brush Tool cursor so I can see the exact area I am painting.

To set your cursor this way:

1. On Mac select the Photoshop menu and choose Preferences ► Display & Cursors; in Windows select the Edit menu and choose Preferences ► Cursors. The Preferences dialog opens with the cursor options.

2. In the Painting Cursors area, select the Full Size Brush Tip option button, and then click OK.

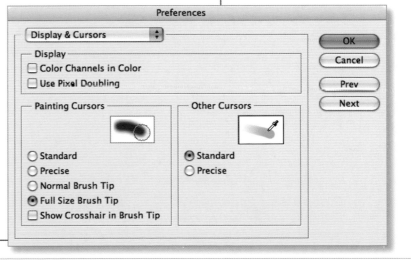

›› Painting on a layer mask

When you paint on a layer mask, you don't see the mask in the image window as you paint on it; instead you see the visible layer (in this case the Background layer). As you paint on the black layer mask with white, the areas of the hidden layer (the "Owls lighter" layer) are revealed.

Here's how

4 Paint right on the image window. Since the "Owls lighter" layer is hidden by the layer mask, keep the lighter version of the owls open in its own image window for reference

1 Select the Brush Tool from the Toolbox

2 Click on the layer mask to make sure it's selected

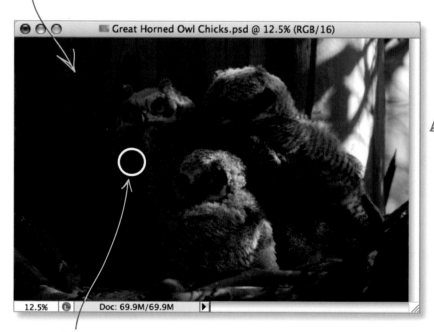
Great Horned Owl Chicks.psd @ 12.5% (RGB/16)

This is the Brush Tool cursor at work. (To find out about setting the cursor, turn to page 49.)

(To find out about setting the cursor, turn to page 49.)

3 Click here in the Toolbox to set white as the foreground color and black as the background color

Knowing Where to Paint

If you're going to paint on a layer mask that hides a layer, you can't see the layer! So how will you know where to paint?

Keep an image window open to the side of your screen that contains the image on the hidden layer. That way, you can refer to it as you paint.

After painting on the bodies and eyes of the owl chicks, here's what the image looks like

Watch Those Edges!
When you paint on a layer mask, be especially careful about edges! Generally, you will want to paint layer masks with graduated edges. That way, you won't have a transition that looks too abrupt and artificial.

The layer mask icon shows a thumbnail of the painting

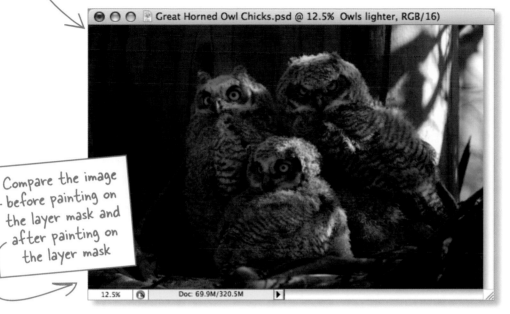

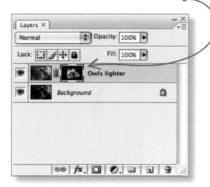

Compare the image before painting on the layer mask and after painting on the layer mask

If you look in the Channels palette, you can see the layer mask

If you look just at the "Owls lighter" layer (without the Background layer visible) this is how much of the layer is blending into the Background layer underneath

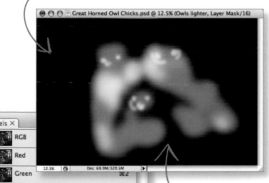

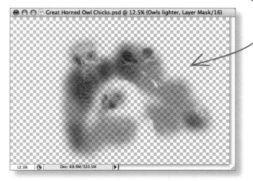

Notice how the white painting is heavier in some areas and lighter in others. The whiter an area is, the more of the layer is revealed. Also a brush with a sharper edge was used in the eye area.

Next Steps

After painting on the "Owls lighter" layer, these same steps will be repeated twice more. First, process two more versions of the Great Horned Owl Chick image in ACR—one version to lighten the owls' breast feathers and a second version just for the eyes.

Next, after opening the two versions in Photoshop, they will be placed in layers on top of the "Owls lighter" layer.

Then, using the Brush Tool and layer masks, areas of the two new versions will be painted in (pages 52–53).

» Adding two more lighter layers and painting in more details

Using the same techniques shown on pages 46–51, create two new versions of the same image in ACR. The first version is exposed for the breast feathers and the second version is exposed for the eyes.

1B

Put this version on a regular layer and rename it "Breast Feathers". Then, drag the image into the image window that already contains the "Owls lighter" and "Background" layers. (Take a look at pages 34–35 for more info.)

Start here

Process this version for the breast feathers

STEP 1

1A

Open as a copy in Photoshop (turn to page 23 for more info)

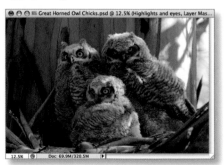

Process this version for the eyes

STEP 2

2B

Put this version on a regular layer and name it "Highlights and eyes". Then, drag it into the image window containing the other three versions.

2A

Open a copy in Photoshop

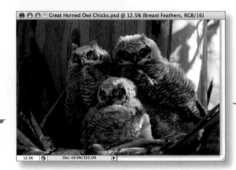

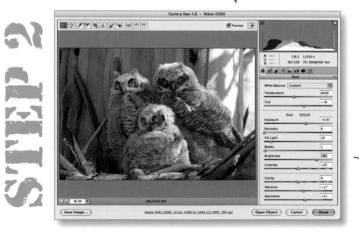

1C Add a Hide All layer mask to the "Breast Feathers" layer and paint on it using the Brush Tool to lighten and emphasize the owls' chest feathers. (Pages 46–51 show you how to do this.)

Here's what the image looks like after painting on the layer mask

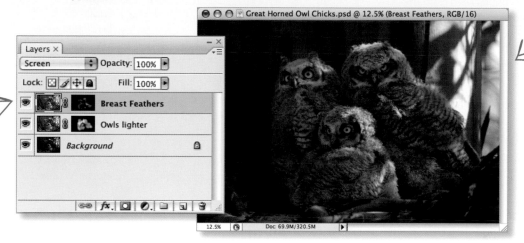

Move on to Step 2

2C Add a layer mask to the "Highlights and eyes" layer, and then paint on the layer mask to reveal the eye area and highlights

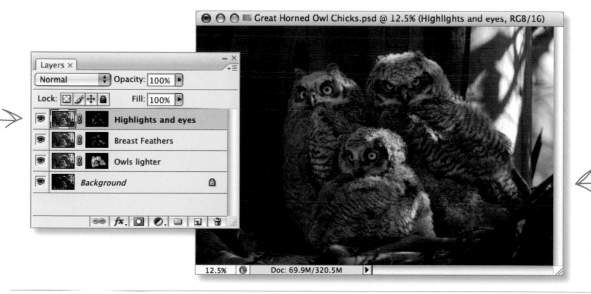

Next Steps
Flattening the layers and cropping the image (pages 54–55)

Here's the finished image with the eyes and highlights painted in

›› Flattening layers

Going on a diet

Since the RAW processing is finished, to take the image forward from this point, I would want to merge the layers together into one Background layer, and then crop the image. Flattening the layers will cut down the file size 75%—from 320MB to 70MB. (Each layer adds as much to file size as the Background layer, no matter what's on the layer.)

Before merging the layers together, save a checkpoint version of the file because merging together layers is a pixel destructive action in Photoshop. You can't go home again. Once you close the image following the merge, the information in the separate layers is lost. So you will want to save a version that contains all the layers and layer masks in case you need to go back to that version.

I wouldn't even consider cropping the image before all the different RAW versions were combined because cropping would lead to alignment problems copying a layer from one image window to another

Core Photoshop work

After the layers have been flattened and the image has been cropped, any work you do on the image is core Photoshop work. You'll find ideas about how to creatively enhance images after they've been processed from RAW into Photoshop starting on page 70.

I *Checkpoint*

Before you flatten the layers save the image! (For more about checkpoints, take a look at page 25.)

Choose Flatten Image from the Layer menu

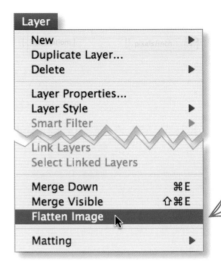

This is what the Layers palette looks like before flattening the layers

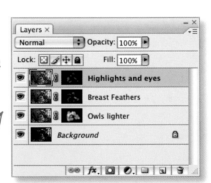

After flattening, the only layer left is the Background

>> Cropping an image

You can click here to change the color of the area showing what will be cropped

Click here to cancel the crop

Photoshop File Edit Image Layer Select Filter Analysis View Window Help

Cropped Area: ○ Delete ○ Hide ☑ Shield Color: ▢ Opacity: 30% ☐ Perspective ⊘ ✓

Ready, set, crop!

From the moment I pressed the shutter, my plan was to crop in on this image. Now that the image has been processed from the RAW, it's time to crop.

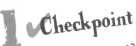

1 ✓ Checkpoint

Before you crop save your image! (For more about checkpoints, take a look at page 25.)

2 Select the Crop Tool from the Toolbox

3

Click and drag a marquee of "marching ants" around the area you want to keep (the area that will be cropped will be shaded with a color shield)

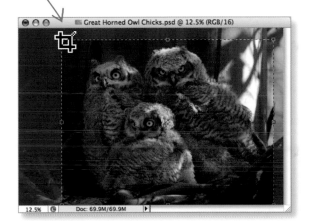

Great Horned Owl Chicks.psd @ 12.5% (RGB/16)

12.5% Doc: 69.9M/69.9M

4 Click the check to commit to the crop or press Return/Enter

5 ✓ Checkpoint

Save your image again after cropping. Cropping is a pixel destructive action, so be sure to save your image **before** and **after** cropping

Figuring out what to crop

It's sometimes hard to know how to crop an image. Often this comes down to a matter of taste and composition. Of course, I try to make the best possible composition in-camera—but this is not always possible.

When I make the decision to crop an image, I try to understand first what is most visually compelling about an image. Cropping should emphasize the compelling aspect of a photo and minimize the parts of the photo that are not important.

In the case of the owls, it was clear to me that I cared about the owls, but not the scraggly eucalyptus background. That's why I was so sure that I would want to crop.

Fortunately, the Photoshop Crop Tool makes it pretty easy to experiment with a variety of crops before actually committing to a crop, so you can see what works best. If you do commit to a crop that you don't like, you can always use the History palette (or your saved checkpoint version) to reverse the crop.

›› Compare these settings and histograms

Small changes in ACR settings have a big impact

The different versions of the RAW file that I combined to create the owl image are really pretty similar to each other. If you look below you can see them going from darker to lighter. Combining them is a simple but extraordinarily powerful concept. You'll get a great deal of mileage using the same straightforward technique on many RAW images with subject matter varying from nature to portraits to architecture.

Take a moment to look at the exposure and color settings for each version in the ACR window. You can easily see the impact of the settings on the image itself. You can also see what changing the settings does to the exposure histogram. Roughly speaking, these kinds of changes are what you should look for when you plan to multi-RAW process a single image file going from darker to lighter.

This histogram is pushed over to the left side, showing that most of the image is underexposed

This tiny spike on the right represents the blown out area on the tree trunk

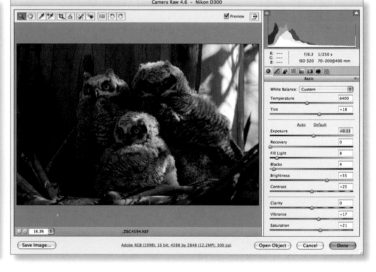

Version #1

This RAW image was underexposed, so I raised the Temperature and Tint to make it look more like it was in real life. This version is the darkest one and it became the Background layer.

Version #2

This next version was processed for the owls in general. I lightened up the image using the Exposure slider. Also, I adjusted the Temperature to give it an overall warm look. This version became the "Owls lighter" layer.

Any single one of these versions of the capture would be pretty "blah" and dull by itself. When they are combined, they create a striking image.

Histograms tell the story

Compare the histograms on these four versions of the same image. Notice how the mountain that starts out on the left side in the first version, moves to the right through the successive versions as they get lighter.

The mountain also becomes a hill. The lightest version (#4) no longer has the complete tonal range in the midtones.

If you had your camera set on Auto exposure, the "As Shot" RAW image would probably look close to this one

For more about histograms and ACR, take a look at page 19

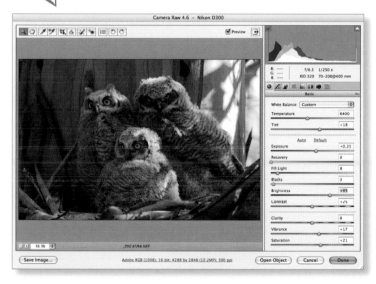

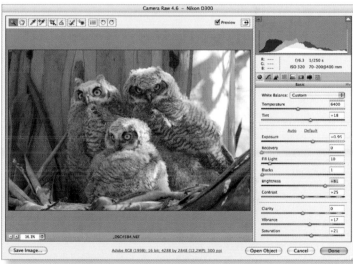

Version #3

This version of the owl chick image was processed with the breast feathers in mind. It didn't matter to me that the upper right corner of the image was becoming more blown out. What was important was the texture and colors of the feathers. This version became the "Breast Feathers" layer.

Version #4

This final version was processed specifically for the eyes. As I moved the Brightness and Exposure sliders, all I paid attention to was the eye color. This lightest version became the "Highlights and eyes" layer.

ONWARD & UPWARD

Next steps with processing

Okay, we're going to take multi-RAW processing one step further.

First you processed two versions of the same landscape image using a gradient on a layer mask (pages 30–39). Next, you processed four versions of the same owl chick image and painted in the details using layer masks (pages 42–55). Now you're moving on to process four versions of a sunflower image and you are going to combine them with a new twist—using blending modes (pages 60–67).

But before you move on, let's go back to the owl chicks for a moment.

Once you have cropped an image the way you like, there are many further steps you can take with an image in the Photoshop darkroom. It depends upon the image but you might want to:

- Burn or dodge portions of the image (pages 72–73)
- Process the image for excess noise (pages 78–81)
- Convert the image to black and white (pages 84–100)
- Combine the image with another image to make a photo-composition (pages 120–129)
- Use LAB color to add color effects to the image (pages 154–180)
- Use filters to add effects to the image (page 182)
- Paint on the image (pages 188–191)

In any case, you will almost certainly want to "finish" the image by adjusting the image's LAB curves (pages 194–197) and applying selective sharpening (pages 198–200).

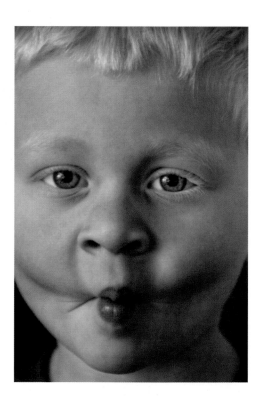

It's usually impossible to combine multiple captures of people because they move. That's where multi-RAW processing, which only uses a single capture, comes into play.

I processed this photo of a four-year-old in the same way as the owl chicks, starting with a dark background layer and using two lighter layers to "paint" in the child's eyes, lips, and cheeks.

Stay Tuned!
Multi-RAW processing and blending modes are coming up next, starting on page 60!

I SHOT THIS IMAGE looking up one of the stairs that Frank Lloyd Wright designed in the Marin Center in San Rafael, California.

To bring out the spiral form of the stairs, I used the same multi-RAW processing techniques that were used on the owl chick image. I started with a dark version for the Background layer and layered in successively lighter versions for the spiral area of the stairs.

>> Multi-RAW Processing: Using blending modes

I WAS COMMISSIONED TO shoot a series of natural but colorful images for a series of book covers. One of the images the client wanted was of a sunflower. I went out to my local supermarket and bought several likely suspects — ah, sunflowers — and brought them home.

In my studio, I draped a chair with black velvet cloth and photographed one of the sunflowers in natural sunlight.

When I approached the multi-RAW processing for this image, I knew I would have to start from darkest to lightest and build the flower up once I had the black background in place.

I also realized that the rather large and dark center of the sunflower would be a special problem. There was no way to light the center of the sunflower to make it sufficiently bright without also destroying the delicacy of the petals. I knew I would have to tackle this issue using the power of Photoshop blending modes in addition to "standard" multi-RAW processing.

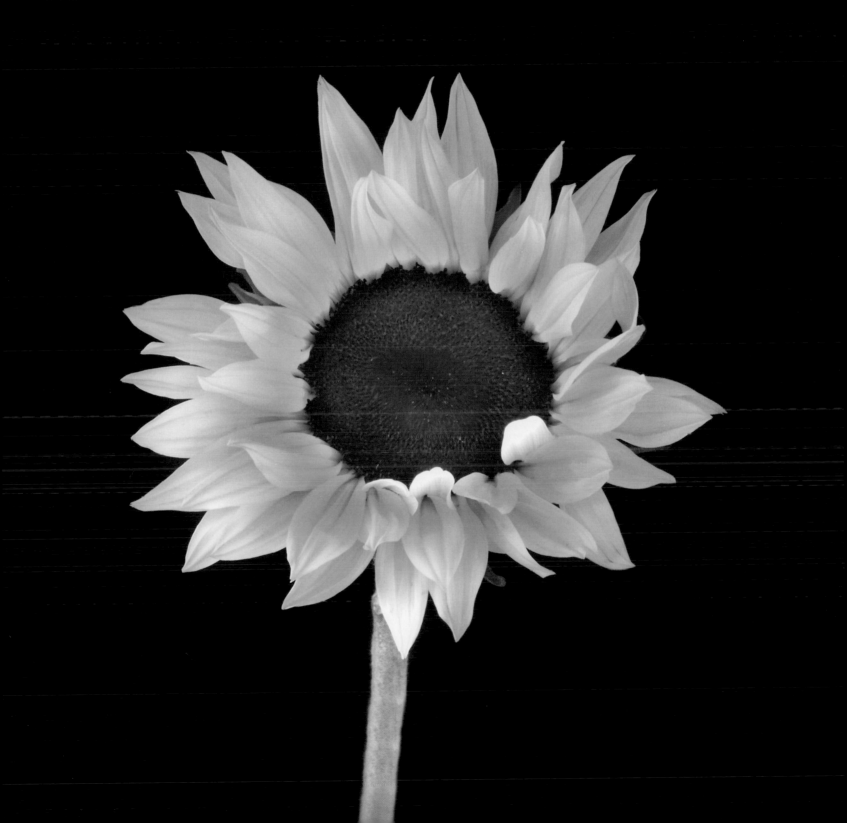

›› Making the sunflower center pop

Post-processing strategy

The center of a sunflower is naturally a fairly dark area. To make the image glow in the way that my client wanted, I would need to substantially brighten the center without destroying the color values in the rest of the flower.

In the owl chick example (pages 42–57), my strategy was to start with a dark version and layer successively lighter versions on top.

Here I did the same thing, with a couple of twists. When shooting on a black background, you really have to go very dark to make sure distracting details, such as lint and hairs on the black velvet cloth, don't show. I processed the first version in ACR with this in mind.

I only processed two versions: one for the dark background and the other for the flower.

I then layered in the lighter flower version using a screen blending mode twice to get the lighter effect in the center of the flower while keeping colors attractive.

Screen blending mode works to lighten all the pixels in the unmasked areas of a layer. For more about the various blending modes and how they work, turn to pages 70–71.

Here's the sunflower capture I used

The darker version

This version was processed for the background. For the White Balance, I used the default Daylight setting of 5500 Kelvin. The only other changes I made were to slightly brighten the exposure (by 0.25 of a stop) and increase the color saturation.

If you look at the histogram, you can see that this version of the image hardly has a pulse. It's almost flatlining, with very little distribution of values except on the extreme left, which represents the black background.

The lighter version

As opposed to the darker version, the lighter version has some signs of life. Looking at the histogram, you can see the yellow mountain on the left that represents the flower.

With this version, I completely ignored the background and worked on the flower. In fact, if you magnify the background in this version, you would be able to see surface details that are undesirable.

The main move I made here was to use the Exposure slider to make the image much brighter. Increasing Fill Light, reducing Blacks, and increasing Brightness added to this effect.

I didn't worry too much about some overall loss of detail in the flower petals, because I knew that the petals would be blending with the darker version.

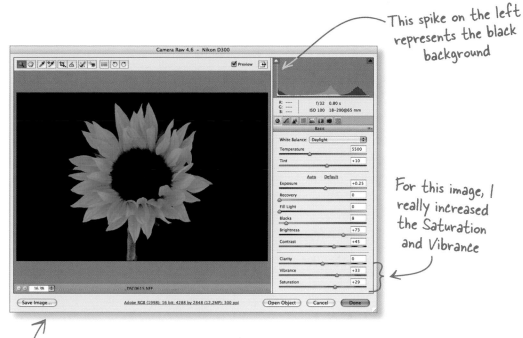

This spike on the left represents the black background

For this image, I really increased the Saturation and Vibrance

It's really amazing that a version of the sunflower that is so dull can become the background for a colorful and publishable image

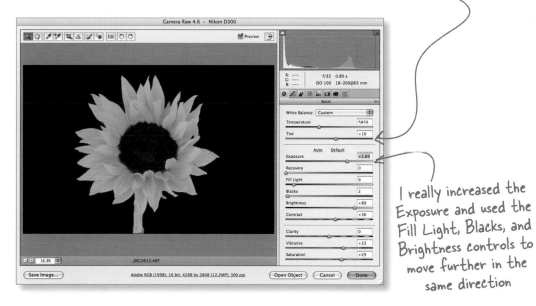

I used the Tint slider to introduce a slight magenta cast around the center of the flower

I really increased the Exposure and used the Fill Light, Blacks, and Brightness controls to move further in the same direction

>> Making the sunflower center pop

Layer the two versions, add a layer mask, and paint on it

After opening both versions in Photoshop, do the following:

1. Change the lighter flower version from a Background layer into a regular layer and rename the layer "Flower" (turn to page 34 for directions on how to do this).

2. Drag the "Flower" layer into the image window containing the darker "Background" layer (for directions on this technique, turn to page 35).

3. Add a Hide All layer mask to hide the "Flower" layer (take a look at page 36 for directions).

4. Choose the Brush Tool from the Toolbox and get it ready to go (turn to page 48 for directions).

5. Click the layer mask on the "Flower" layer to select it and paint on the layer mask to reveal the lighter flower (take a look at page 50 for directions on painting on a layer mask).

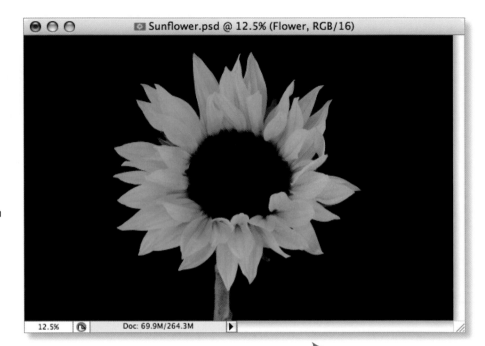

After painting on the layer mask, the sunflower looks like this. Notice that the flower is lighter, but the petal tips, stem, and center is not light enough, yet...

When you have finished these steps, your Layers palette should look like this

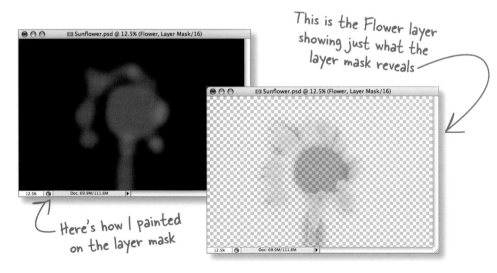

Here's how I painted on the layer mask

This is the Flower layer showing just what the layer mask reveals

›› Duplicating the Flower layer

Layer it again, Sam

In order to continue lightening the flower, a copy of the "Flower" layer with an unused layer mask needs to be added to the image.

1 Make sure the "Flower" layer is selected in the Layers palette, and then choose Duplicate Layer from the Layer menu

2 In the Duplicate Layer dialog that opens, name the new layer "Petals and center", then click OK

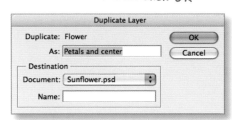

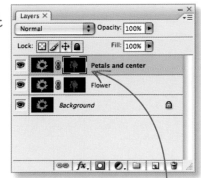

Here's how the Layers palette looks after duplicating the layer. However, the "Petals and center" layer still has the old layer mask from the Flower layer. You'll need to remove it and add a new black layer mask.

3 Remove the layer mask by selecting the "Petals and center" layer in the Layers palette, and then choosing Layer > Layer Mask > Delete

You can also delete the layer mask using the Layers palette. Drag the layer mask onto the tiny trash can icon at the lower right corner of the palette. If you do this, a dialog will open asking if you want to apply the layer mask before it's removed...click Delete.

4 Add a new black Hide All layer mask to the "Petals and center" layer by selecting Layer > Layer Mask > Hide All

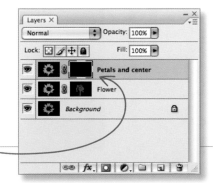

Next Step
Change the blending mode of the "Petals and center" layer (pages 66–67)

» Setting the blending mode to Screen

Making the sunflower lighter

The Screen blending mode works to make every non-white pixel in the combined layers lighter. Blending a layer with itself using the Screen blending mode is a great way to lighten a photo.

You can use a layer mask to control exactly which portions of the finished image are lightened. This is the technique used here on the sunflower, and also used in preference to conventional dodging (see pages 72–73 for a discussion about using blending modes instead of the Photoshop Burn and Dodge Tools).

☆ *This is the method I use to lighten an area within an image instead of using the Dodge Tool*

1 Duplicate the "Flower" layer, call it "Petals and center", and then delete the layer mask that was created when you duplicated the layer. (For directions on how to do this, turn to page 65.)

2 Click the Blending Mode drop-down list and select Screen

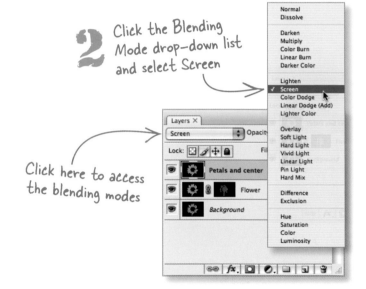

Click here to access the blending modes

By default the Normal blending mode is applied to every layer

The layer's blending mode setting is Normal

Here's how the Layers palette looks after duplicating the layer

Here's what the "Petals and center" layer looks like after selecting the Screen blending mode

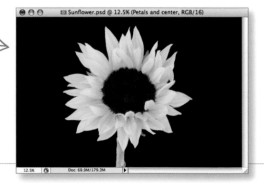

›› Painting in the details to finish the image

Painting in details and duplicating the layer again

Finishing the image uses the same painting and layering techniques that this case study has already used.

The sunflower is really coming to life, but the center is still a bit dark and lacks detail

After painting on the layer mask, the sunflower image looks like this

Here's how I painted on the layer mask

1 Add a black layer mask to the "Petals and center" layer (look at step 4 on page 65 for directions)

2 Use the Brush Tool to paint in the center, petal tips, and stem on the layer mask (take a look at pages 48–51 for info)

This is the "Petals and center" layer showing what the layer mask reveals

3 Duplicate the "Petals and center" layer and call the new layer "Center and stem". Then, remove the duplicated layer mask and add a new black Hide All layer mask to the new layer (turn to page 36 for directions). The layer's blending mode is already set to Screen (which is exactly what you want).

Here are the layer mask and the "Center and stem" layer

4 Get the Brush Tool out one last time and lighten the center and stem by painting in those areas. Notice how much lighter the center is now.

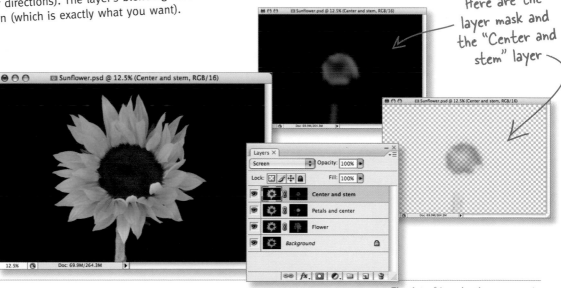

Shooting against black velvet

You can get a great deal of mileage out of an inexpensive piece of black velvet cloth, available at most fabric stores. The piece I used was two yards long and 50" wide and cost less than $10. Compared to other fabrics, black velvet is particularly good at absorbing light and is non-reflective. It comes through in a photo as very black, so that objects seem to float on it.

You can put any kind of object or still life on black velvet cloth. It works well to drape the cloth over a chair or to put it on a table.

Many kinds of light sources will work. For the sunflower shown on page 61, I used sunlight coming through a window. But I've also successfully used an LED headlamp and a low wattage common household lamp.

If you're using an overall average exposure reading, you'll want to "underexpose" significantly so the velvet really appears black and so the subject of the photo isn't overexposed. Alternatively, you can take a spot meter reading on the subject itself.

You'll probably want to do this kind of photography using a tripod so you can shoot at a slow shutter speed and a low ISO with the lens stopped down for high depth-of-field.

Shooting on black velvet presents a great opportunity for hand HDR work if you shoot multiple exposures at successively slower shutter speeds (the f-stop stays the same). Hand HDR is explained starting on page 106.

To the left is the original dandelion photo. To the right is an image made from the photo in the Photoshop darkroom. I used layers, layer masks, blending modes and painting to create the finished version.

IN THE EARLY MORNING a field was covered with a dense mist. I photographed the dandelion shown at the left covered with water drops up close and personal with a macro lens, extension tubes, and a tripod. In Photoshop, using a combination of layers and different blending modes, I transformed the relatively bland original photo into the colorful, striking image you see here.

›› How blending modes affect a layer

Darks, lights, and midtones

Blending modes are one of the key features you can use in Photoshop to impact how your images look. A blending mode controls the way the pixels from one layer blend with the pixels in the layer beneath.

If you've never taken your blending mode off Normal, you're in for a wonderful surprise.

Photoshop is a visual program. I'm all in favor of finding out what different blending modes do by testing them out. After all, there's nothing like seeing something for yourself. That said, there are some relationships between blending modes that you should know about.

On the Blending Mode drop-down list, the blending modes are divided into categories for darkening, lightening, and increasing contrast. In addition, there are some specialized blending modes—Difference and Exclusion—and blending modes that primarily impact color.

Blending mode test

On the next page is a quick test to see how a few blending modes affect lights, midtones, and darks. I'm using the yellow poppy image from pages 6–7. This image includes shadowed areas with lights and darks as the Background layer. On the layer above, called "Test strips", I've put three rectangles: one white, one 50% gray, and one black.

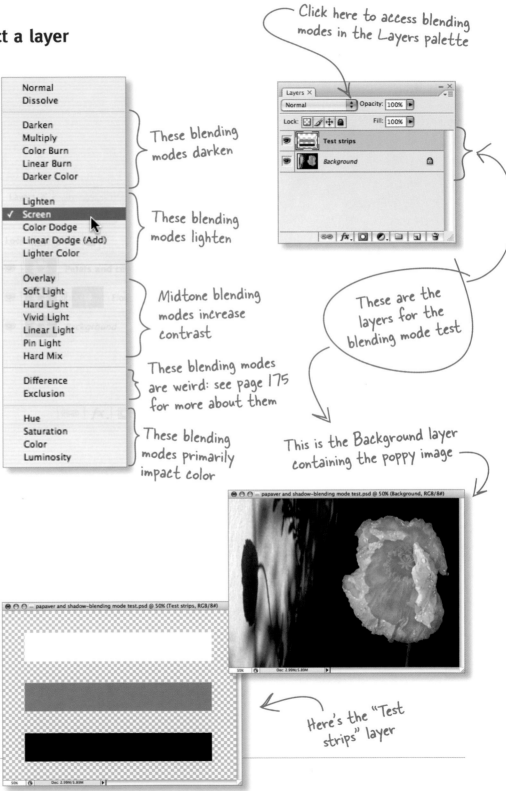

These blending modes darken

These blending modes lighten

Midtone blending modes increase contrast

These blending modes are weird: see page 175 for more about them

These blending modes primarily impact color

Click here to access blending modes in the Layers palette

These are the layers for the blending mode test

This is the Background layer containing the poppy image

Here's the "Test strips" layer

Normal

This is how the image looks with the Normal blending mode selected.

Multiply

Here's the image with the Multiply blending mode selected. Since this blending mode affects dark areas, the white strip disappears and has no effect on the image. The blending mode darkens the area under the gray strip.

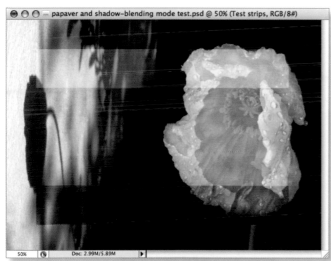

Soft Light

Soft Light is a blending mode that works on the portions of an image that include gray. Soft Light and the other midtone blending modes increase contrast.

Here the gray strip disappears, the white strip lightens the area it is over, and the black strip darkens the area it is over.

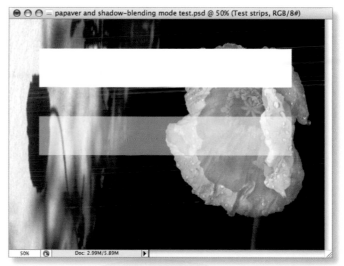

Screen

When I select the Screen blending mode, which affects lights, the black strip disappears. This blending mode lightens the area under the gray strip.

>> Burning and dodging

The right way to burn and dodge

In the chemical darkroom, one of the most fun parts of making a print was bringing out details by burning and dodging.

Burning used an enlarger to expose a specific area of a print through a hole of some kind in black cardboard, constantly kept in motion so its edge did not show. The result was a darkened area.

Dodging was the opposite: while the enlarger was exposing, a black cardboard disk on some kind of stick (often a wire coat hanger!) was continually waved above an area that needed lightening.

Coming to Photoshop with fond memories of jiggling coat hangers in the darkroom, I naturally turned to the Burn Tool and the Dodge Tool when I needed to do the digital analog of chemical darkroom burning and dodging.

But today, I do *not* use the Burn or Dodge Tools. Once you know how to use blending modes and layer masks, you'll find that they are a more powerful and flexible way to get the results you want. Unlike the Burn and Dodge Tools, using blending modes and layer masks to lighten and darken specific areas within an image is non-destructive. It's also great that you can easily modify your burn or dodge if you decide that you have gone a bit too far.

Once you try burning and dodging the masking and blending mode way, I bet that you won't go back to the "old fashioned" Burn and Dodge Tools.

Dodging

1 This columbine is a bit dark on the lower inner petals and the stamens.

2 Duplicate the background layer, change the blending mode to Screen, and add a Hide All layer mask (directions on page 36).

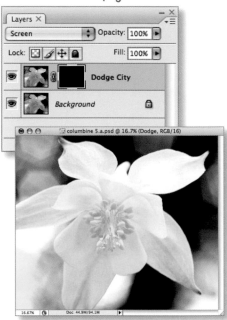

3 Use the Brush Tool and gently paint on the layer mask to lighten the petals and stamens. (Info about painting on a layer mask is on pages 48–51.)

I photographed this columbine outdoors in a garden hanging from its own stem. With light behind, the petals were in shadow. The shadowed areas of the petals needed some selective and careful brightening.

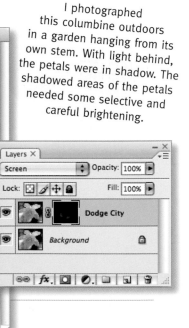

Burning

The tiny flower in the center of this balloon flower is too light and lacks detail.

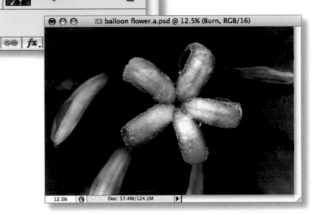
2 Duplicate the Background layer, change the blending mode to Multiply, and add a Hide All layer mask (directions on page 36).

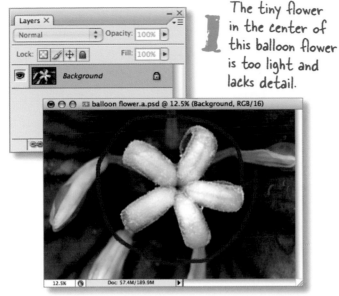

3 Use the Brush Tool to darken the center by painting on the layer mask (info on pages 48–51).

The white efflorescence within this balloon flower is a tiny flower within a flower. An overall exposure for the flower made the efflorescence too bright and caused a loss of detail. To adjust this issue, I needed to "burn" the inner flower.

What size Brush Tool should you use?

As I showed you before (pages 48–51), I usually burn and dodge with a 0% Hardness setting. To find the size brush you should use, look at the area you need to burn or dodge. You really need to be able to see what you're going to work on, which means you'll probably want to magnify the area. Choose a brush size that is proportional to the area you want to burn or dodge. If your brush is too big, you'll change areas you don't want to touch. And if your brush is too small, you risk creating lines in your photo.

YOU CAN THINK OF noise as static in a digital photo. All digital signals and communication will create some noise as an inherent and often unwanted side effect—and this includes digital photographic capture.

There are several different kinds of noise. From a practical viewpoint, without going into the general theory, you need to know what causes noise (see page 76), when noise is useful (and when it is not), and how to remove it when you don't want it.

Surprise! Noise can be a good thing. An image without noise can look "toothless"—flat and lacking in texture. There are times where I either leave noise in a high noise image, or add noise on purpose. The photo to the right was taken in extremely low light conditions at ISO 2000. When I processed it in the digital darkroom, I decided that the noise was really an integral part of the image so I left it in.

When it comes to processing a noisy image, you should know that removing noise inherently unsharpens—this is just the way it is. It's rarely a good idea to uniformly remove noise from an entire image. Instead, noise removal should be done on one or more duplicate layers. Using layer masks, you can perform stronger noise processing in areas that need it most, taking care not to remove the noise from areas that should stay sharp.

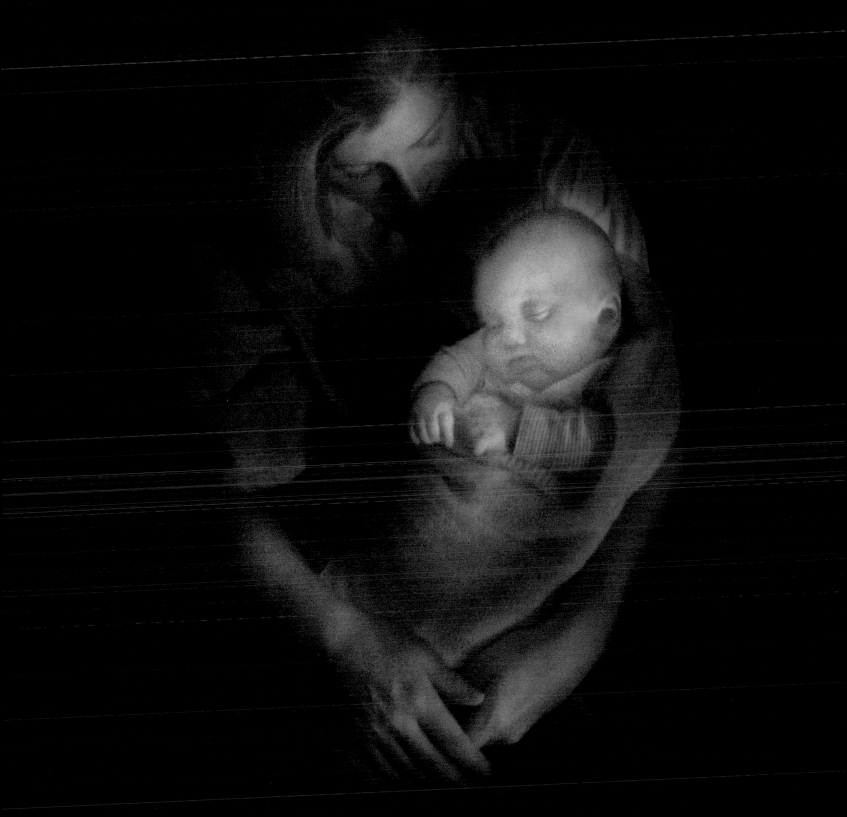

What causes noise?

As a matter of physics, the smaller the sensor, the more noise there is for a given capture size. There are many other causes of noise in a digital capture including:

- The native ability of the sensor and the camera's processing software.

- The ISO setting used. The higher the ISO is, the more noise there will be.

- The size of the image. The larger the image, the more noise.

- The exposure time. Exposures that are longer than about 5 seconds begin to greatly increase the noise in an image.

- The overall exposure settings in relation to the brightness of the subject. Underexposed areas tend to have more noise.

As a practical matter, you have the camera that you have, so the causes of noise that you can do something about are the ISO and exposure settings. (For more info about exposing for post-processing, take a look at page 104).

Many cameras have settings that will reduce noise in high ISO or long exposure situations. You should refer to your camera manual to find out how to use these settings.

The photo of the Poppy emerging (left) and the tiny Lobelia flower (right) share a Photoshop darkroom characteristic. Both have added noise.

Looking at these images on my computer, I felt that the noise I saw enhanced the images rather than detracting from them. So I actually increased the noise level in each image using the Photoshop Add Noise filter.

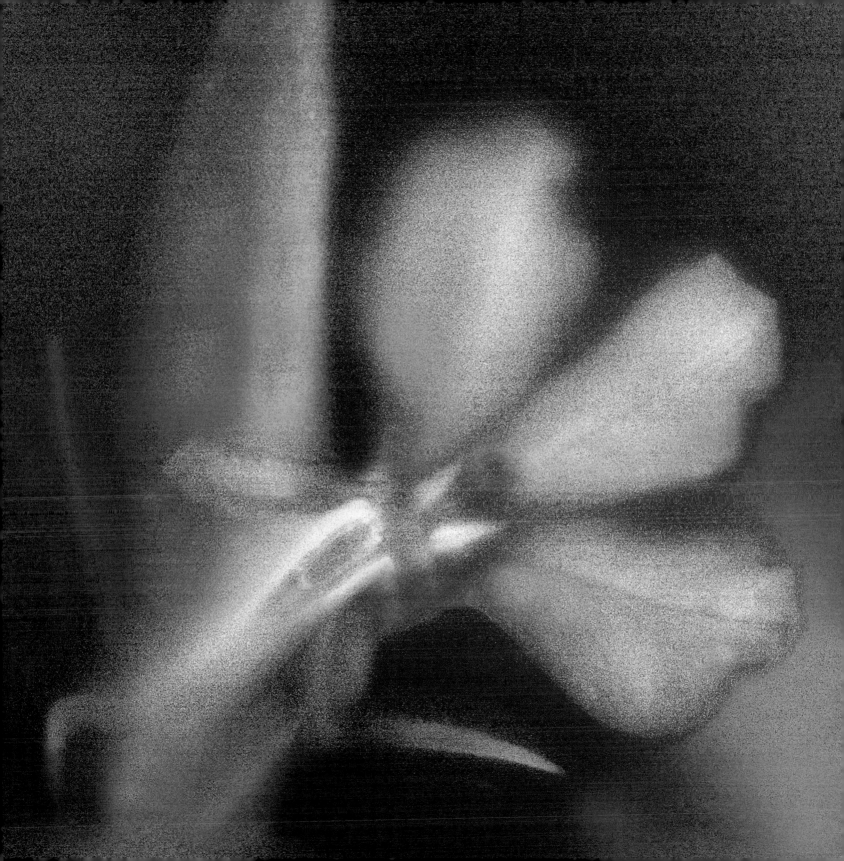

›› Noise processing tools and Photoshop

Post-processing to remove noise

Once I finish the RAW processing of an image, if I am going to remove noise, I like to do the noise processing as an early step in the Photoshop darkroom. The reason for this is that if you leave noise in, it can get multiplied in later steps when blending layers together.

The general scheme for removing noise is to duplicate the Background layer, use a noise reduction tool to process the duplicate layer for moderate noise,

add a Hide All layer mask, and paint in the areas that need noise removal. Next, if the image has areas of extremely high noise, duplicate the Background layer again. Drag this new duplicate to the top of the layer stack and use a noise reduction tool to process the duplicate for high noise. Then, paint on a Hide All layer mask to remove noise.

Now, about those noise reduction tools. There are quite a few good tools for processing noise. In Photoshop, from the Filter menu select Noise ▸ Reduce

Noise, and then play with the settings in the Reduce Noise dialog. I prefer to use the Noise Ninja Photoshop plug-in. You can download a trial version at http://www.picturecode.com/download.htm. Once Noise Ninja is installed it will appear on the Photoshop Filters menu.

It doesn't really matter what tools you use to process noise. What does matter is how you use your tool of choice. The way to remove noise is to paint successively strong noise processing on layers—only in the areas that need it.

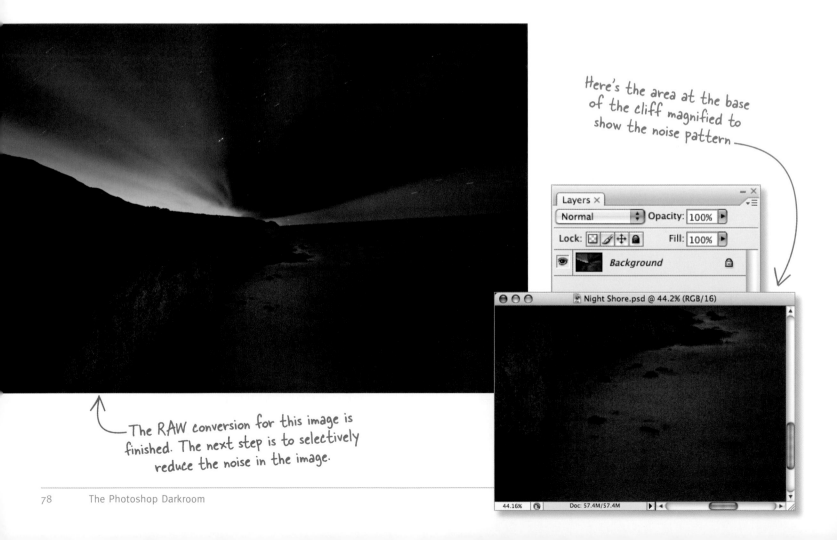

Here's the area at the base of the cliff magnified to show the noise pattern

The RAW conversion for this image is finished. The next step is to selectively reduce the noise in the image.

Selectively processing an image for noise

The *Night Shore* image shown at the left is pretty noisy. You could process the entire image at once for noise, but that would make the image too smooth and lose a lot of the detail.

Instead, selectively processing the image for noise—using heavy noise reduction on the cliff, hill, and lower right areas, and moderate noise processing on the sky—will leave an image that has texture, plenty of detail, and is aesthetically pleasing.

The way to go about selectively processing an image for noise is to use a noise processing tool combined with the same techniques you used for multi-RAW processing: layers, layer masks, and painting.

Here's how

1 Duplicate the Background layer and name it "Moderate" (for info turn to page 65)

2 With the Moderate layer selected, open Noise Ninja by choosing Filter ▸ PictureCode ▸ Noise Ninja

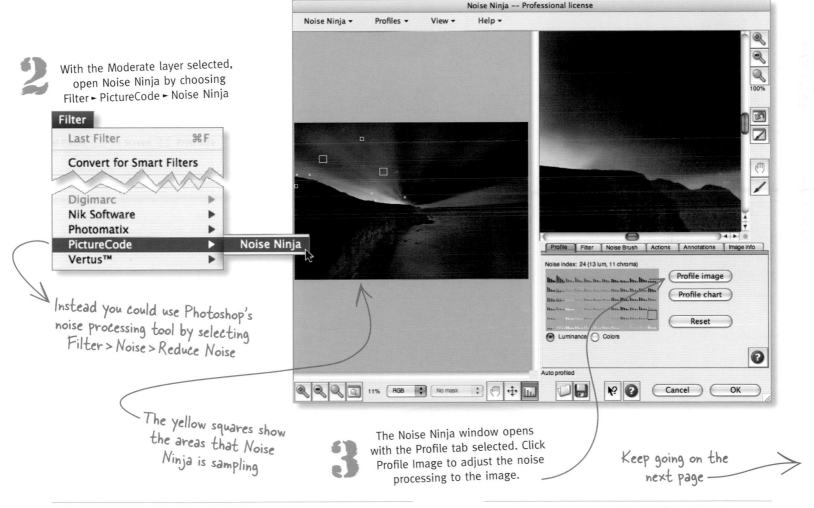

Instead you could use Photoshop's noise processing tool by selecting Filter > Noise > Reduce Noise

The yellow squares show the areas that Noise Ninja is sampling

3 The Noise Ninja window opens with the Profile tab selected. Click Profile Image to adjust the noise processing to the image.

Keep going on the next page —

4 Click the Filter tab and accept the default values. (If default values aren't showing, click Reset to get moderate noise settings back).

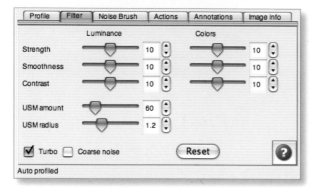

5 Click OK in the Noise Ninja dialog to apply the noise reduction to the "Moderate" layer.

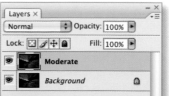

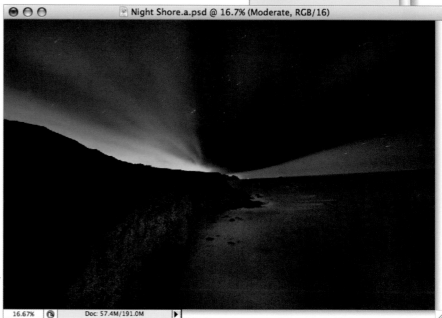

The moderate noise processing looks good overall, so there's no need to add a Hide All layer mask to the layer and paint in portions of the layer.

The sky cliff and lower right area still look like they need more noise processing so it's time to do some heavier noise reduction on another layer

6 Duplicate the Background layer and name it "Heavy." Then, drag the layer to the top of the layer stack.

7 Open Noise Ninja again (Filter ▸ PictureCode ▸ Noise Ninja) and click the Filter tab. Move the Strength, Smoothness, and Colors sliders to the right and the Contrast slider to the left for heavier noise reduction. Make sure Coarse Noise is checked. Adjust the sliders until the image looks good.

Click OK in the Noise Ninja dialog to apply the noise reduction to the "Heavy" layer.

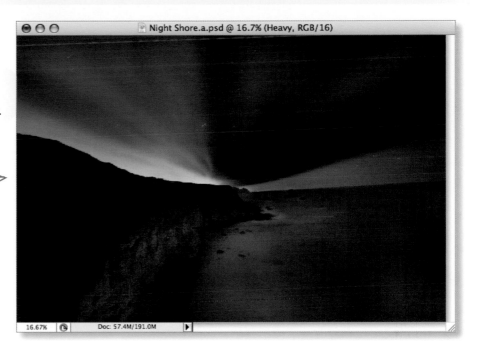

The sky here looks much smoother than the Background layer with no noise reduction, shown on page 76

Add a Hide All layer mask to the "Heavy" layer (info page 36) and paint in the noise reduction onto the cliff, sky, and lower right with the Brush Tool set at 0% Hardness, 100% Opacity, and 100% Flow (info for Brush Tool settings on page 48).

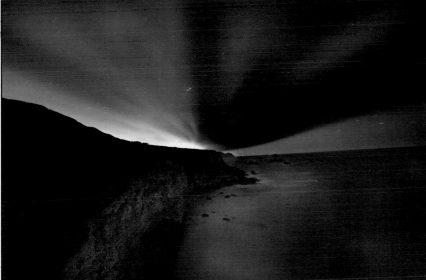

Process it again, Sam!

You can process an image for noise more than once. As I approached the end of my Photoshop darkroom workflow with this photo, I felt that the noise on the cliff and the lower right was still a bit too heavy. So I processed the image for selective noise reduction again—using layers, of course!—concentrating on that lower right quadrant and the cliff. The results are shown on page 82.

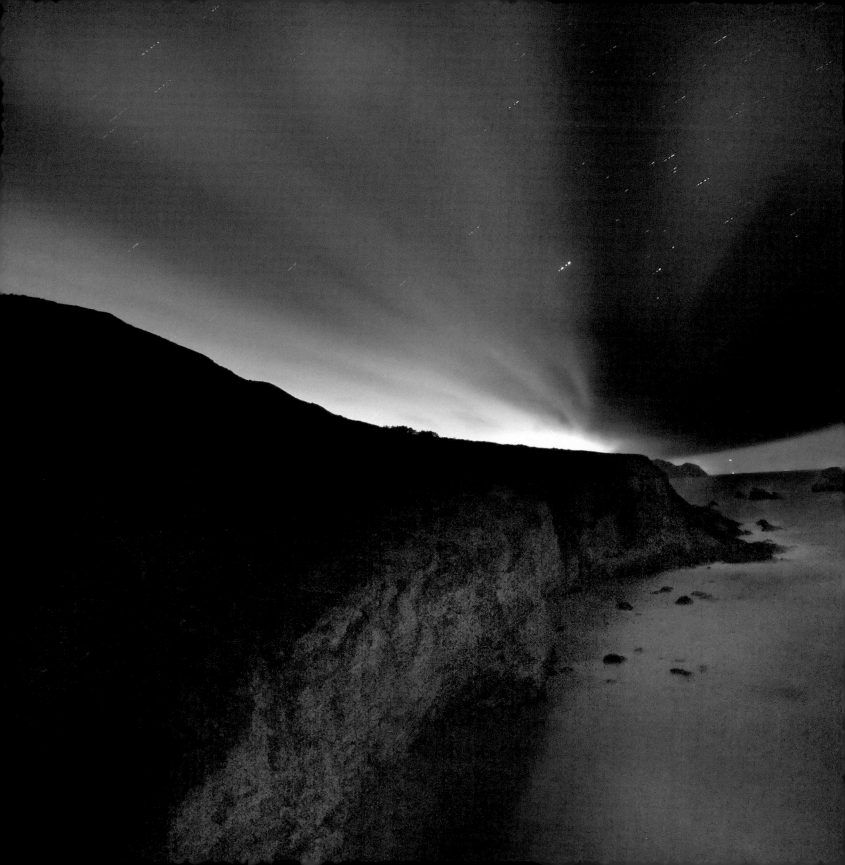

I TOOK THIS NIGHT shot of clouds rushing in front of the distant lights of San Francisco from a remote rock jutting into the Pacific ocean. The long five-minute exposure smoothed the huge breakers rolling in, but also added considerable noise.

Selective noise processing as shown on pages 78–81 allowed me to create a post-processed image that is both dramatic and aesthetically pleasing.

MONOCHROME IMAGERY—black and white—resonates with the history of photography. Even apart from the association with the old masters of photography, there's a great deal of power in black and white photography. The absence of color lets the composition and lines of the subject come through with complete clarity.

Black and white imagery in digital photography requires a new approach. It's a mistake to set your camera to shoot in Black & White mode as this just serves to drop the color information. (The only reason for doing this is to get a preview of what your image might look like in black and white.) It's also a mistake to choose a black and white conversion technique in the Photoshop darkroom that simply drops the color information.

The best approach is to shoot your image in color and process it to take full advantage of the color information. Once you are happy with the image, you can then use selective black and white conversion on multiple layers to control exactly how each part of your image converts to black and white. This allows you to have an extremely expanded tonal range in your monochrome imagery with very white whites, very black blacks, and subtle gradations between the two extremes.

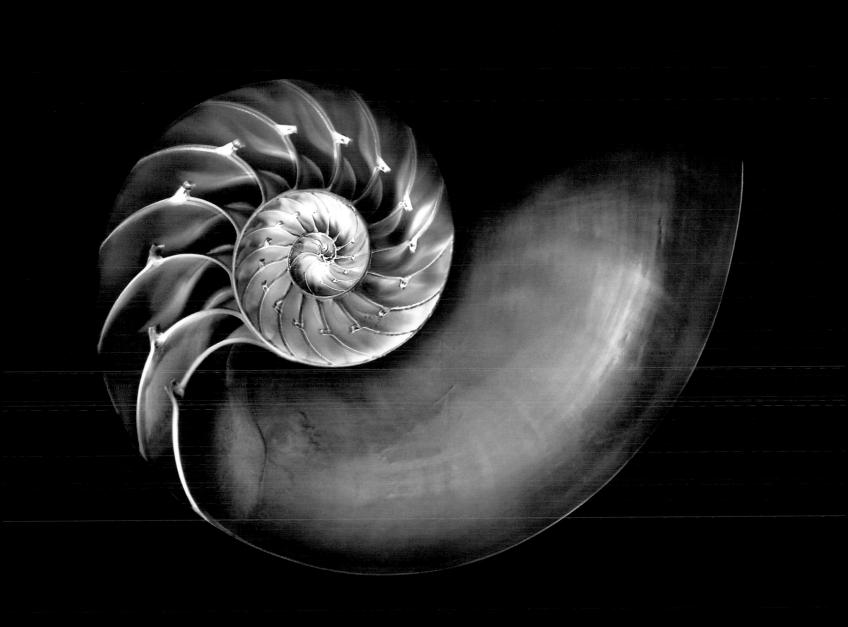

» Using color information to convert to black and white

Black and white nirvana

On the road to black and white nirvana, there are many side paths that can take you down the proverbial route to Hades. So when you start to create black and white imagery, keep both your goal and the methods that you are going to use clearly in mind.

Monochrome imagery starts with pre-visualization. For the most part we see in color and not all color views are suitable for black and white rendition. You need to look carefully to compose images that will work in black and white. What good black and white imagery all has in common is a striking use of light that is not dependent on the color values of that light.

As you process your image that will end up black and white in ACR and Photoshop, you need to be very aware that your tools for modifying the image and its tonal range are far more extensive when it has multiple channels—e.g. RGB—than when it only has a single channel—e.g. grayscale. Therefore, the bulk of your work on the image needs to be done *before* you convert it to black and white.

Like the Paul Simon song *50 Ways to Leave Your Lover*, Photoshop provides many ways to do the actual black and white conversion. Unfortunately, the most simple of these conversion techniques simply drop color information instead of using the color information flexibly in your conversion process. So don't get seduced by the ease of these techniques.

Truly striking black and white imagery requires just a little bit more work.

SHOWDOWN AT THE PHOTOSHOP BLACK & WHITE CORRAL:

THE GOOD

- Use the Channel Mixer on a duplicate layer (Image ▸ Adjustments ▸ Channel Mixer) or on an adjustment layer (Layer ▸ New Adjustment Layer ▸ Channel Mixer)
- Convert a duplicate layer to black and white (Image ▸ Adjustments ▸ Black & White)
- Add a black and white adjustment layer (Layer ▸ New Adjustment Layer ▸ Black & White)
- Use a third party black and white filter, such as NIK Silver Efex Pro

Black & White adjustment layers are available in Photoshop CS3 and later

These methods use all the color information to get the black and white conversion you want

THE BAD

- With an RGB image select Image ▸ Mode ▸ Grayscale
- With an RGB image select Image ▸ Adjustments ▸ Desaturate
- Convert to LAB color and delete the A and B channels

These methods drop color information

THE UGLY

Here's how:

1. Create a new layer at the top of the layer stack in the Layers palette.
2. Use the Paint Bucket Tool to fill the layer with black.
3. In the Layers palette, select the Color blending mode.

This method can create interesting black & white effects but it doesn't use all the color information flexibly

›› Using the Channel Mixer

Playing with the Red, Green, and Blue sliders

I like this method because the ability to tweak the Red, Green, and Blue channels using sliders, with each channel contributing to the result, seems very flexible and intuitive. Normally, you want to keep the total of the three sliders to 100%. It's possible to create dramatic effects by deviating from this. To create this kind of drama, you typically increase two channels very high, and compensate by making the third channel a negative percentage.

Here's how

1 Duplicate the Background layer and call it "Channel Mix"

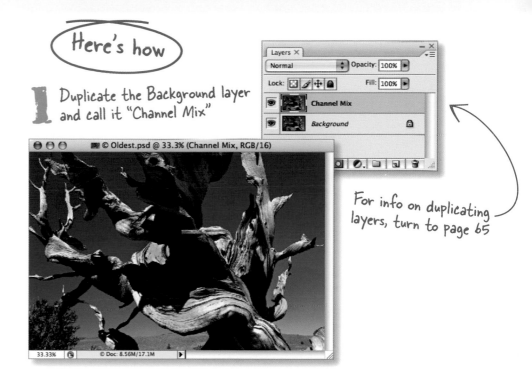

For info on duplicating layers, turn to page 65

2 Click the Add new fill or adjustment layer button at the bottom of the Layers palette and select Channel Mixer from the drop-down list

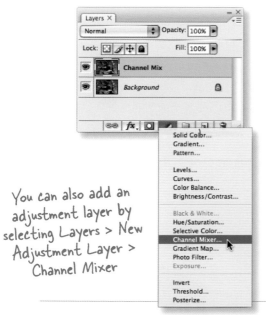

You can also add an adjustment layer by selecting Layers > New Adjustment Layer > Channel Mixer

3 Check the Monochrome check box and then use the Red, Green, and Blue sliders to get the results you want

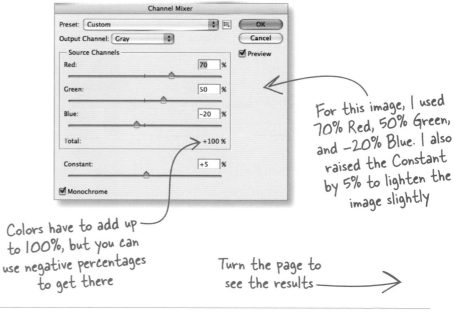

For this image, I used 70% Red, 50% Green, and –20% Blue. I also raised the Constant by 5% to lighten the image slightly

Colors have to add up to 100%, but you can use negative percentages to get there

Turn the page to see the results

Here's the way the image looks with the Channel Mixer settings applied to the adjustment layer

Notice that the adjustment layer automatically adds a Reveal All (white) layer mask

If you want to adjust the Channel Mixer settings, double-click here

A Channel Mixer setting that has been called the "Ansel Adams" effect is 160% Red, 140% Green, and -200% Blue. This still totals 100%, but when I tried the settings on this photo, the results looked garish to me

See how the "Ansel Adams" effect increases the tonal range between the whites and blacks—perhaps in this case too much!

›› Converting to black and white with an adjustment layer

Choosing an image for conversion

Startled awake and bleary-eyed, I walked the Yosemite Valley floor as a rock slide filled the atmosphere with dust. The rising sun created crepuscular rays as it shone through the redwood trees.

When I looked at the series of images showing the sunlight shining through the forest in Adobe Bridge, I was struck with the spiritual quality of the imagery (who really needs to know the back story about the rock slide and me staying out the night before shooting stars?). However, I couldn't see much color. Apart from a little blue in the sky and a bit of sepia near the photographer on the road, this was essentially a monochrome image.

These two factors—the spiritual nature of the image and the lack of color—convinced me that this was a great candidate for black and white conversion.

The first step in the conversion process was to multi-RAW process the image as though it were a normal RGB color image. This was an easier than normal conversion process because I didn't have to worry about precise color hues, only gradations of light and dark. If the blue in the sky became an unattractive blue, it really didn't matter because it was going to black and white toward the end of the conversion process anyway.

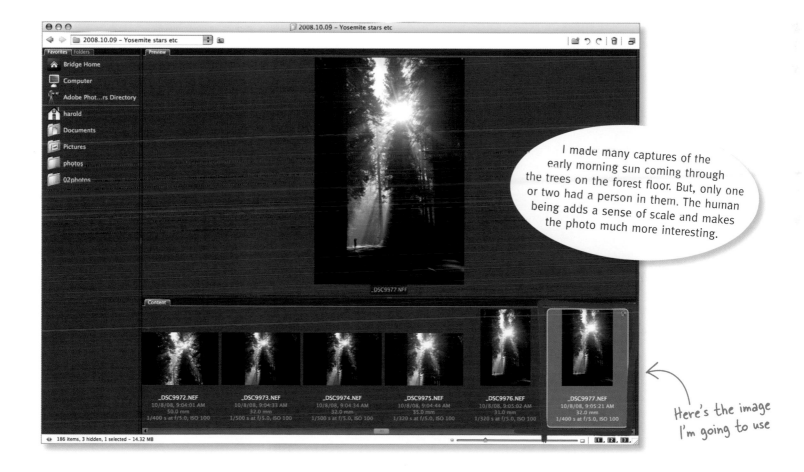

I made many captures of the early morning sun coming through the trees on the forest floor. But, only one or two had a person in them. The human being adds a sense of scale and makes the photo much more interesting.

Here's the image I'm going to use

›› Part 1: Multi-RAW processing

Exaggerating lights and darks

When I looked at this image in ACR, I knew that I would be ultimately converting it to black and white; therefore, I did the multi-RAW processing to exaggerate the light and shadow areas without worrying about the quality of the color.

To get the color image to the place that I wanted took three versions in ACR and five layers in Photoshop. Besides the Background layer, two of these layers served to selectively lighten the image, and two served to selectively darken it.

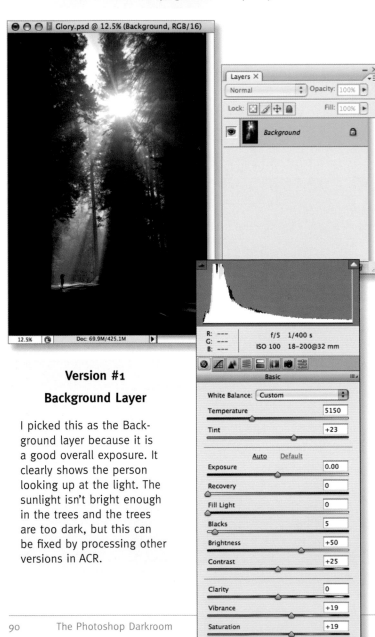

Version #1

Background Layer

I picked this as the Background layer because it is a good overall exposure. It clearly shows the person looking up at the light. The sunlight isn't bright enough in the trees and the trees are too dark, but this can be fixed by processing other versions in ACR.

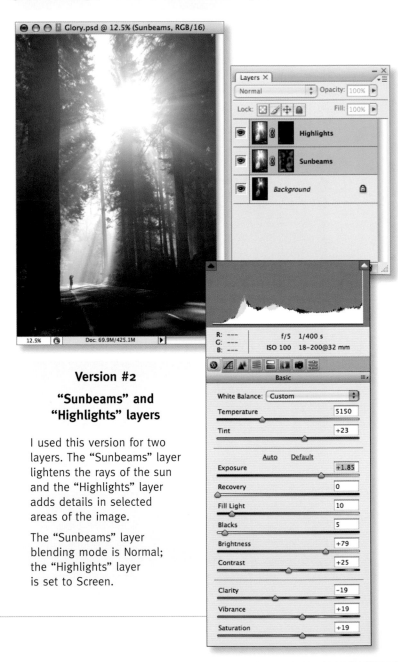

Version #2

"Sunbeams" and "Highlights" layers

I used this version for two layers. The "Sunbeams" layer lightens the rays of the sun and the "Highlights" layer adds details in selected areas of the image.

The "Sunbeams" layer blending mode is Normal; the "Highlights" layer is set to Screen.

Before converting this image to black and white, I processed the image to extend the photo's tonal range

For more about the multi-RAW processing techniques shown on these two pages, check out the multi-RAW case study starting on page 44

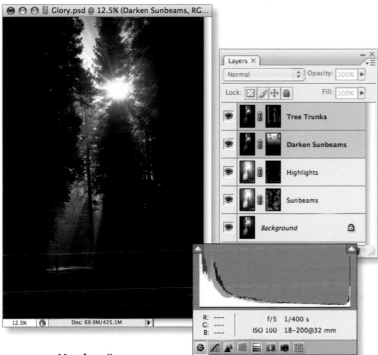

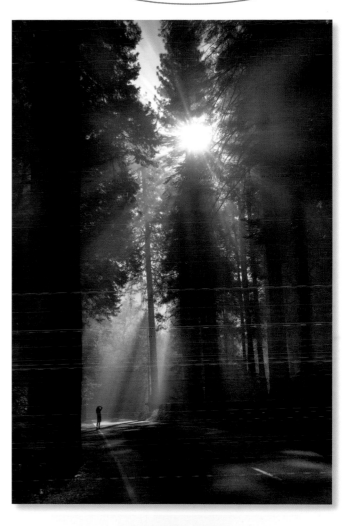

Version #3

"Darken Sunbeams" and "Tree Trunks" layers

The primary purpose of this version, the "Darken Sunbeams" layer, was to selectively darken some areas of the sunbeams which had become too bright. I also used a second layer, "Tree Trunks", made from this version to strongly paint in selective dark lines created by tree trunks.

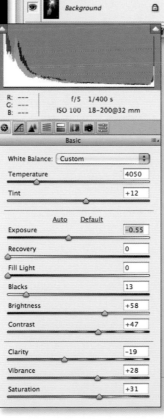

Composite image

Here's the way the layers look put together. I wouldn't be very happy with this as a color image—note the murky quality of the sepia and the pathetic blue in the sky—but it's a good basis for a black and white conversion.

›› Part 2: The black and white conversion

Doing it more than once

Black and white imagery depends on effective graphic composition to work. The lines, or "bones," of your photo are displayed to the world in black and white; whereas, in color the essential form of the image is often cloaked with attractive and seductive color values.

The stark nature of black and white means that you have to pay special attention to emphasizing your composition when you convert an image to black and white. Sometimes all this takes is the right black and white conversion process. But, more often no single conversion process is going to work overall. In this case, the winning strategy is to start with the best overall conversion you can find and then layer on supplemental conversions to improve the composition and tonal range.

Just as multi-RAW processing involves creating more than one version of an image from a RAW file, optimal black and white conversion usually requires more than one black and white version of the color image. As with multi-RAW processing the different black and white versions are put together using layers, masking, gradients, and the Brush Tool. You can think of this as multi-B&W processing!

Here's how

1 ✓Checkpoint

Before you start the black and white conversion, save off a copy of the color image with its layers unmerged. Then, flatten the layers to make a single layer image and save it with a new name. (For more about flattening layers, check out page 54. To find out about workflow, turn to page 25.)

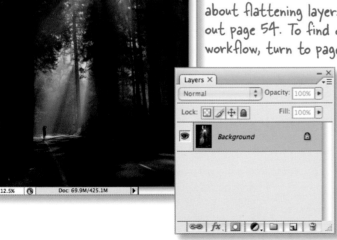

2 Duplicate the Background layer and name the duplicate layer "Max Black" (for info, take a look at page 65)

The duplicate background layer will become the black and white background for the converted image.

As a matter of good practice when doing black and white conversions, duplicate the Background layer and leave the color information in the Background layer alone. The untouched color Background layer serves as another backup.

Black and White adjustment layers are available in Photoshop CS3 and later

3 Click the Add new fill or adjustment layer button at the bottom of the Layers palette and select Black & White from the drop-down list

You can also add the adjustment layer by selecting Layers > New Adjustment Layer > Black & White

Some of the names of the presets mimic traditional darkroom techniques. For example, the Red Filter preset simulates what it would have been like to put a red filter over an enlarger lens.

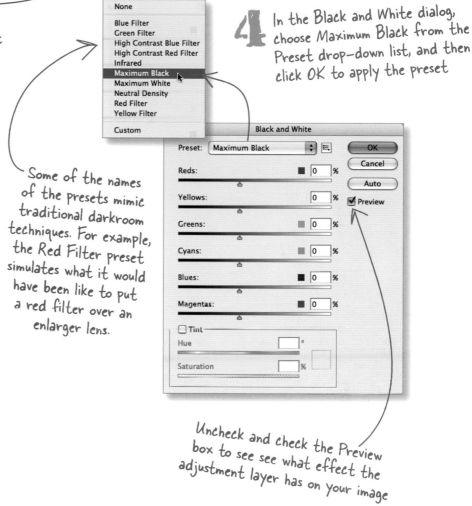

4 In the Black and White dialog, choose Maximum Black from the Preset drop-down list, and then click OK to apply the preset

Uncheck and check the Preview box to see see what effect the adjustment layer has on your image

Play With Those Presets!

Since you want the duplicate Background layer in your stack to be a good overall conversion, you'll need to find the best overall Black & White preset for the conversion (in this case, the "Max Black" layer). What I find myself often doing is scrolling through the presets and finding which works best overall. To the extent that you succeed and have a good overall conversion, you'll have less work to do when adding layers on top of it.

Turn the page to see how the Maximum Black preset affected the image

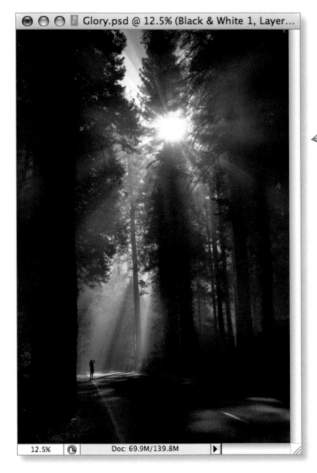

Glory.psd @ 12.5% (Black & White 1, Layer...

12.5% Doc: 69.9M/139.8M

Where do you go from here?
While the image does look pretty good, I think it would look even better if the sunbeams were brighter. That would add more drama and compositional focus. So next, I'm going to duplicate the Background layer again, find a Black & White adjustment layer preset that emphasizes the sunbeams, add a layer mask, and paint in the sunbeams (steps 6–10 on pages 95–97).

The Maximum Black preset does a pretty good job of creating a nice black and white image (though a few layers with some painting on layer masks will enhance the image even more)

The adjustment layer automatically adds a white Reveal All layer mask

To find out my thinking about why I merge down the adjustment layer, take a look at "Harold, why the heck..." on page 96

5
With the adjustment layer selected, flatten the Black & White adjustment layer down onto the "Max Black" layer by selecting Layer > Merge Down

This leaves you with two layers: "Background" and "Max Black"

6 Duplicate the Background layer, name the new layer "Max White" and drag it to the top of the layer stack in the Layers palette

Drag the new layer up to the top of the layer stack

Notice how the Maximum White preset really brings out the sunbeams on the Max White layer

7 Click the Add new fill or adjustment layer button at the bottom of the Layers palette and select Black & White from the drop-down list (see step 3 on page 93 for info)

8 In the Black and White dialog, choose Maximum White from the Preset drop-down list, and then click OK to apply the preset

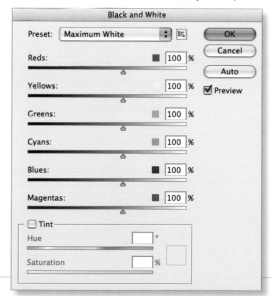

9 Select Layer > Merge Down to flatten the Black & White adjustment layer down onto the "Max White" layer. Then, choose Layers > Layer Mask > Hide All to add a layer mask to the "Max White" layer —

Take a look at step 5 on page 94 for info about merging layers

Turn to page 36 for more about adding Hide All layer masks

"Never trust anything that can think for itself if you can't see where it keeps its brain."
— Arthur Weasley

10 Select the Brush Tool from the Toolbox and paint in the sunbeams on the layer mask with the Brush Tool set at 0% Hardness, 50% Opacity, and 50% Flow (details about Brush Tool settings are on page 48)

This is theoretical and isn't really practical, so skip it if you want!

Harold, why the heck did you just flatten the Black & White adjustment layer down onto the "Max White" layer, and then add a Hide All layer mask? You don't need to do that—the adjustment layer already had a layer mask!

Good question! This is just one of my foibles (you don't have to do it like me!). Adjustment layers automatically add a white Reveal All layer mask, but for black and white conversions, I prefer to paint on a black Hide All layer mask. This is because once I have the base black and white layer in place, I simply want to make small, incremental adjustments. These adjustments are easier to accomplish by *painting in* what I do want on a new layer instead of *painting out* everything that I don't want.

Sure, I could turn the white Reveal All layer mask into a Hide All layer mask by selecting the mask and then choosing Image ▸ Adjustments ▸ Invert. But that's roughly comparable to the amount of work involved in merging down an adjustment layer and adding a Hide All layer mask.

Then there's the Harry Potter where-does-it-keep-its-brain-issue, as in "never trust anything that can think for itself if you can't see where it keeps its brain."

I know I'm supposed to like adjustment layers. And, I do! They are really useful and I'm using Black & White adjustment layers for this case study. But still, the idea that an adjustment layer is simply a "gloss" on the underlying layer is a bit mind boggling particularly when you begin to work on an image that contains a stack of many layers. (Imagine how confusing 10 layers and 10 adjustment layers would be!) I just prefer to work on "real layers" where I can see what is going on, even if I take the hit because my file size is larger.

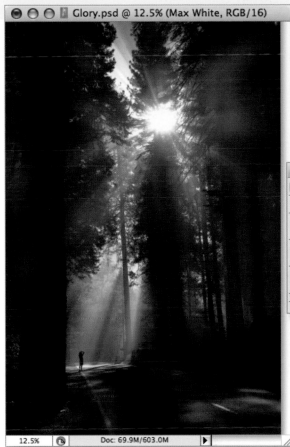

After painting on the Max White layer mask, the sunbeams are definitely more interesting

This "Max White" layer is probably the most important one in the conversion. For the "Max Black" layer, you could use any decent conversion. This layer lays the foundation for a subtle and distinctive conversion process.

I like the general lightness on the forest floor, but I could use more tonal gradations, creating the illusion of more detail

Here's the layer mask and here's the part of the "Max White" layer that shows

Next Steps

This image is definitely shaping up, but a little more work needs to be done on the sunbeams and highlights. It's time to add more layers using various Black & White adjustment layer presets, and then paint in the details on layer masks (pages 98–99).

These are kind of ghost trees on a transparent field, but I guess that's the idea

11

Repeat steps 6–10 on pages 95–96 except name the layer "Red" and select the Red Filter preset in the Black & White adjustment layer dialog

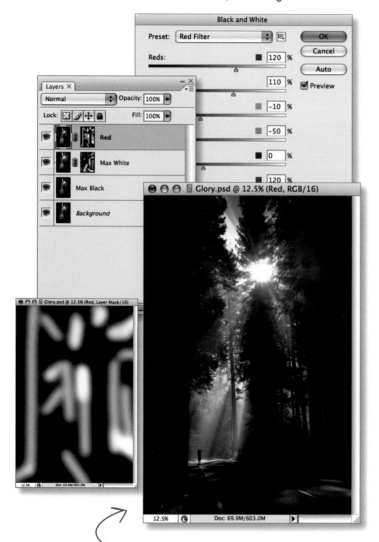

I chose the Red Filter for this layer because I wanted to bring out contrast in the midtone areas

12

Repeat steps 6–10 on pages 95–96 except name the layer "Infrared" and select the Infrared preset in the Black & White adjustment layer dialog.

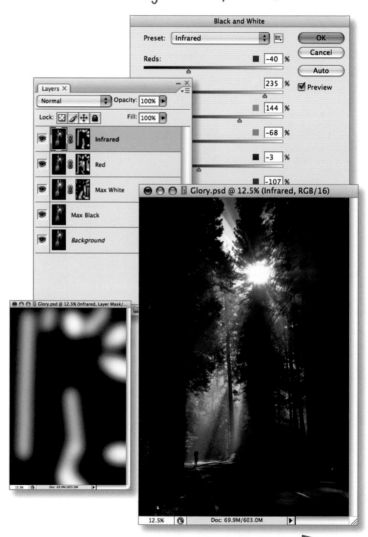

The Infrared preset often functions by inversion. The tonal values can be close to the opposite of where they started before the adjustment layer was applied

13

Repeat steps 6-10 on pages 95-96 except
name the layer "High Contrast Red" and select
the High Contrast Red Filter preset in the
Black & White adjustment layer dialog.

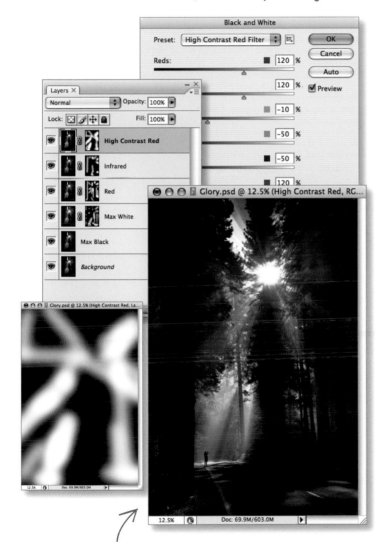

With the High Contrast Red Filter, I
added a little more variation than the
straight Red Filter in the midtones

14

Duplicate the "High Contrast Red" layer and
name the duplicate "Screen Mode". Put the
new layer at the top of the layer stack and
change the layer's blending mode to Screen.
Repeat steps 9 & 10 on page 96.

Six layers later, the black
and white image is finished. I
think the effort was worth
it; to judge for yourself,
check out the full size
version on page 103

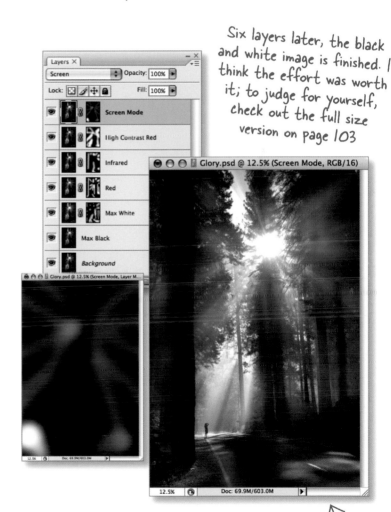

Screen mode selectively
lightened the action performed
by the High Contrast Red Filter

Layering: Strategies and tactics

Generally, it helps to have an overall strategy when working on any kind of conversion that involves multiple layers. This is true whether you are talking about multi-RAW processing or converting a photo with color information into black and white.

A good way to go, and the one I use in my black and white conversions, is to get the black and white conversion generally right on the first duplicate of the Background layer. Once the conversion is in the right ballpark, I can then add successive layers that tweak specific areas.

You can think of this as a pyramid approach. The further up the layer stack you are, the more specific and limited are the areas being tweaked.

I'm not saying that this is the only way to go about things. But, no matter what your overall plan, it does help to be organized with a consistent process. That way, when you come back and look at your layer stack later, you'll be able to pick up the gist of what you've done.

Another important idea is to keep the functionality of each layer to a single purpose as much as possible. For example, if I want to use an adjustment layer with the Maximum White preset, to lighten both the foreground with a gradient and to use the Brush Tool to add highlights in the upper part of the image, it's a good practice to use two layers instead of one. That way, you'll be able to keep better track of the impact of your layers. More importantly, if you need to adjust the overall opacity of either effect, you can tweak each layer independently.

One layer should be established for each job and if you need another job done, simply duplicate the layer to accomplish the new task.

This point is analogous to a computer software programming principle: rather than trying to cram multiple functions into a single variable, one variable should do only one job. If you need something else accomplished, use a new variable.

As many layers in the stack as it takes

Layer stack

Top

Details

Layer 3

Layer 2

Layer 1 – Overall adjustment

Overall adjustment

Bottom

Background layer

About the photos on pages 101–103

Span (page 101) is a 10-second exposure of cars on the Golden Gate Bridge. I felt the photo was perfect for black and white conversion because the image itself had very black blacks and very bright highlights—the car headlights and street lights. While the photo was also effective in color, there was nothing essential about the color to the image. Converting to black and white added a wonderful, foggy atmospheric quality.

Woodland Path (page 102) was taken on a foggy morning on the slopes of Mount Tamalpais, California. I liked the effect of the path heading through the forest floor in the color version, but when I converted the photo to black and white, it increased the dramatic impact of the composition.

Glory (finished version, page 103) is the subject of the black and white conversion case study on pages 89–99.

Shooting for the Photoshop darkroom

As a former film photographer, I have found that I need to think about photography differently with digital and the Photoshop darkroom in mind. To some extent the difference boils down to an eternal existential photographic question: Why do we take pictures? Is it to "capture reality" or for some other reason?

My extensive work in the Photoshop darkroom has led me to believe that there's no possible sense in which one *can* capture reality, even if that is what one wanted to do. I have another simple goal: to create striking and beautiful images.

This goal implies the methods I use to get there. Whenever I am looking at a situation with my camera, I am thinking about what I can turn it into using post-processing. Therefore, I need to compose and expose for the maximum number of possibilities on the computer. Sometimes I'll shoot different pieces with the idea of combining them. At other times, I know that I'll only be using a portion of an image. Even for seemingly conventional landscapes, like the view of the Grand Canyon from Navajo Point to the right, I'll shoot multiple exposures with the plan of combining them later (see Hand HDR starting on page 106).

I don't go around looking at the world as it is. Rather, I look at the world as it could be, or as it should be, or as I can make it.

It does take a bit of time to shift one's perspective from conventional photography to the holistic embrace of digital capture and software post-processing. In the meantime, whether you embrace the Photoshop darkroom as much as I have or not, it makes sense to photograph as well as you can in the camera. I do look to make sure that any flaws that remain in my captures can be adjusted later in Photoshop. For example, imagery that is too dark can usually be lightened successfully. In fact, I often tend to underexpose, accepting the trade-off of more heavily saturated colors in exchange for the added noise.

Note that the one thing you cannot fix in the Photoshop darkroom are blown out highlights, because there's no data present. Make sure to underexpose hugely bright subjects like the setting sun.

⟩⟩ Hand HDR (High Dynamic Range) Imaging

UP EARLY IN THE MORNING in Yosemite Valley, the sun was rising behind the forest and over the Merced River. The reflections were gorgeous, and I wanted to create a photo that showed the reflections in the river and the mountains and blue sky.

THE PROBLEM: The human eye can take in a bigger contrast range than a camera. No one digital exposure can properly capture both the brighter areas and deeper shadows, even using multi-RAW processing to the max.

THE SOLUTION: Bracket exposures and combine multiple exposures in Photoshop using layers, layer masks, gradients, and painting. This is a hand approach to HDR imaging.

YOU SHOULD: In any situation that involves significant darks and lights, shoot RAW and bracket the shutter speed in your exposures, provided the subject is not in motion.

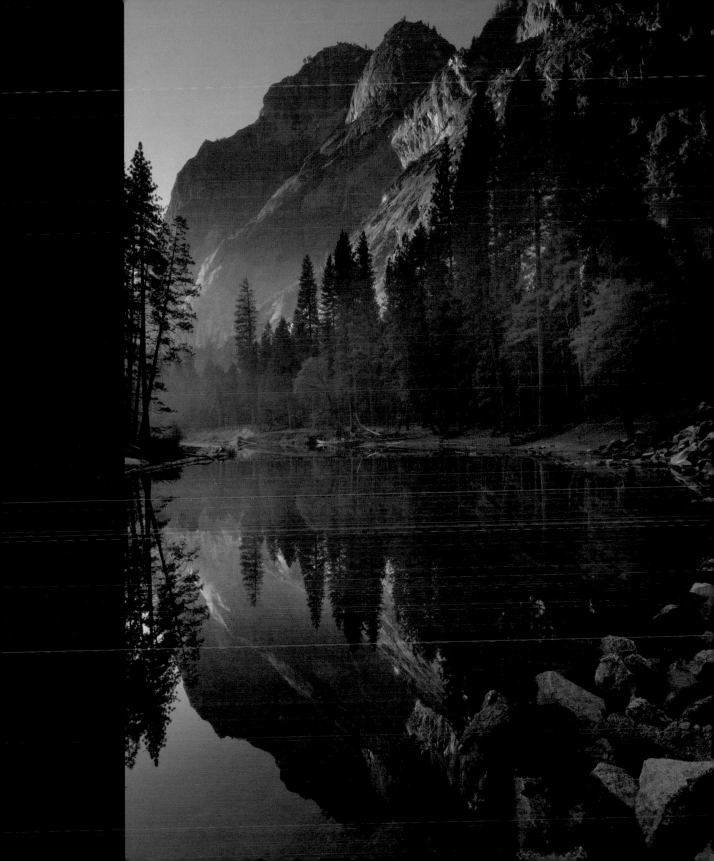

›› Photograph different exposures to capture a full dynamic range

Bracketing the full dynamic range

When you want to photograph a scene that contains mixed lighting, you should know that no camera can capture the full dynamic range from light to dark that your eye can see.

Even if you use the best exposure values, you'll only come up with an average exposure in a single shot. You can expose for light areas or dark areas, but it's not possible to expose for both at the same time. Even multi-

RAW processing can take you so far.

The solution is to take several exposures for light areas, darks areas, and areas that are in between. This is called *bracketing*.

Combining exposures

The best parts of each exposure can be combined in Photoshop using layers to create a single composite image.

This technique works best when the camera is on a tripod and the subjects

are not moving. Many cameras have bracketing modes but these don't usually give you enough exposure latitude. You should plan to bracket manually with the camera set to Manual exposure.

The aperture setting usually needs to stay constant across the different exposures. The reason for this is that if you change the aperture setting, you will change the depth-of-field and the appearance of the capture. So when you bracket, it works best to adjust shutter speed rather than aperture.

Photos taken at shutter speeds from 1/13 of a second to 1 second

You can read the camera settings here from the meta data

✱ Use manual exposure settings to bracket (camera bracket programs don't give enough exposure range for this technique). Keep the aperture the same, and change the shutter speeds

All photos taken at f/22 for maximum depth-of-field

Shutter speed: 1 second

This image works for the water, but not the sky

The best of both worlds

It's not an "either or" situation. You don't have to choose between multi-RAW processing and hand HDR. Many situations that present a high dynamic range with bracketing multiple exposures as the solution also call out for multi-RAW processing.

You can use the exposure latitude within a single RAW capture (see page 32) to extend the dynamic range in your bracketed exposures even further. In addition, you can use the shifts in color balance inherent in multi-RAW processing to control the way specific areas of your hand HDR image look.

In fact, it's a rare situation in which I use hand HDR without also using some of the techniques that I've shown you in the sections on multi-RAW processing.

This example focuses on hand HDR to make the technique perfectly clear. But, in the "real world," I almost always combine the techniques.

This one works for the sky, but not the water

Shutter speed: 1/13 of a second

›› Selecting and processing several images

Extending the dynamic range

You have several captures that bracket the dynamic range of an image. But no single capture gets the entire dynamic range that you saw with your eyes when you took the photo. You can reproduce the entire dynamic range that you saw by combining the bracketed exposures with layers in Photoshop to create a composite image with a greater dynamic range than any single image.

Layering captures

Pick a capture and then extend its dynamic range by layering other captures that are darker or lighter than the original one. For example, one of the bracketed exposures might capture bright sunny areas in your photo best while another exposure might capture dark shaded areas best.

Start with the best overall capture.

Convert it using ACR and then open it in Photoshop. (To find out how to convert a capture using ACR and open it in Photoshop, turn to page 16.)

Next, select the captures you want to use to adjust specific areas of the image, such as lighter or darker areas. Convert the captures using ACR and open them in Photoshop.

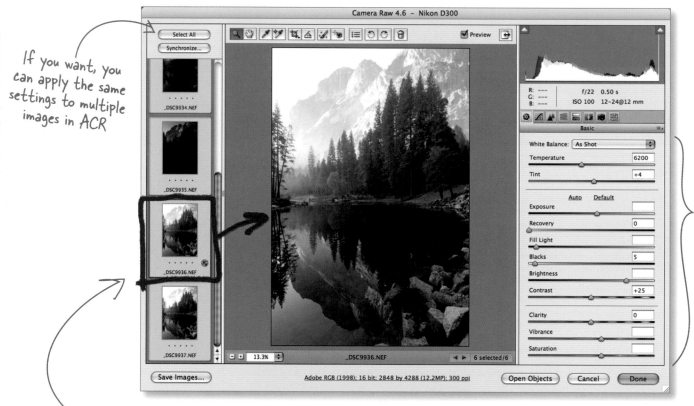

If you want, you can apply the same settings to multiple images in ACR

This is the best overall photo. I'll use it for the water. Notice how blown out the sky is. I need to find and convert a photo that captures the tonal range of the sky. Then, I'll convert two more photos: one to enhance light areas further and one to enhance dark areas further.

For more about these sliders and converting images in ACR, turn to pages 15-23

SKY

I picked this photo and processed it to get the best blue for the sky. When I layer this photo in Photoshop over the water image (shown to the left), I'll use it to enhance the sky.

Next Steps
Start with the best overall capture, and use it as the bottom layer in Photoshop. Next, add an image in a layer above it to extend the tonal range of the sky (pages 112–113).

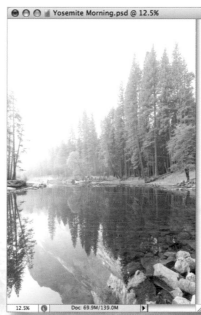

LIGHT

After combining the water and sky photos, I'll add this photo as a layer and use it to enhance trees and their reflection in the water

I'm going to layer this photo over the composite and use it to enhance the dark tones

DARK

›› Layering photos and adding a layer mask

Combining Sky and Water

Combining two photos—one specifically processed for the water and one specifically processed for the sky—will be the start of a

composite photo with a greater tonal range than any single photo in the series.

When one photo is placed on a layer over another photo on a

layer, by default it will completely hide the layer underneath. Later on, a layer mask and gradient will be used to blend the two layers (pages 36–39).

Here's how

1 Open the photo that was processed for the water

Choose Layer > New > Layer from Background to make a regular layer and rename the layer "Water"

When you open the photo, it appears as a Background layer in the Layers palette

3 Open the photo that was processed for the sky. This photo will also appear as a Background layer. Use the same menu selection from step 2 to change the layer to a regular layer. Rename it "Sky."

4

Select the Move tool from the Toolbox —

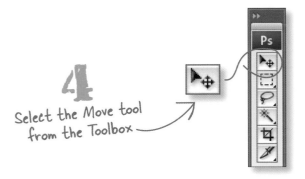

Now there are two layers: "Sky" and "Water"

5

Hold down the Shift key and use the Move tool to drag the Sky photo onto the Water photo window

Release the Shift key after you release the mouse button or the two photos won't be perfectly aligned.

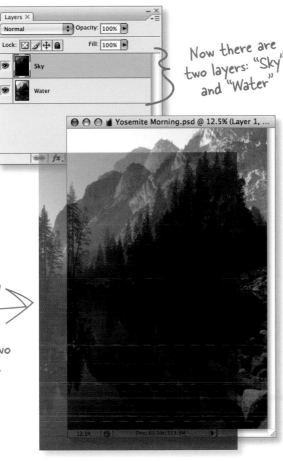

6 With the "Sky" layer selected in the Layers palette, choose Layer > Layer Mask > Hide All. A black layer mask appears on the Sky layer, completely hiding the Sky layer, making the Water layer visible

For more about layer masks, turn to page 36

Next Step

Draw a gradient on the "Sky" layer mask to blend the two layers, letting the best of each photo show through (pages 114–115).

›› Drawing a gradient on a layer mask

Revealing the sky

It's very hard to recover a blown-out sky in a photo. But, shoot two versions with one properly exposed for the sky, combine them, and use a layer mask and gradient to reveal the sky, and voilà! This technique takes all of about 30 seconds once you get the hang of it. Combining good photographic technique with the Photoshop darkroom in this way allows you to capture imagery that would have been out of the question on film.

To find out more about the Gradient Tool and using it with layer masks, check out pages 37–38

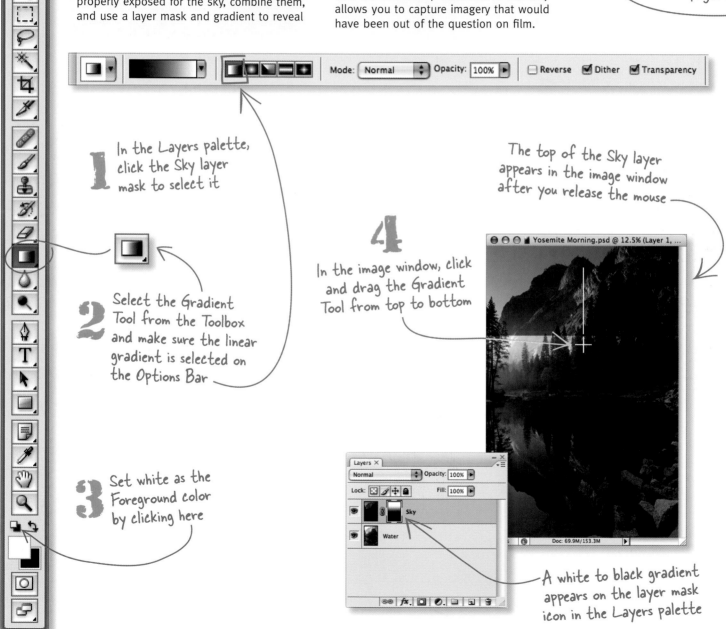

1 In the Layers palette, click the Sky layer mask to select it

2 Select the Gradient Tool from the Toolbox and make sure the linear gradient is selected on the Options Bar

3 Set white as the Foreground color by clicking here

4 In the image window, click and drag the Gradient Tool from top to bottom

The top of the Sky layer appears in the image window after you release the mouse

A white to black gradient appears on the layer mask icon in the Layers palette

This is the photo that was processed for the sky (the "Sky" layer)

Sky

Here's the composite photo

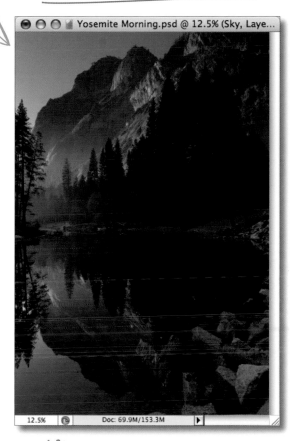

This photo was processed for the water (the "Water" layer)

Water

After adding the gradient to the Sky layer mask, the composite photo has a greater dynamic range than the individual Water and Sky photos

Next Steps
Add two more photos to the composite image to enhance light and dark tones using layer masks, painting, and blending modes (pages 116–117).

›› Painting in lights and darks

Finishing the image

Sometimes when the scene before you presents a really great tonal range, and you've bracketed like crazy, you need to process extreme exposure versions for specific areas.

In the case of the Yosemite scene here, the trees and their reflections are extremely dark even after a "proper" exposure for the general area is combined into the layer stack.

The solution is to turn to an extremely "overexposed" version, and delicately paint in a few specific spots on the layer mask.

Similarly, the mountains and rocks aren't bad, but they could use just a little bit more contrast so that some dark areas work to highlight the brighter areas.

To accomplish this goal, I used a really dark capture on top of the layer stack, used the Multiply blending mode, and painted in a couple of delicate, low opacity brush strokes on the layer mask.

Start here

Open the light photo, hold down the Shift key, and drag the photo from its image window onto the composite photo. Name the layer "Light." Add a Hide All layer mask to the "Light" layer and paint in the trees and the trees' reflections

The "Light" layer is used to lighten the trees and their reflection along the water's edge (compare with the composite photo on page 115)

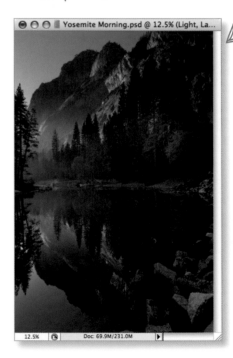

To find out how to drag an image from one window to another, turn to page 35

The steps for adding a Hide All layer mask are on page 36

For more about using the Brush Tool and painting on a layer mask, check out pages 48–51

2 Open the dark photo, hold down the Shift key, and drag the photo from its image window onto the composite photo. Name the layer "Dark." Change the layer's blending mode to Multiply (for more about blending modes, turn to page 70). Add a Hide All layer mask to the layer and gently paint on the rocks and mountainside

Finished hand HDR

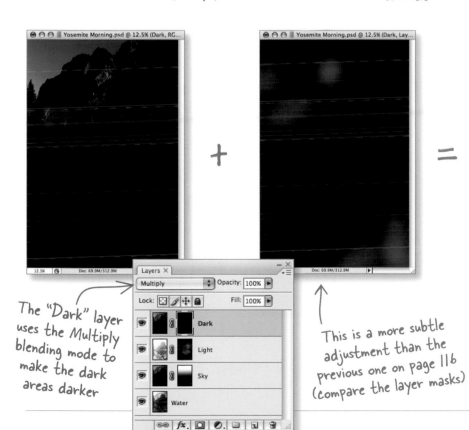

The "Dark" layer uses the Multiply blending mode to make the dark areas darker

This is a more subtle adjustment than the previous one on page 116 (compare the layer masks)

The "Dark" layer is used to slightly darken the rocks on the lower right and the mountainside at the upper left

HDR doesn't have to be just landscapes

To create this image of a medley of poppies, I photographed the flowers using a daylight-balanced light box. The flowers were placed on the lightbox and sprayed with water to increase their transparency.

With my camera on a tripod positioned directly above the flowers, I stopped a telephoto macro lens all the way down to its smallest opening. I knew I would need to bracket the exposures for subsequent hand HDR processing to maximize the apparent transparency of the image. So I made five different exposures, all at ISO 100 and f/51, with exposure times ranging between 1/2 of a second and 8 seconds.

There's an interesting point about how you do one of these brackets for transparency. You want to start at the "proper" exposure and "overexpose" from there. In other words, the exposure that the camera thinks is right is actually too dark to be of any use and will be the darkest exposure in your range.

Here are some of the exposures I combined to create the image

>> Photo Compositing

SINCE THE DAWN OF photography, practitioners have wanted to combine disparate photographic elements to create unreal and surreal imagery. Some of the most accomplished photographers who used photo compositing prior to the digital Photoshop darkroom were Man Ray and Jerry Uelsmann. Man Ray created sophisticated and striking surreal images while Uelsmann used his virtuosity in the chemical darkroom to create weird and compelling alternative universes.

The art of putting together more than one image to create a new image is called *photo compositing*, or sometimes *compositing* for short.

While Man Ray and Jerry Uelsmann worked extremely hard to mechanically put together their photo composites, the comparable tasks in the Photoshop darkroom are vastly easier. The tools needed are once again layers and masking—not the tape-and-scissors layers and masking of Man Ray and Uelsmann, but rather the virtual layers and masking that I've shown you in this book.

Of course, ease of technique is no substitute for vision. Just because it's easy to create fantastic alternative universes in Photoshop doesn't mean it's a good idea unless you have a cohesive visual conception.

If you've made it this far in *The Photoshop Darkroom*, you shouldn't have too much problem with the mechanics of digital photo compositing. Assembling photo composites that are meaningful and striking is a different matter, and requires artistic vision.

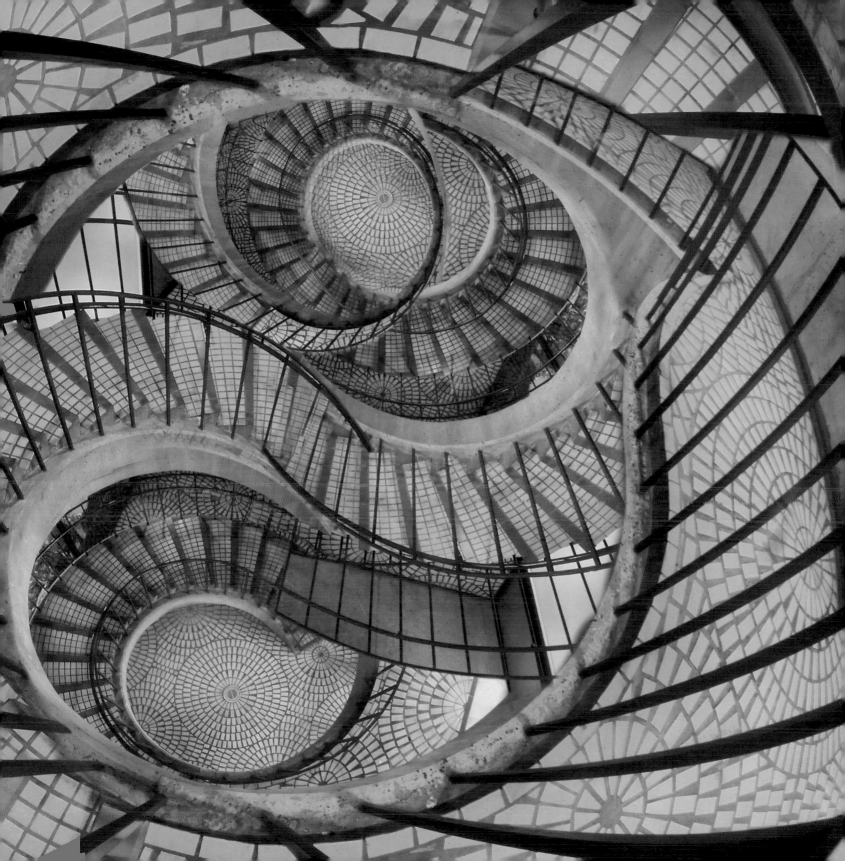

›› Combining two different photos

How different can you be?

It's hard to imagine two photos as different as the two used in this case study. The first photo shows a dark, back stairway in the Embarcadero Center in San Francisco. I used a fisheye lens and a long exposure on a tripod to lighten a closed-in and apparently dingy scene.

The nautilus shell is a combination of a studio shot on black velvet with a flatbed scan of the center of the shell.

Both images are potentially worthy in and of themselves. In fact, the nautilus shell has been published as it is a number of times.

So how did I come to think of putting the two together?

It was a dark and rainy night. By the clock it was 3 a.m. and I couldn't sleep. I was looking through my image files. Suddenly, an inspiration hit me—or was it the insomniac bravado of despair?

It became clear to me that if I rotated the shell and reduced it in size, I could place it smack-dab in the middle of the Embarcadero stairs, and blend it in seamlessly. Helping with this idea was the tonal similarities of the images. The color values were very close.

This kind of combination of two images with completely different subject matter is a tricky thing. It only works in a small percentage of cases. But when it does work, you can really hit a home run.

The completed image shown in this case study, Spirals, has been published, exhibited, and won prizes.

It's really important to think carefully about color values and the way composites fit together if you're planning to combine two photos. These photos work together because the colors are similar and because the spirals work well together. The differences in scale between the two photos can be easily adjusted.

Get started

1 Select the Move Tool in the Toolbox and drag the shell image into the Stairs image. Name the new top layer "Shell"

Since the Shell image is square and the Stairway image is not, the shell won't fit exactly in the image window (that's ok!)

There are two layers: "Stair" and "Shell"

Click here to open the Opacity slider

2 In the Layers palette, lower the opacity of the "Shells" layer down to 65%. That way, you'll be able to see the "Stairs" layer while working on the "Shells" layer for the next few steps. (When the composition is complete, you'll put the opacity back at 100%)

Use the slider to set the opacity

Next Steps

To fit the center of the shell in the stairwell, you're going to need to resize the image by scaling it down, and rotate it (pages 124–125)

» Scaling and rotating a layer

Transforming a layer

Now that you have the Shell image on top of the Stairway image, you need to rotate the shell and make it smaller so the center of the shell will fit seamlessly into the stairwell.

Photoshop makes this easy because you can go back and forth between rotating and scaling as you adjust the "Shell" layer.

Start off by bringing the size of the shell down a bit, then rotate the shell to get it closer into position. Next, resize the shell down a bit more until it fits into the stairwell, and finish rotating the shell into position.

Make sure the "Shell" layer is selected in the Layers palette before you start

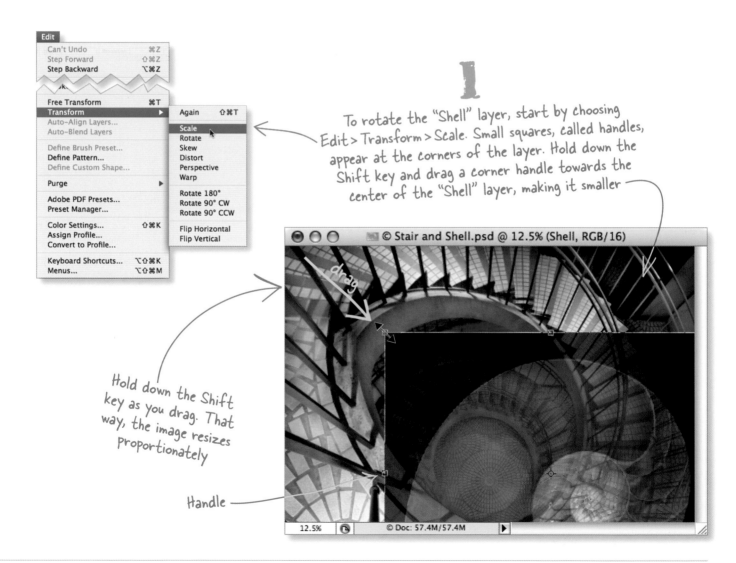

To rotate the "Shell" layer, start by choosing Edit > Transform > Scale. Small squares, called handles, appear at the corners of the layer. Hold down the Shift key and drag a corner handle towards the center of the "Shell" layer, making it smaller

Hold down the Shift key as you drag. That way, the image resizes proportionately

Handle

2 Right-click (or Control + click) on the Shell to open the Transform pop-up menu. Select Rotate from the menu. Position the mouse over one of the handles and click and drag to rotate the shell. Use the pop-up menu to switch between scaling and rotating

Drag down to rotate the shell counterclockwise

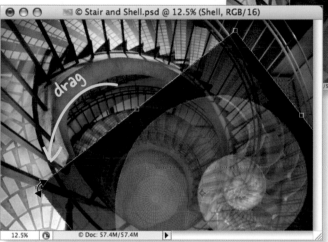

3 As you scale and rotate the "Shell" layer, reposition the layer closer to the stairwell by placing the cursor at the center of the layer, clicking, and dragging it into a new position

4 Repeat steps 1–3 until the "Shell" layer is positioned exactly where you want it, then click the check button on the Options Bar ✓

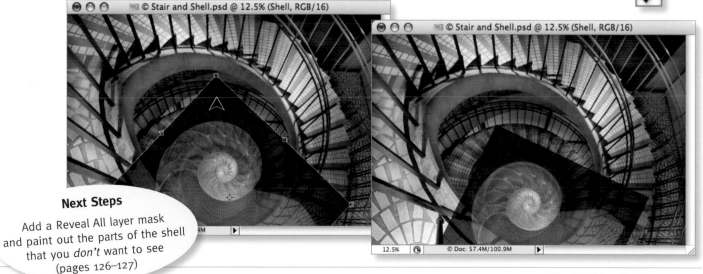

Next Steps

Add a Reveal All layer mask and paint out the parts of the shell that you *don't* want to see (pages 126–127)

›› Adding a Reveal All layer mask and painting

Finishing the image

In most of the examples in the book so far, I've shown you layer masking with a black Hide All layer mask because it was easier to paint in the areas you did want rather than painting out the unwanted areas.

In contrast, this example uses a white Reveal All layer mask. You do want to include a large portion of the masked layer. In this situation if you hid the layer entirely, it would be next to impossible to "see" which areas needed to be painted in. A white Reveal All layer mask solves this problem because you can see what you are doing as you paint out the areas you don't want.

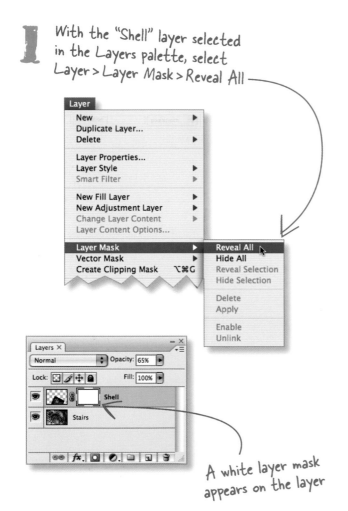

1 With the "Shell" layer selected in the Layers palette, select Layer > Layer Mask > Reveal All

A white layer mask appears on the layer

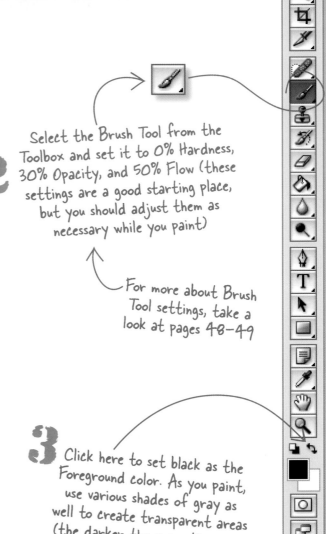

2 Select the Brush Tool from the Toolbox and set it to 0% Hardness, 30% Opacity, and 50% Flow (these settings are a good starting place, but you should adjust them as necessary while you paint)

For more about Brush Tool settings, take a look at pages 48–49

3 Click here to set black as the Foreground color. As you paint, use various shades of gray as well to create transparent areas (the darker the gray, the more transparent the layer will be)

4 Select the Zoom Tool from the Toolbox and magnify the image so you can see what you're doing. You should be working close to the pixel-level to achieve smooth transitions between layers

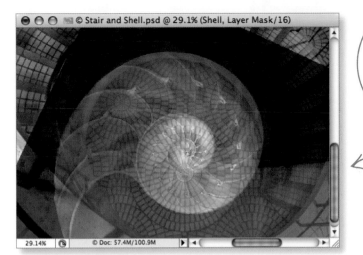

© Stair and Shell.psd @ 29.1% (Shell, Layer Mask/16)

29.14% © Doc: 57.4M/100.9M

It's really important when compositing to zoom in close enough to see edge areas

Zoom in as much as you need to in order to clearly see the edges of the shell

5 Paint out the parts of the shell that you don't want to see

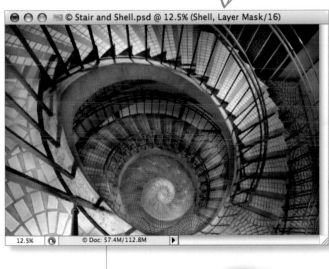

© Stair and Shell.psd @ 12.5% (Shell, Layer Mask/16)

12.5% © Doc: 57.4M/112.8M

6 On the Layers palette, change the opacity of the "Shell" layer back to 100%

Layers ×

Normal Opacity: 100%

Lock:

Shell

Stairs

...yer Mask/16)

12.5% © Doc: 57.4M/112.8M

Here's what the layer mask looks like after the painting is done

Turn the page to see the finished image.

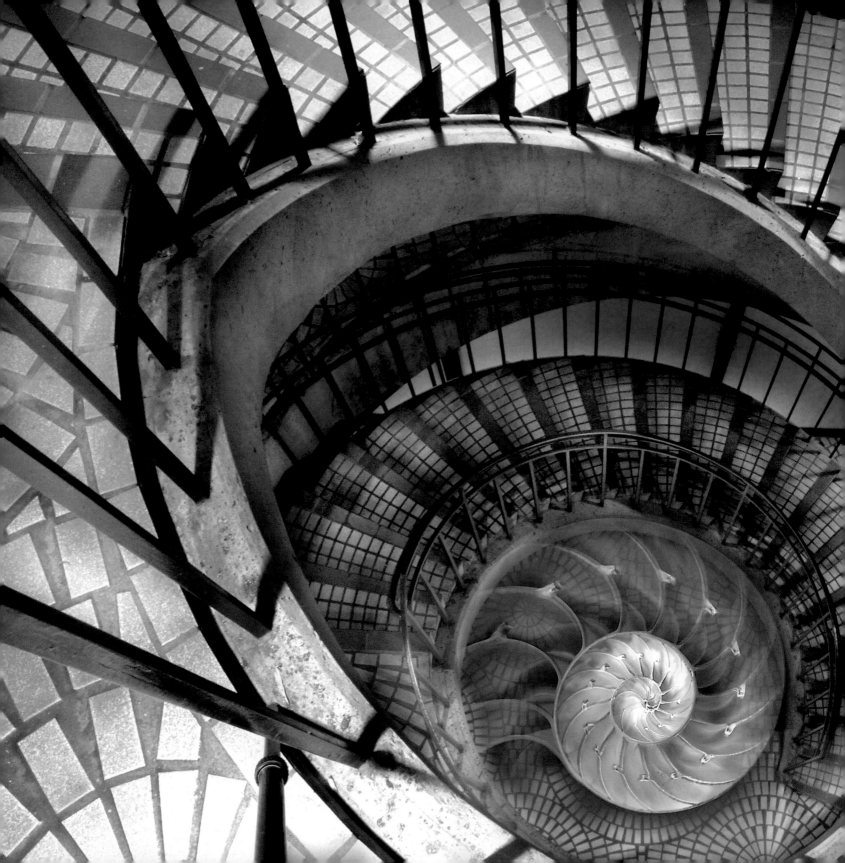

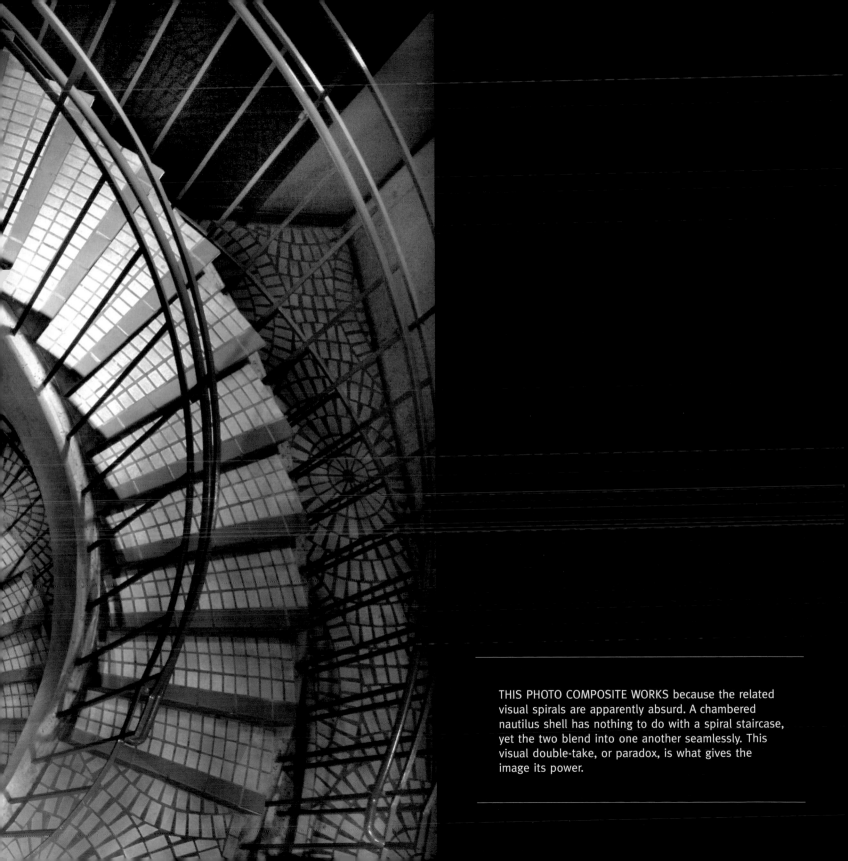

THIS PHOTO COMPOSITE WORKS because the related visual spirals are apparently absurd. A chambered nautilus shell has nothing to do with a spiral staircase, yet the two blend into one another seamlessly. This visual double-take, or paradox, is what gives the image its power.

Compositing an image with itself

At first glance, the image to the right appears to be a naturalistic view down a tunnel of Cyprus Pines. Actually, the image is a photo composite that uses one photo combined with—itself!

Like the image on page 121, this image uses self-replication to create a more powerful combined image. Whereas the point of the combination on page 121 is to create a surreal and dreamlike effect, the point here is to elongate the tunnel, apparently naturally.

The kind of self replication shown here is both easy to accomplish and potentially very visually effective. You need to pick subject matter which seems to repeat. That way, it is easy to combine the repeating portions of the image at various sizes.

With an appropriate image chosen, duplicate the image. Next, reduce or enlarge the duplicate to match the pattern of the original. Then, drag and drop the duplicate as a layer over the original, and use the masking techniques that I've shown you to paint in the appropriate parts.

The original image before manipulation isn't bad itself. You can see it below. Which you like better is a judgement call, but if you compare the two versions, you'll certainly get a sense of what you can do when you combine an image with itself using scaling and self-replication.

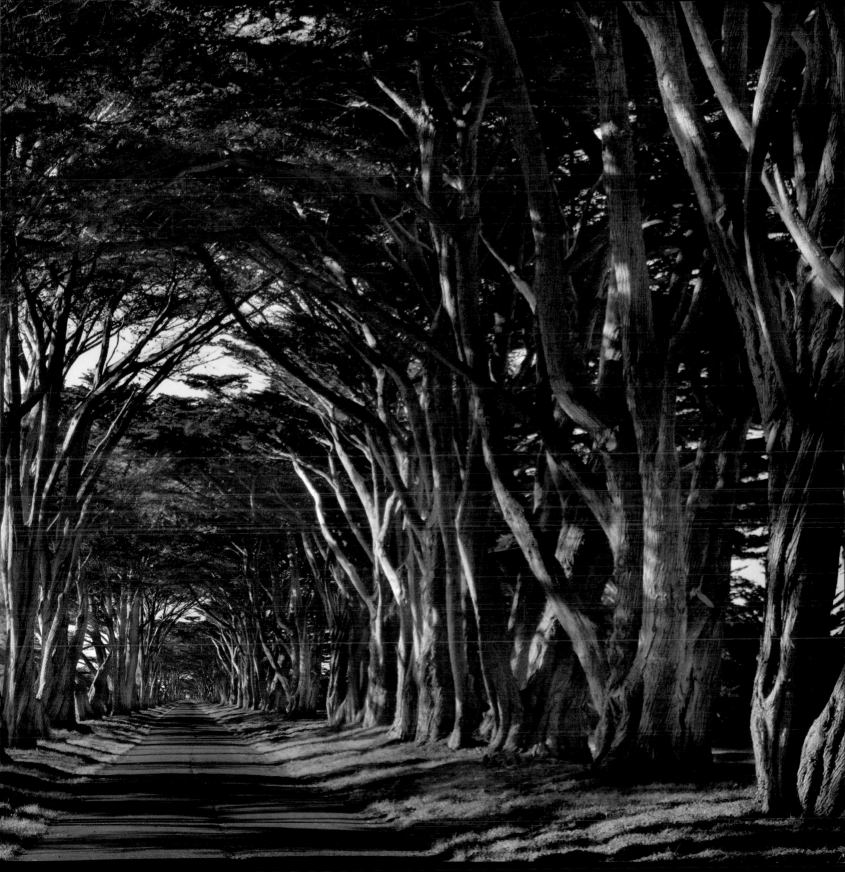

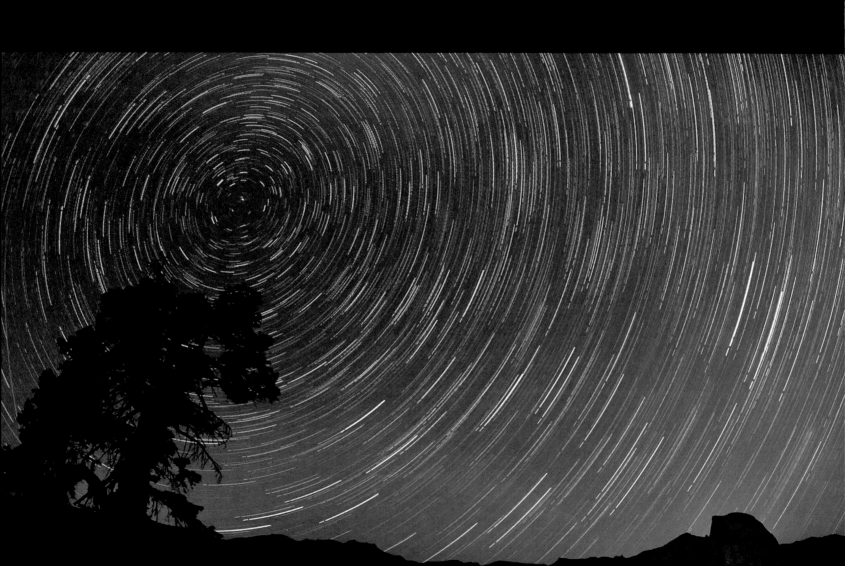

>> Colors of the night

I LIKE TO SPEND TIME photographing the wilderness at night. The image on the left was shot at Glacier Point in Yosemite National Park, and shows Half Dome and Yosemite Valley.

A great deal of what I capture in my night sessions has to do with stars, starlight, and star trails.

When I started out with night photography, I captured star trails using extremely long exposures, sometimes as long as several hours. While images captured using these long exposures can be very effective, extreme levels of noise caused by the long exposure time are always a problem.

I was very excited to learn about another way to capture star trails at night—*stacking*. Stacking is actually a form of compositing and is used when there's motion in the subject matter. The idea is to substitute many shorter exposures for a single longer exposure. This image was created using 12 four minute exposures, with each exposure at ISO 200 and f/4.

Stacking software, such as the Photoshop Statistics script that I used to create this image, combines the individual captures to create a single image that shows the motion of the stars over time.

If you look at the image, you'll note that there's an interesting purple flare at each corner of the image. This was caused by the camera sensor overheating. I actually like the effect, and consider it closer to a "feature" than a "bug."

For another example of star stacking, check out the image of the beached boat and star trails on page 4.

›› Stacking

Segmenting long exposures

Stacking software originated in astronomers' desire to capture stars in motion. The idea is to combine many relatively short exposures rather than taking one longer exposure. An advantage of this approach is that there is less noise in the final image.

The point of stacking is not to extend dynamic range. Rather, a pixel-by-pixel calculation is made. Typically, the brightest pixel from each image is selected. This works extremely well for stars in motion in a dark sky because the star trail will always be the brightest thing there. The sky is dark

so it disappears behind the star trails.

For details about how to create your own stack of images, see the "Arts & Crafts" project on page 144. I used 12 images, shown on page 136, to make the stack used in this case study. Each image was shot at 4 minutes, f/4, and ISO 100. This is a pretty good general exposure for starlight.

One problem with a stack created in this way is that the foreground is going to be dark. The exposure I just mentioned is not enough to properly expose a dark landscape at night. So generally, my stacked star trail images include a foreground capture that is

layered and masked over the stack.

To start this case study, you need to prepare the RAW image files for stacking by using ACR to convert them to PSD files. After that step is completed, you'll combine them to create your stack composite using Photoshop's Statistics script. Next, process a separate lighter exposure for the foreground in ACR and open it in Photoshop. Then, combine the foreground image with the stacked composite using layers, a layer mask, painting, and a gradient to create an image that shows both star trails and detail in the foreground.

After choosing File > Open in Photoshop, in the Open dialog select the 12 RAW images that need to be processed at the same time in ACR

You can also open these images in ACR by multi-selecting them in Adobe Bridge

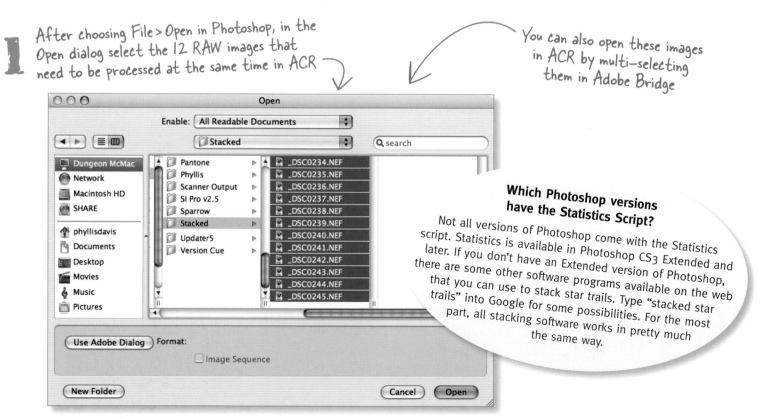

Which Photoshop versions have the Statistics Script?

Not all versions of Photoshop come with the Statistics script. Statistics is available in Photoshop CS3 Extended and later. If you don't have an Extended version of Photoshop, there are some other software programs available on the web that you can use to stack star trails. Type "stacked star trails" into Google for some possibilities. For the most part, all stacking software works in pretty much the same way.

2

Click Select All at the upper left of the ACR window. This way, the settings you select in ACR will be applied to all the images at the same time

All 12 RAW captures will be processed using the same settings

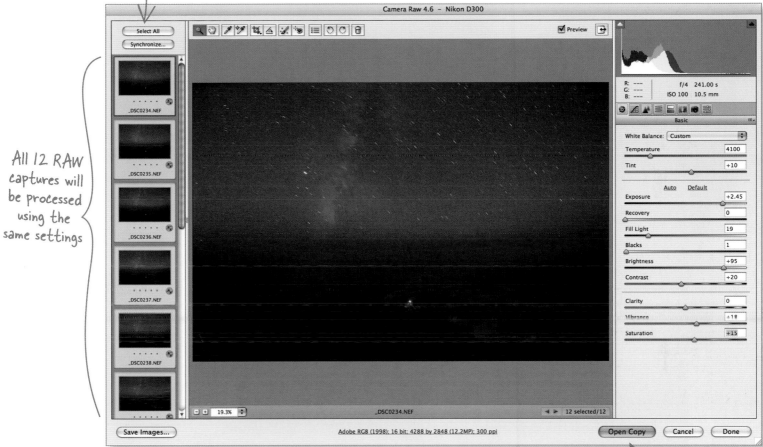

3 Use the sliders in the ACR window to choose the settings you'd like (for more about ACR settings, turn to pages 16–17)

4 Hold down the Alt/Option key and open the 12 images as copies in Photoshop (for more about this, turn to page 23)

Turn the page to see the 12 processed images

Here are the 12 RAW files processed using the same settings in ACR

#1 _DSC0234.psd @ 12.5% (RGB/16)
#2 _DSC0235.psd @ 12.5% (RGB/16)
#3 _DSC0236.psd @ 12.5% (RGB/16)
#4 _DSC0237.psd @ 12.5% (RGB/16)
#5 _DSC0238.psd @ 12.5% (RGB/16)
#6 _DSC0239.psd @ 12.5% (RGB/16)
#7 _DSC0240.psd @ 12.5% (RGB/16)
#8 _DSC0241.psd @ 12.5% (RGB/16)
#9 _DSC0242.psd @ 12.5% (RGB/16)
#10 _DSC0243.psd @ 12.5% (RGB/16)
#11 _DSC0244.psd @ 12.5% (RGB/16)
#12 _DSC0245.psd @ 12.5% (RGB/16)

I sometimes find that the default ACR settings work well enough for stacked star trail images. There's often no real reason to fuss too much over the ACR settings for images going into a stack

Next Step

Stack the 12 images together using Photoshop's Statistics script (pages 137–138).

›› Stacking with Statistics

Just what the heck is skewness?

I like to use Photoshop's Statistics script to create my stacked composites. This script lets you choose a statistical method to determine how the pixels in the layers are actually blended. You can fool around with the list of methods available, but what I've found is that the three best ones are Maximum, Range, and Mean.

Personally, I don't remember my college statistics course well enough to know what statistical methods like *Kurtosis* or *Skewness* do, and it's not well documented in Photoshop, so the only way to really find out is to try a setting and see.

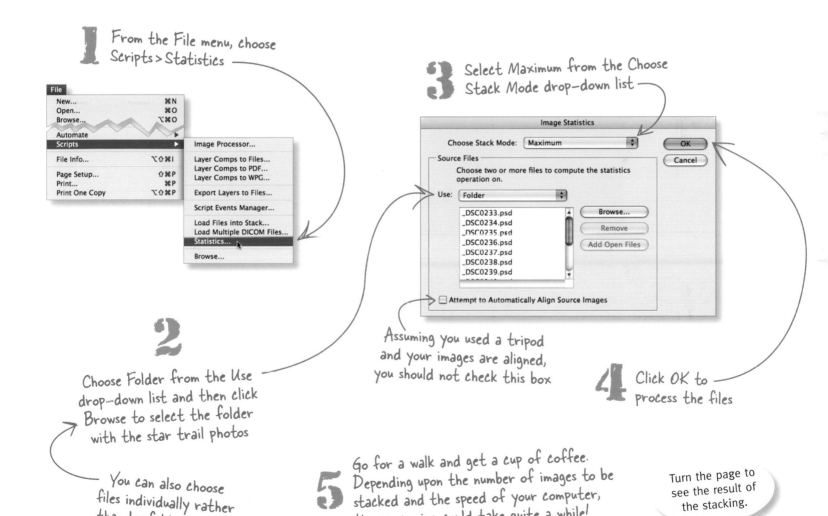

1 From the File menu, choose Scripts > Statistics

2 Choose Folder from the Use drop-down list and then click Browse to select the folder with the star trail photos

You can also choose files individually rather than by folder, or you can add open files

3 Select Maximum from the Choose Stack Mode drop-down list

Assuming you used a tripod and your images are aligned, you should not check this box

4 Click OK to process the files

5 Go for a walk and get a cup of coffee. Depending upon the number of images to be stacked and the speed of your computer, the processing could take quite a while!

Turn the page to see the result of the stacking.

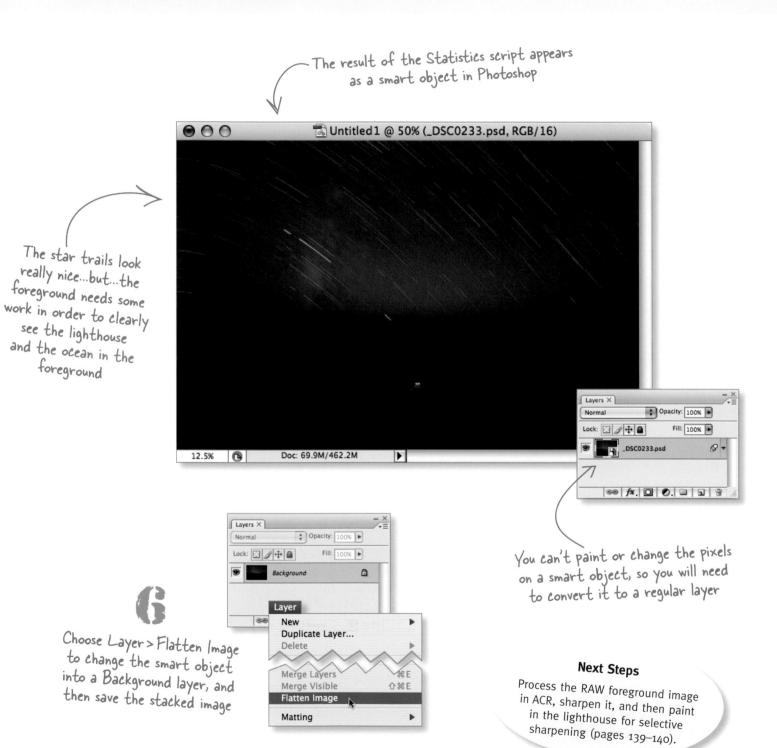

The result of the Statistics script appears as a smart object in Photoshop

The star trails look really nice...but...the foreground needs some work in order to clearly see the lighthouse and the ocean in the foreground

You can't paint or change the pixels on a smart object, so you will need to convert it to a regular layer

6

Choose Layer > Flatten Image to change the smart object into a Background layer, and then save the stacked image

Next Steps

Process the RAW foreground image in ACR, sharpen it, and then paint in the lighthouse for selective sharpening (pages 139–140).

›› Working on the foreground image

Selectively sharpening the lighthouse

Looking at the foreground layer, I decided it would be really neat to be sure that the lighthouse was extremely crisp and sharp. I realized that the lighthouse is a small detail in this overwhelmingly vast image of stars and ocean that I call *Edge of Night*.

I liked the idea of one crisp detail that shows more and more the closer you look at it.

My technique for sharpening uses LAB color and is explained starting on page 198. You won't be surprised to learn that to apply this kind of sharpening I work on a duplicate layer, add a layer mask, and paint in the area I want to selectively sharpen.

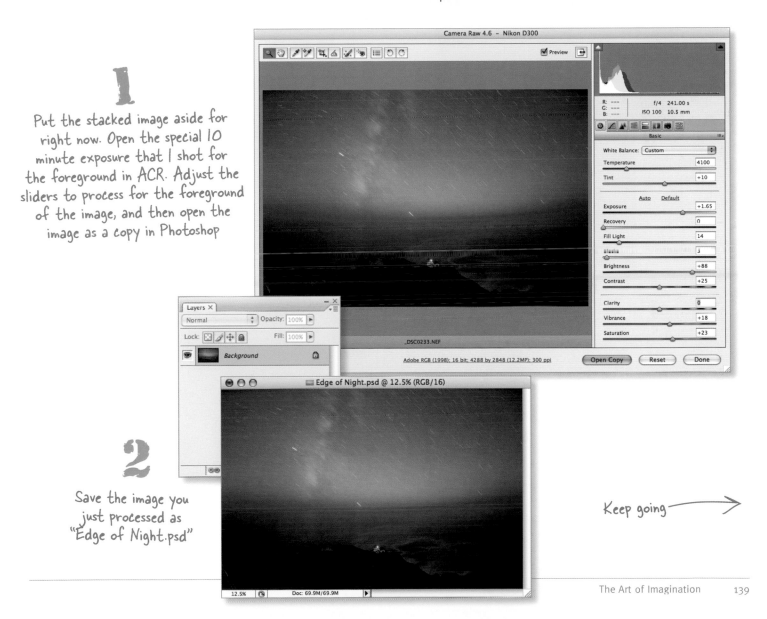

1

Put the stacked image aside for right now. Open the special 10 minute exposure that I shot for the foreground in ACR. Adjust the sliders to process for the foreground of the image, and then open the image as a copy in Photoshop

2

Save the image you just processed as "Edge of Night.psd"

Keep going ⟶

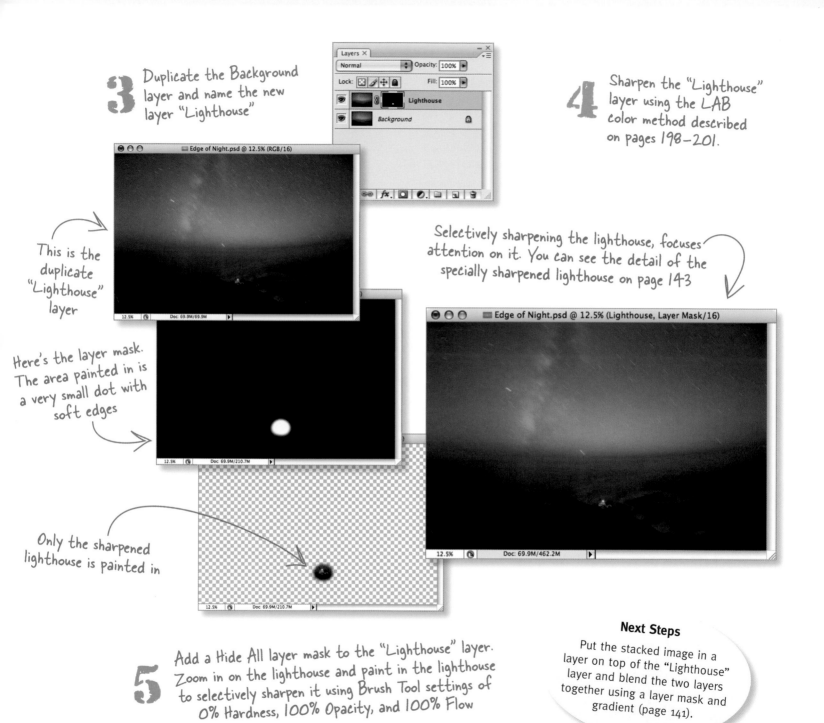

3 Duplicate the Background layer and name the new layer "Lighthouse"

4 Sharpen the "Lighthouse" layer using the LAB color method described on pages 198–201.

This is the duplicate "Lighthouse" layer

Selectively sharpening the lighthouse, focuses attention on it. You can see the detail of the specially sharpened lighthouse on page 143

Here's the layer mask. The area painted in is a very small dot with soft edges

Only the sharpened lighthouse is painted in

5 Add a Hide All layer mask to the "Lighthouse" layer. Zoom in on the lighthouse and paint in the lighthouse to selectively sharpen it using Brush Tool settings of 0% Hardness, 100% Opacity, and 100% Flow

Next Steps

Put the stacked image in a layer on top of the "Lighthouse" layer and blend the two layers together using a layer mask and gradient (page 141).

›› Putting it all together

You know what to do...

Combining the "Star trail" layer with the "Lighthouse" layer is no big deal for you by now. It's the same technique that I showed you in the first multi-RAW case study, on pages 32–39.

To finish the image, add a Hide All layer mask to the "Star trails" layer. Next, use the Gradient Tool to draw a gradient on a layer mask to blend the two images together.

1 Holding down the Shift key, drag the stacked composite image from its image window into the window with the "Lighthouse" layer. Rename this layer "Star trails"

2 Add a Hide All layer mask to the "Star trails" layer, then use the Gradient Tool to drag a white-to-black gradient down the mask

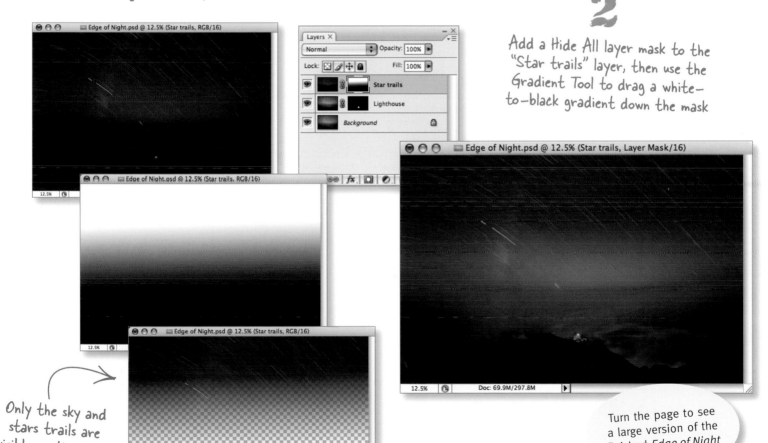

Only the sky and stars trails are visible on the layer

Turn the page to see a large version of the finished *Edge of Night*

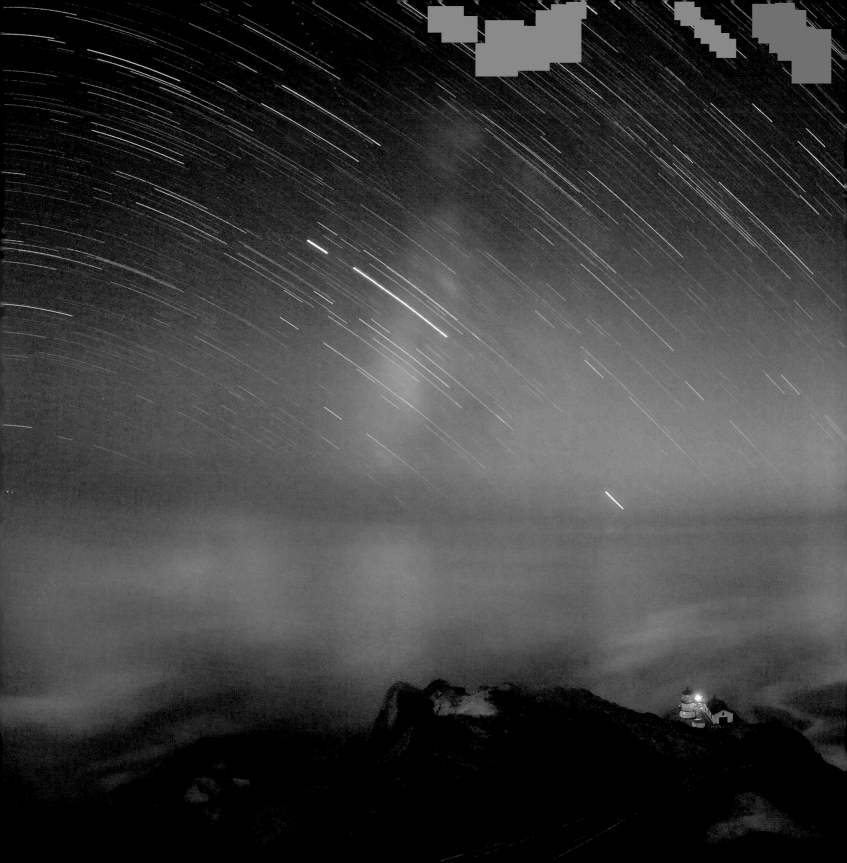

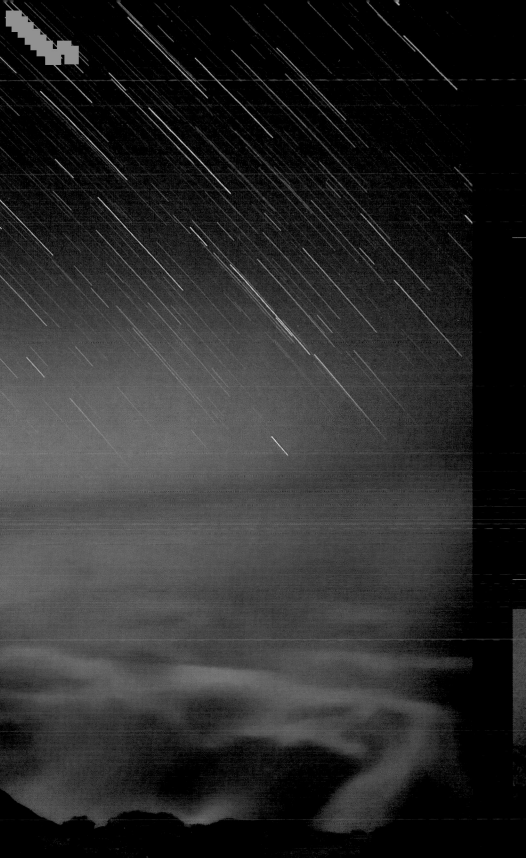

LOOKING AT THIS IMAGE of the lighthouse in Point Reyes National Seashore, you may notice something odd about the star trails. There's a space between the shorter star trails and the longer star trails.

Okay, so I cheated. When it comes to the digital darkroom, I have no shame. I confess that I loaded the 10 minute "foreground" exposure into my stack. The shorter star trails are from the four minute exposures and the longer trails are from the one 10 minute exposure.

There are a couple of things I like about this image that have nothing to do with star trails. I love the way the long time exposure softened and flattened the pounding surf.

I also think the sharpening used on the lighthouse is very effective. The closer you look at the lighthouse, the more you see.

"ARTS & CRAFTS" PROJECT

Shooting your own star trail stack

If you want to make your own star trail stack, the first thing you need to think about is, "How dark is dark?" Star trail photography is only really effective when the night is really black. You need to be sure that the moon isn't up, and you won't be able to create effective star trails anywhere near city lights.

The closer your camera is pointed towards due north, the greater curvature you'll get in your star trails. Since the North Star doesn't move relative to the Earth, it will appear as a stationary dot surrounded by curving star trails.

A wide-angle lens will give you longer star trails. I like to shoot star trails with my 10.5mm digital fisheye lens for maximum curvature and length of star trails.

Bear in mind that a photograph simply of the sky with star trails is probably not that interesting. You need to compose your star trail photograph with something interesting in the foreground as well as in the sky.

Besides a camera and sturdy tripod, a crucial piece of equipment that you will need is a programmable interval timer, such as the Nikon MC–36 shown here.

Make sure you put a fresh battery in your camera. Turn long-exposure noise processing off because it interferes with the short interval between exposure necessary for stacking exposures. With your camera set to Manual exposure, turn the shutter speed to the Bulb setting. Set the aperture to a setting in the f/2.8 to f/5.6 range, and the ISO to 100 or 200.

Plug your programmable interval timer into your camera. Set the timer to shoot the number of exposures you want in your stack at 4 minutes per exposure. Set the interval to 4 minutes, 1 second. This means that each subsequent exposure will start 1 second after the previous exposure has finished.

Wear warm clothing, bring a cup of coffee, and maybe a friend for conversation while the stack is being captured, and don't fall into any pits in the dark like I've done a number of times (but lived to tell the tale as witnessed by the writing of this book!).

The Nikon MC–36 is a programmable interval timer that works with some Nikon DSLRs. Comparable interval timers can be found for most DSLR cameras.

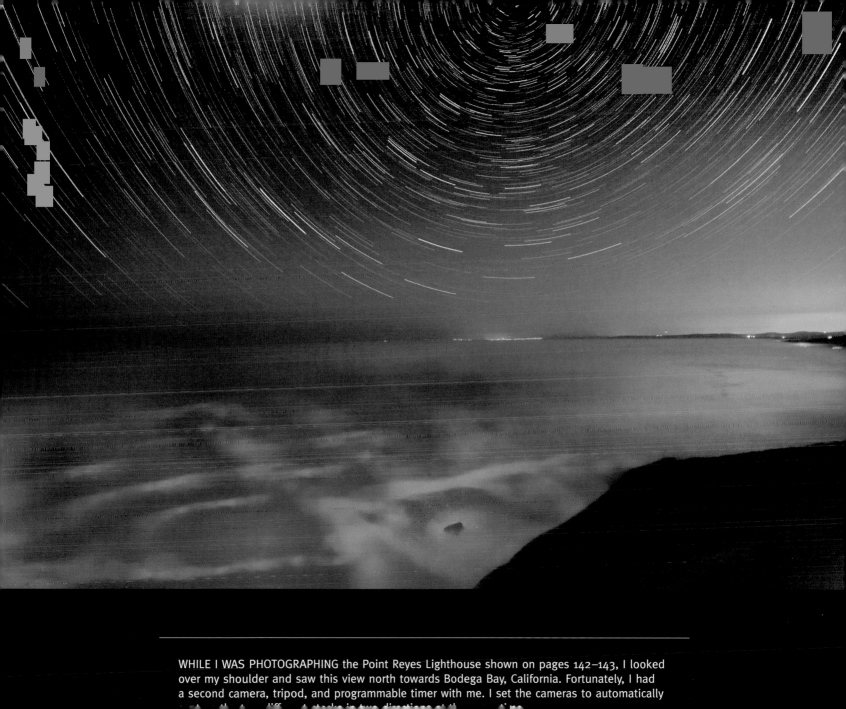

WHILE I WAS PHOTOGRAPHING the Point Reyes Lighthouse shown on pages 142–143, I looked over my shoulder and saw this view north towards Bodega Bay, California. Fortunately, I had a second camera, tripod, and programmable timer with me. I set the cameras to automatically

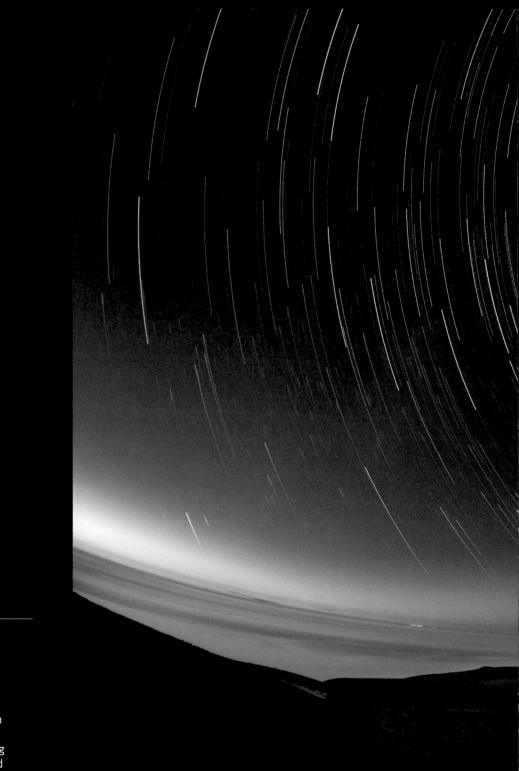

THIS IS AN IMAGE of the North Fork of Point Reyes
National Seashore in California, a little north of San
Francisco. The view points north with Polaris in the
center for maximum star trails.

I drove out on a balmy night with my 11 year-old son
and set the programmable interval timer to stack 16
four minute exposures. While the shutter was clicking
away, my son and I lay back on the grassy slope and

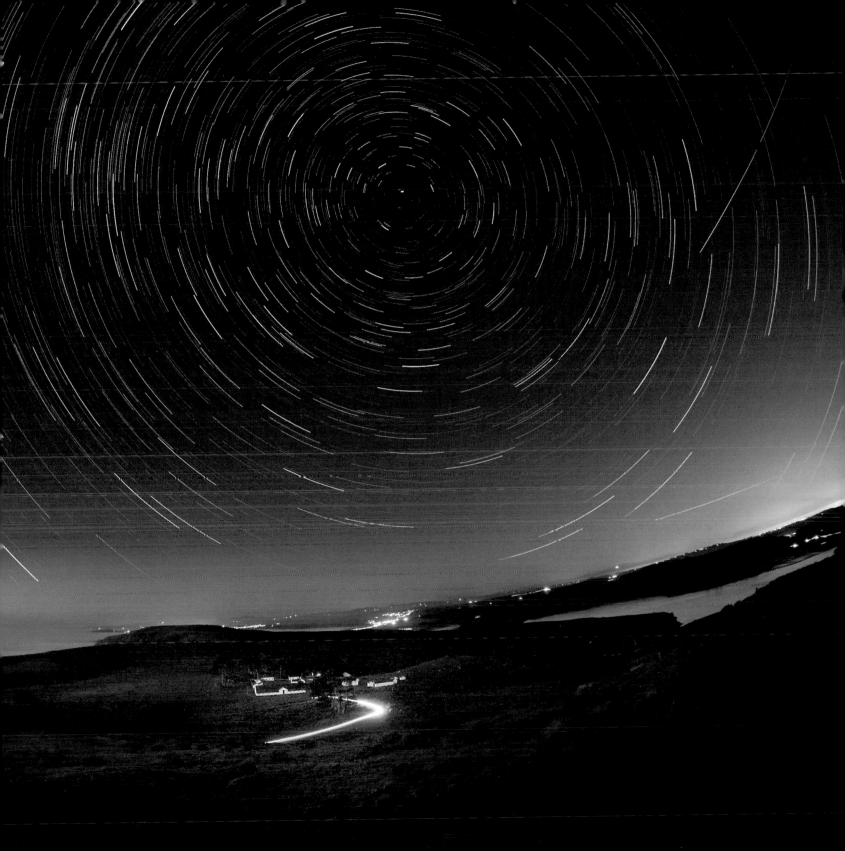

A Pixel Does Not Know Its Origin

›› A digital image has a father and a mother

IF YOU THINK ABOUT Photoshop, you'll see that there are really two very different kinds of tools available in the software. One strain of Photoshop thought assumes that you are working with a photograph with the idea of altering or improving it. The other approach is to paint or draw in Photoshop from the ground up. With artwork done this way, you are a complete creator limited only by your skill and vision.

Surprise! The two approaches are not as different as you might think. When you are working in really close on a photograph and editing at the pixel-level, the tools that are best to use are those that also work to create images from scratch. In other words, a pixel does not know its origin. A pixel does not know if it came from a digital capture or from the Brush Tool. A pixel is just a pixel no matter how it gets there.

For me, my digital photographic imagery converges with digital painting. Some photographers don't like altering photos as a matter of principle, but I do not feel this way. Of course, this depends upon context, and journalism should imply integrity.

I appreciate it very much when someone says that one of my images looks more like a painting than a photograph. The fact is that many of my images are as much digital painting as photography.

As I have matured with the Photoshop darkroom, my favorite techniques for moving my images along the progression from photo to painting involve converting the images to LAB color, applying adjustments to channels within LAB, and then blending the adjusted layers back into the original. You will see the specifics about how to do this in the case study starting on page 170. But before we get there, let's have a look at some of the concepts that I've just mentioned.

Channels

Every image in Photoshop is divided into channels. Channels are a crucial concept to the Photoshop darkroom. RGB color images, meant to be displayed on a monitor, are divided into red (R), green (G), and blue (B) channels. Your camera captures photographs as RGB images.

CMYK images, meant for reproduction in print media such as *The Photoshop Darkroom*, are divided into cyan (C), magenta (M), yellow (Y), and black (K) channels. As an example, since this book is being reproduced using CMYK inks, all the images in this book have been prepared using the CMYK color space.

You can see the channels associated with any image on the Channels palette.

Continued on page 153

On a field trip to downtown Oakland, California, I photographed reflections of office buildings shown on the left. A series of photo compositing and LAB channel moves produced the image to the right.

The structure of LAB consists of three channels:

- The L channel, or Lightness channel, contains luminance information which is another way of saying that it holds the black and white information for an image. A great deal of the power of LAB color comes from the separation of luminance from color information.

- The A channel contains green and magenta information. At a given pixel point, an A channel value of zero means that the pixel is neither green nor magenta. −128 on the A channel scale in Photoshop means that the pixel is entirely green, and +127 means that the pixel is entirely magenta. This kind of color organization is called *opponent color* because the colors in the channel are at opposite ends of the color scale from one another.

- The B channel contains blue and yellow information. In Photoshop, when the B channel value is zero, the pixel is neutral between yellow and blue. −128 on the B channel scale represents pure blue, and +127 represents pure yellow.

Blending channels

The general process for blending a channel into an image is to start by duplicating the image. You can adjust the channel that you are interested in using in the duplicate. Then copy the entire adjusted image (all channels) back over the original image as a layer. This process will become clearer as you follow the case study that starts on page 170.

Once you've copied the image with the adjusted channel over the original image as a layer, you can change the blending mode to get the effect you want, and use a layer mask to selectively paint it in.

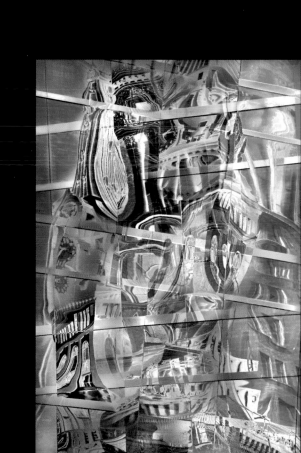

The image shown on page 151 turned out not to be my final variation. Some additional LAB channel operations produced the pink and blue versions you see here.

›› Working creatively with LAB color

LAB channel adjustments

The first step in working with LAB color is converting your image to the LAB color space. It's easy to do and I'll show you how.

The next step is to duplicate the image so you have a copy to do creative LAB work on. The idea is that once you've performed LAB channel adjustments on the copy, you can drag it over the original as a layer, select a

blending mode, and if necessary use masking to achieve the affect you would like.

I'll walk you through this process in the context of a practical example: Converting the poppy image shown below using an inversion as a base layer so the poppies appear to rest on a black background. The case study starts on page 170.

Before you start the case study you

need to know how to work with some LAB color adjustments and the process you use to achieve these adjustments. This section shows you the seven most useful LAB channel adjustments.

I use these adjustments in many of my images. You can use these adjustments very successfully in your own creative work in the Photoshop darkroom. You can also use them as a starting place for LAB adjustments that you come up with on your own.

This is the starting image for the case study that starts on page 170. This image is shown larger on page 119

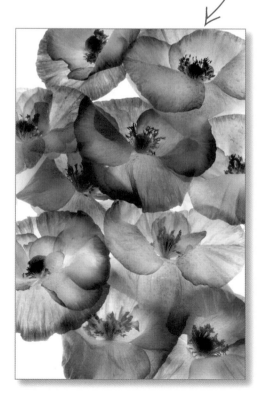

Converting to LAB

LAB color uses three channels: Lightness for the black and white information, A for green and magenta information, and B for the blue and

yellow information. Each channel is a grayscale image that represents this color information. The LAB color space was created to approximate the way we see color with our eyes.

Convert to LAB color by selecting Image > Mode > Lab Color

Image	
Mode ▶	
Adjustments ▶	
Duplicate...	
Apply Image...	
Calculations...	
Image Size... ⌥⌘I	
Canvas Size... ⌥⌘C	
Pixel Aspect Ratio ▶	
Rotate Canvas ▶	
Crop	
Trim...	
Reveal All	
Variables ▶	

Bitmap
Grayscale
Duotone
Indexed Color
RGB Color
CMYK Color
✓ Lab Color
Multichannel

✓ **8 Bits/Channel**
16 Bits/Channel
32 Bits/Channel

Color Table...

You can also convert to LAB color by selecting Edit > Convert to Profile and choosing LAB from the Profile drop-down list in the Destination Space area

Channels ×

👁 Lab ⌘~

👁 Lightness ⌘1

👁 a ⌘2

👁 b ⌘3

This is the Channels palette showing LAB color

›› Getting to know the Channels palette

Playing with eyeballs

The LAB color space, like the RGB color space, contains three channels. CMYK contains four channels.

You can view each channel individually by clicking on it in the Channels palette. When you select a channel, the other channels are deselected and the tiny eyeballs to the left of the channel name disappears (meaning that channel is not visible). With one channel selected, you can click on the eyeball box to make a second channel visible (though the channel will not be selected unless you click on its name). To make all the channels visible and select all of them as well, click the composite channel at the top of the Channels palette.

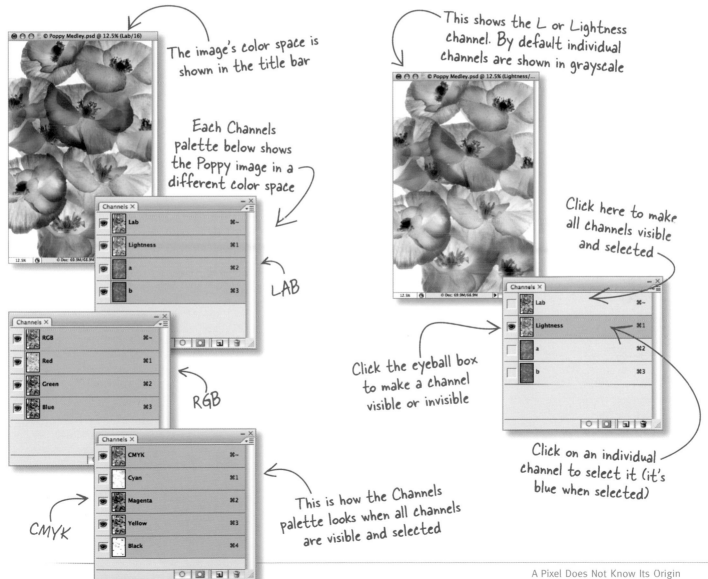

The image's color space is shown in the title bar

Each Channels palette below shows the Poppy image in a different color space

LAB

RGB

CMYK

This shows the L or Lightness channel. By default individual channels are shown in grayscale

Click here to make all channels visible and selected

Click the eyeball box to make a channel visible or invisible

Click on an individual channel to select it (it's blue when selected)

This is how the Channels palette looks when all channels are visible and selected

›› Duplicating an image

Working on a duplicate

After I convert an image to LAB color, I make a duplicate of the image. This isn't the same thing as duplicating a layer.

What's the difference? Duplicating a layer does just that: it makes a duplicate of a selected layer *within the same image*. Whereas, duplicating an entire image *creates a completely new image* (albeit one that is exactly the same) that I can work on in LAB.

After I finish working on the duplicate I drag it into the original image window where it becomes just another layer.

One other thing you should pay attention to: the duplicate image is not automatically saved. Depending upon what you are going to do with it, you may want to save it before you work on it.

Choose Image > Duplicate, and then type in a name for the image, and click OK. Remember that the duplicate is not automatically saved

I created this image of an Anemone primarily using equalizations of the L and B channels of the photo in LAB color

Just what is an inversion?

Inverting means replacing each color pixel with a pixel of its opposite color. Black becomes white, and white becomes black. In LAB color, pure magenta becomes pure green and vice versa; similarly, pure blue becomes pure yellow and vice versa.

You can invert all the channels in an image, or a single channel. It's perfectly possible to invert images and channels in RGB, but it's more powerful doing it in LAB because of the color opponent structure of each color channel.

Using LAB channel adjustments to enhance color

On the next few pages I'll show you a number of adjustments of LAB color images and channels, applied to the duplicate image that you've made. "What," you may be thinking, "is the point of this?"

I use the sequence of LAB channel adjustments that I am showing you here as a color palette that I can use in conjunction with a variety of blending modes to enhance—and even

completely alter—the color values in my images.

I've written a Photoshop action that performs all seven LAB adjustments shown on pages 168–169. Each adjustment will appear as its own duplicate image. I routinely run this action on a duplicate image of most photos I take. I then inspect the results and see which LAB channel adjustment I want to use.

My action is available for download and installation in Photoshop from

the web page associated with this book, *www.focalpress.com/ photoshopdarkroom.*

Inverting all LAB channels

The first adjustment is in some ways the simplest. To create what is always a striking effect, invert the entire image in LAB color. When you perform this adjustment, whites will become black, and blacks will become white. Often this adjustment produces exotic and electric blues that can be used to add excitement to an image.

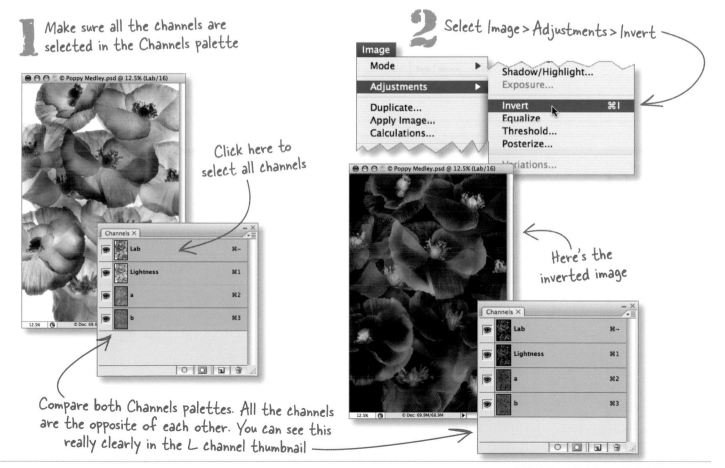

1 Make sure all the channels are selected in the Channels palette

Click here to select all channels

2 Select Image > Adjustments > Invert

Here's the inverted image

Compare both Channels palettes. All the channels are the opposite of each other. You can see this really clearly in the L channel thumbnail

⟫ Inverting the L channel

Painting with LAB

Inversion of a specific LAB channel replaces the pixels in that channel, but not the other channels. The most useful single channel conversion is to invert only the L channel.

I use inversion of the L channel when I want to put an image that is on white on a black background. This is a pretty common move for me, and lets me achieve a "two-fer." By taking one photo, I can come up with two related

images like flowers shown at the top of pages 168–169.

A and B channel inversions are good for adding specific colors back into an image. For example, if you start with red in your image, an inversion of the A channel will give you green. You can then "paint" the green in specific areas.

Since the application of the "new" color is done by creating a layer stack and using layer masks and painting,

it's possible to achieve great effects without having to be particularly good at painting because the shapes are exactly the same. This is a key point to understand. By inverting the channel, you've changed the colors, but the composition is still the same.

In other words, LAB channel adjustments allow you to add incredibly cool artistic effects to your photos without having to have much in the way of manual painting skills.

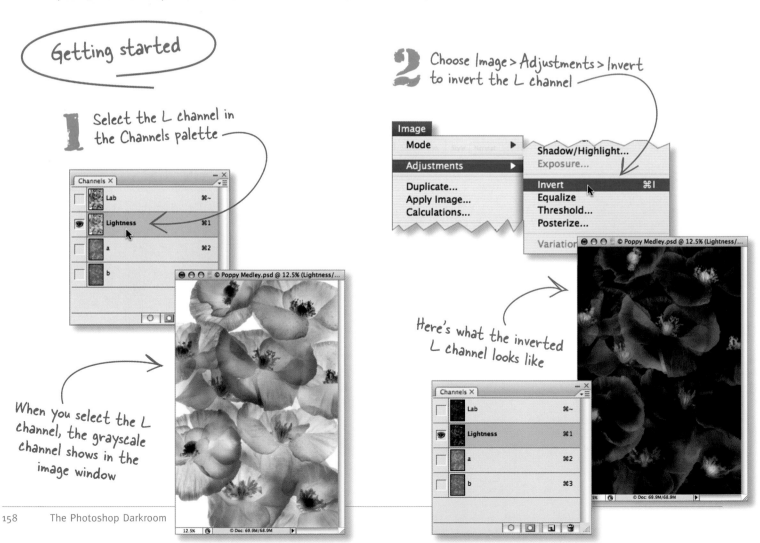

Getting started

1 Select the L channel in the Channels palette

When you select the L channel, the grayscale channel shows in the image window

2 Choose Image > Adjustments > Invert to invert the L channel

Here's what the inverted L channel looks like

3 Click the composite channel at the top of the Channels palette to select all the channels and see how the inversion affects the image

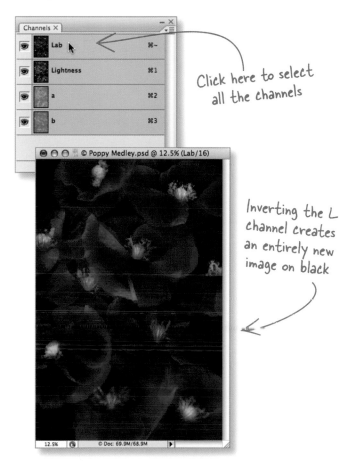

Click here to select all the channels

Inverting the L channel creates an entirely new image on black

Select all channels before dragging

After inverting a channel, make sure to select all channels before dragging the image into another image window as a layer (otherwise, you get a grayscale piece of nonsense—we've all done it!)

Clematis duet

The clematis shown below with the white background was shot on a white lightbox. I combined a number of different exposures using hand-HDR (as explained starting on page 106) to enhance the apparent transparency of the image.

After processing the clematis on white, I duplicated the image and inverted the L channel. As usual, the L channel itself lacked contrast and subtlety in the lighter areas. So the work that remained was to add back what was missing: some of the lightness of the flower and more contrast in the petals.

The clematis on black, shown at the bottom, is the result. I have found that images paired this way are favorably received as print duets.

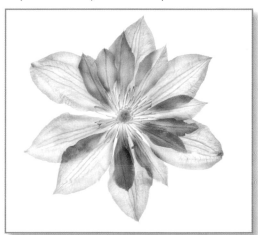

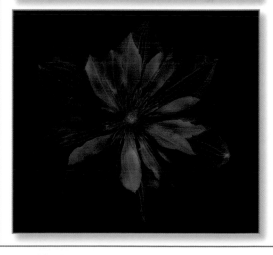

>> Inverting the A channel

Green and magenta

The A channel contains the green and magenta information in an image. When you invert the channel, magenta pixels are changed to green and vice versa.

Select the A channel in the Channels palette

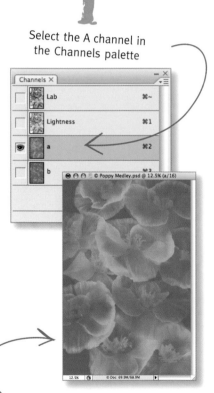

When you select the A channel, the grayscale channel shows in the image window

2 Choose Image ► Adjustments ► Invert to invert the A channel

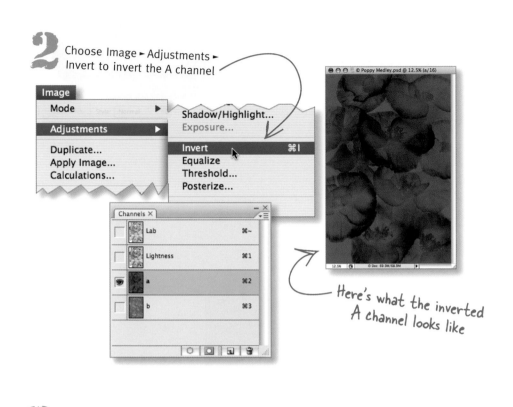

Here's what the inverted A channel looks like

3 Click the composite channel at the top of the Channels palette to select all the channels and see how the inversion affects the image

Click here to select all the channels

Inverting the A channel creates a very green image

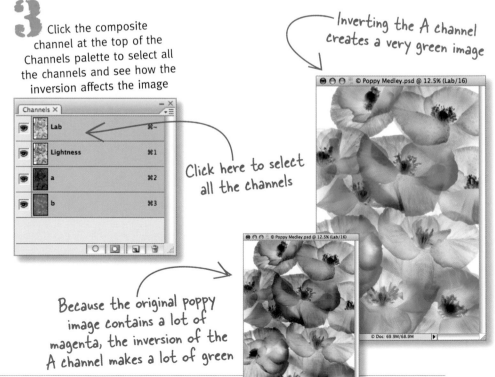

Because the original poppy image contains a lot of magenta, the inversion of the A channel makes a lot of green

›› Inverting the B channel

Blue and yellow

The B channel contains the blue and yellow information in an image. When you invert the channel, blue pixels are changed to yellow and vice versa.

1

Select the B channel in the Channels palette

When you select the B channel, the grayscale channel shows in the image window

2 Choose Image ► Adjustments ► Invert to invert the B channel

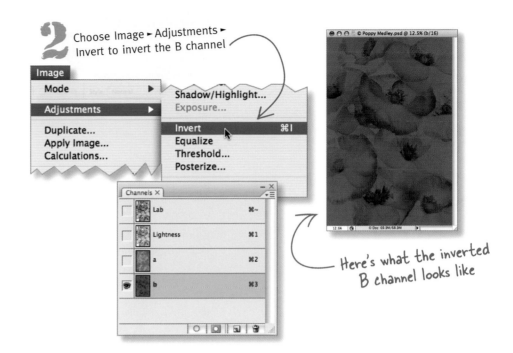

Here's what the inverted B channel looks like

3 Click the composite channel at the top of the Channels palette to select all the channels and see how the inversion affects the image

Click here to select all the channels

Inverting the B channel makes the petals turn violet because the B channel petals are blue and this color mixes with the magenta petals of the A channel

The centers of the poppies in the original image are yellow, so they convert to blue in the inversion

›› Equalizing the L channel

Taking colors and contrast to the max

Equalizing individual LAB channels is as useful—maybe more useful—than inverting channels.

When you use the equalize adjustment Photoshop grabs the lightest pixel and changes it to white and grabs the darkest pixel and changes that one to black. Then all the values in between are redistributed to fit these new end points. In other words, the existing values are exaggerated in both directions.

When you equalize a LAB channel things get much more interesting. If you consider the color opponent nature of a LAB channel, you'll see

that spreading out the range of values within the channel is going to spread out the range of opponent colors within a channel. This interesting effect can be very useful.

If the A channel has a little bit of green and a little bit of magenta in different areas, once you equalize the channel, there will be a whole lot of green and magenta in these areas.

If the B channel has a tiny bit of yellow and blue in different locations, then equalizing the B channel will create a ton of yellow and blue in these locations.

Equalizing the L channel does exactly the same thing as equalizing the entire LAB image, which is why I do not

include an overall equalization in this sequence of adjustments.

The impact of expanding the white-black color opponent range, which is what an equalization of the L channel (or the entire LAB image) does, is to extend and expand the contrast range of an image. While this effect doesn't look good at 100% opacity, I employ an equalized L channel at low opacity in almost all my images. Specifically, I equalize the L channel, grab the entire image, and drag it into the original image as a layer. I then use Soft Light blending mode at 10%–12% opacity over the entire image. This gently increases the contrast ranges in my images without making anything look too harsh.

1. Select the L channel in the Channels palette

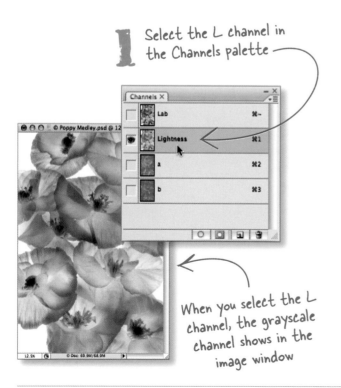

When you select the L channel, the grayscale channel shows in the image window

2. Choose Image > Adjustments > Equalize to equalize the L channel

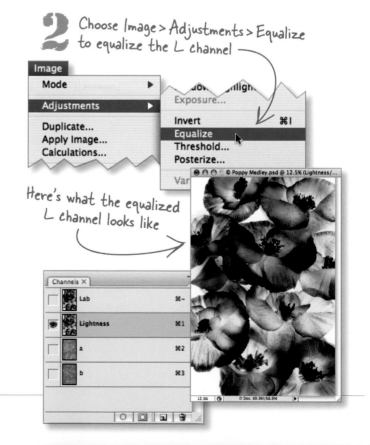

Here's what the equalized L channel looks like

3 Click the composite channel at the top of the Channels palette to select all the channels and see how the equalization affects the image

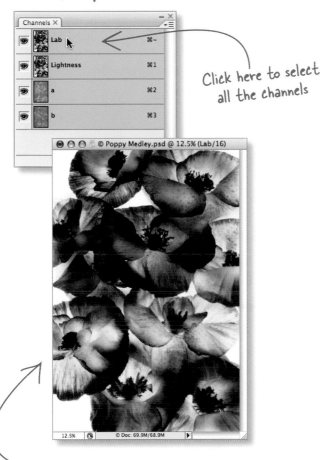

Click here to select all the channels

Because the equalization spreads out the range of pixel values, the magenta poppy petals of the original image become a darker brick color when the L channel is equalized

Why equalize the L channel?

Equalizing the L channel has the same impact as equalizing the entire LAB image. The effect is to spread out the black and white values, creating a higher contrast image. If you blend the equalized L channel back into an image using the Soft Light blending mode, the midtones of the image will show an expanded tonal range. (To understand about how the Soft Light blending mode works, turn to page 71).

Be careful when you use Soft Light to blend in the L channel equalization that you don't overdo the effect because it can look garish. When I do this move, I usually keep the Opacity in the 10%–15% range which leads to a subtle effect.

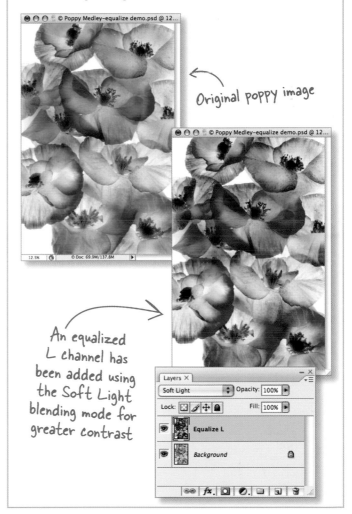

Original poppy image

An equalized L channel has been added using the Soft Light blending mode for greater contrast

>> Equalizing the A channel

Expanding the green and magenta

Equalization spreads out the pixel range from the darkest pixel to the lightest pixel. So when the A channel is equalized, a lot more green appears after the adjustment. This is because there is so little green and so much magenta in the original that the pixel redistribution is dramatic, shifting the channel over towards the green end of the spectrum.

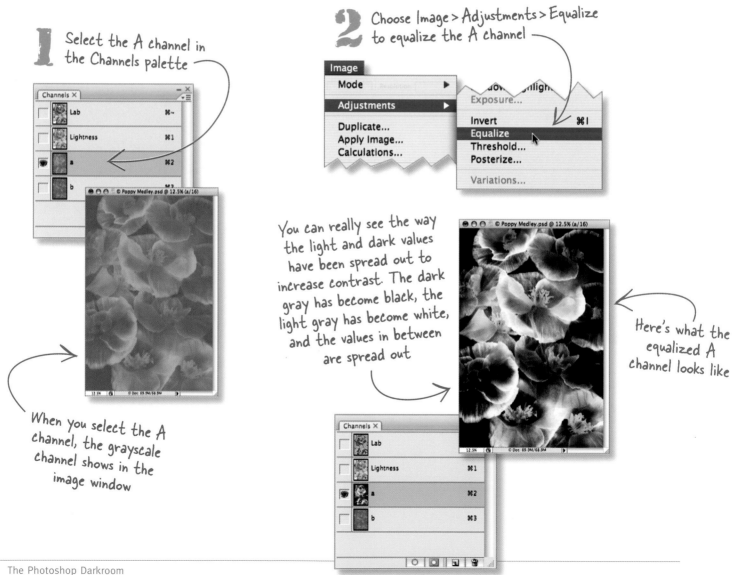

1 Select the A channel in the Channels palette

2 Choose Image > Adjustments > Equalize to equalize the A channel

When you select the A channel, the grayscale channel shows in the image window

You can really see the way the light and dark values have been spread out to increase contrast. The dark gray has become black, the light gray has become white, and the values in between are spread out

Here's what the equalized A channel looks like

3 Click the composite channel at the top of the Channels palette to select all the channels and see how the inversion affects the image

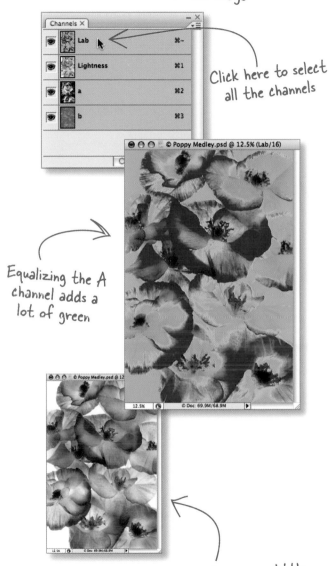

Click here to select all the channels

Equalizing the A channel adds a lot of green

Since the original poppy image contains very little green, the equalization of the A channel pushes the image over to the green side of the spectrum

Why equalize the A channel?

The point of equalizing the A channel is to be able to add in significant but selective colors in the green to magenta range. When I blend an A channel equalization back into the original, I use the Color blending mode.

You should be aware that a Color blend in the LAB color space is surprisingly powerful. You want to use a layer mask (for selectivity) and the Brush Tool with the Opacity set below 10%. Any higher setting than 10% and you risk having your colors look unnatural and garish.

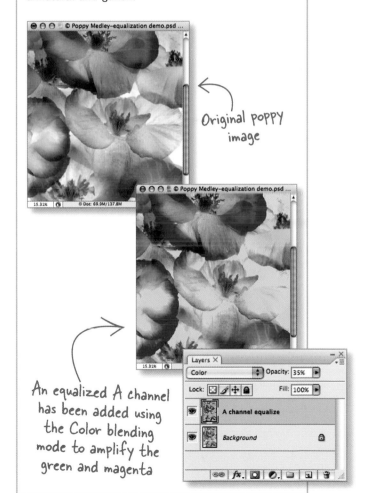

Original poppy image

An equalized A channel has been added using the Color blending mode to amplify the green and magenta

›› Equalizing the B channel

Expanding the blue and yellow

The poppy image contains very little blue, mostly some very light shading on the petals. Since there is so little blue in the image, equalizing the B channel increases the blue part of the spectrum while making the yellow stamens in the image very yellow.

2 Choose Image > Adjustments > Equalize to equalize the B channel

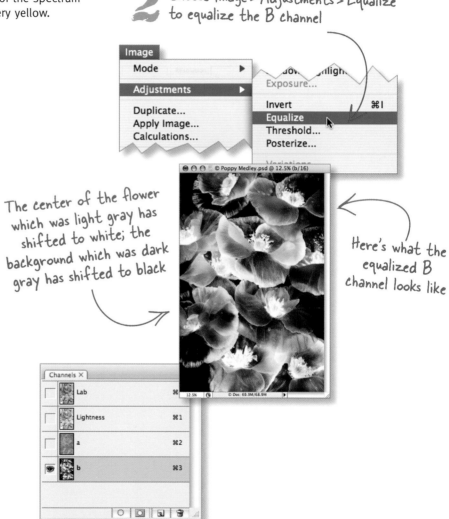

1 Select the B channel in the Channels palette

The center of the flower which was light gray has shifted to white; the background which was dark gray has shifted to black

Here's what the equalized B channel looks like

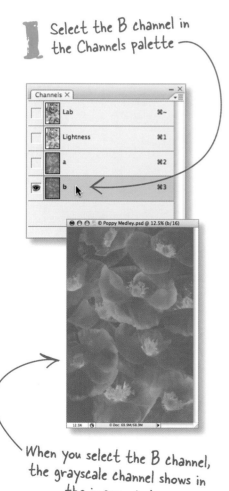

When you select the B channel, the grayscale channel shows in the image window

All seven LAB channel inversion and equalization adjustments are shown together on pages 168–169.

3 Click the composite channel at the top of the Channels palette to select all the channels and see how the inversion affects the image

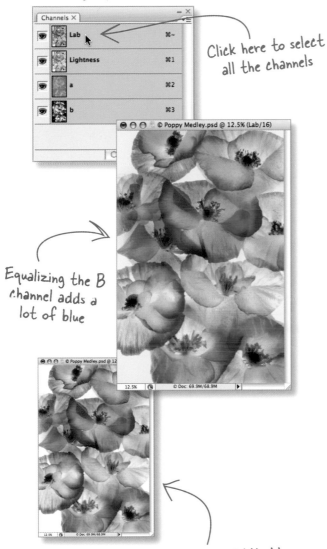

Click here to select all the channels

Equalizing the B channel adds a lot of blue

The original poppy image contains very little blue, so the equalization of the B channel pushes the image over to the blue side of the spectrum

Why equalize the B channel?

As with the A channel, the point of equalizing the B channel is to be able to alter or add colors. In the case of the B channel, the colors you gain are at the ends of the yellow to blue range in the image. When I blend a B channel equalization back into the original, I use the Color blending mode.

As I've noted, Color blends are very powerful in LAB. Use a layer mask and selectively paint in what you want with an Opacity setting of 10% or less.

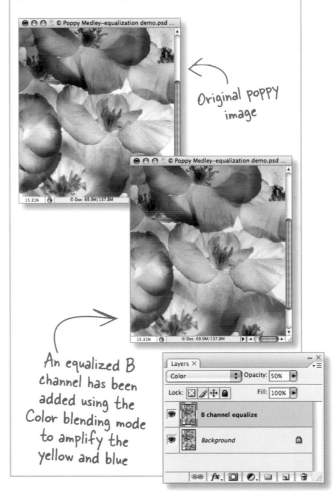

Original poppy image

An equalized B channel has been added using the Color blending mode to amplify the yellow and blue

Here's the way this transparent flower looked after I photographed it on a white lightbox.

<u>Original version</u>

This is a photograph of
a medley of poppies on
a white background.

<u>All LAB channels inverted</u>

This adjustment tends to
give interesting effects that
are opposite to the color
values in the base image.

<u>L channel inverted</u>

Good for putting a white
image on black or a black
image on white.

<u>A channel inverted</u>

Good for adding colors
opposite to the prevailing
green/magenta values
to the image.

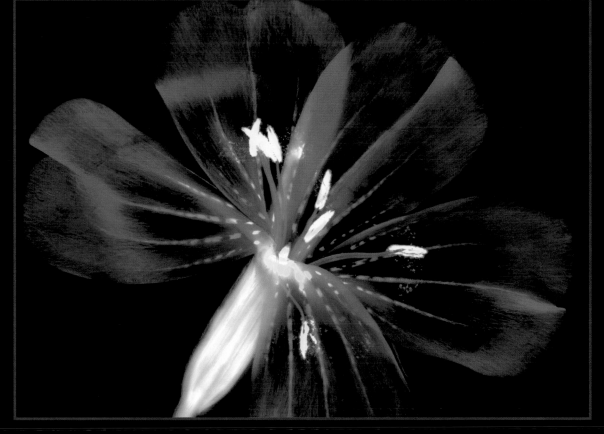

Using the LAB L channel inversion as the basis for a new image, I created this very special flower on black.

B channel inverted

This one is good for adding colors opposite to the prevailing blue/yellow values to the image.

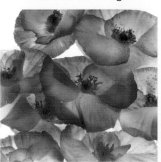

L channel equalized

This channel is good for adding contrast to an image, and for special effects. Good as the basis for a new image.

A channel equalized

This is good for adding green and magenta values to an image.

B channel equalized

This channel adjustment is good for adding blue and yellow values to an image.

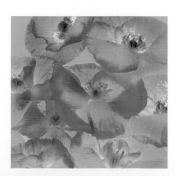

» Recap: Starting in the middle

Working with the L channel inversion

When I looked at the LAB channel inversions and equalizations of the Poppy Medley on White, I was struck by the inversion of the L channel. As is often the case, this channel move transposed the image with a striking black background effect.

This L channel inversion is the starting place for the case study. Looking at the L channel inversion, there are a couple of problems with it. But these can be fixed.

The part of the image showing the core of the flower—stamens and pistils—is no longer acceptable. This can be remedied by painting in some of the original image that captures these details nicely.

The image also lacks overall contrast. I'll show you a couple of LAB channel techniques to overcome this problem.

Finally, some of the petals in the image need to appear more transparent. I'll show you an interesting and effective way to paint transparency into an image with a black background.

Here's the original "Poppy Medley on White." You can see it larger on page 119

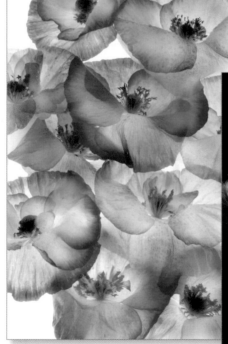

This is the image with the L channel inverted so it appears to be on black. This is the starting place for the case study

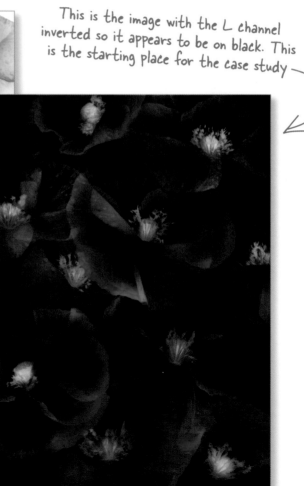

Turn to pages 158–159 to find out how this inversion was made

›› Painting some details back in

Selectively painting

The first and most important move with the inversion is to drag the original white version over the black version, add a Hide All layer mask to the layer, and selectively paint in the petals and other areas that need lightening and transparency. Each adjustment may seem minor, but combined they do create significant changes.

1 Hold down Shift and drag the white version of the image onto the black version and name it "White version" (for more about this, turn to page 35)

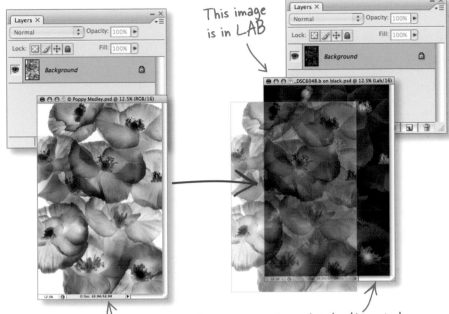

This image is in LAB

Even though this image is RGB, when you drag it into this window, it automatically changes to LAB

2 Add a Hide All layer mask to the "White version" layer

Directions for adding a Hide All layer mask are on page 36

Now the image is ready for the next step, so turn the page...

3 Gently paint in the petals to lighten them and appear more transparent

For info about the Brush Tool and painting on a layer mask, turn to page 48

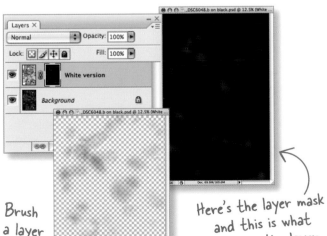

Here's the layer mask and this is what shows on the layer

›› LAB channels as your palette

Doing it more than once

Once I'm in the right ballpark with my image and I'm headed for the wrap-up, it's time (you guessed it) for more LAB inversions and equalization.

What I generally do is to duplicate the image again and run all seven basic LAB moves on the duplicate, and then see what I can use.

It's a process that can go on a long, long time: creating a new image based on LAB channel operations, then refining the image with another set of LAB moves (and the related layer stack).

One of the hardest things is deciding when the image is finished. This is very much a judgement call.

Once upon a time, I used to paint with oil paints. Sometimes I came up with a painting that wasn't half bad, but I would go on too far and it would get muddy. The same thing can happen with a LAB channel layer stack. If you see that your image is starting to get murky, you've probably gone too far and should revert back to your last checkpoint.

Checkpoint

1 Save the image off as a checkpoint, and then flatten the layers (directions on page 54), and then save a new version of the image

See page 25 for checkpoints

After flattening the layers, only the Background layer is left

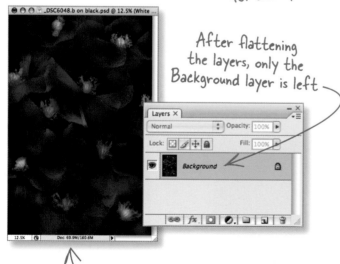

This image is in the LAB color space

2 Duplicate the image by choosing Image > Duplicate

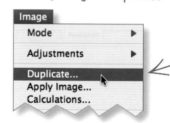

For more about duplicating an image, turn to page 156

3 Using the duplicate you just made, run the four LAB inversions shown on pages 157–161 and the three LAB equalizations described on pages 162–167. When you are finished, close the duplicate, but keep the eight other windows open

Here are the 8 images that are open right now

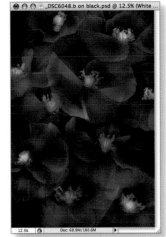

Black version from
step 1 on page 172

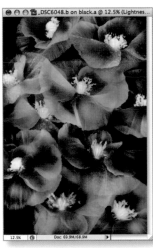

L channel equalized

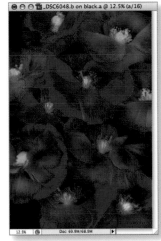

A channel equalized

B channel equalized

LAB channels inverted

L channel inverted

A channel inverted

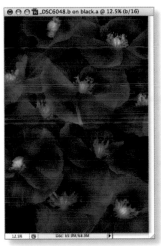

B channel inverted

I always run all seven LAB moves even if I'm only going to use one or two of them. The LAB channel inversions and equalizations are the color palette that I have to paint with. In combination with the blending modes, these channels create an enormous number of possibilities. You can use your vision and imagination as your guide.

These inversions and equalizations based on the black background version of the poppy image resemble, but are not exactly the same as, the inversions and equalizations from the white background version on pages 157–167. Compare them and see.

Keep going ⟶

4 Now, you're going to use the LAB inversion of the original white poppy image that you created on page 157. Hold down the Shift key and drag it from its image window onto the flattened black version

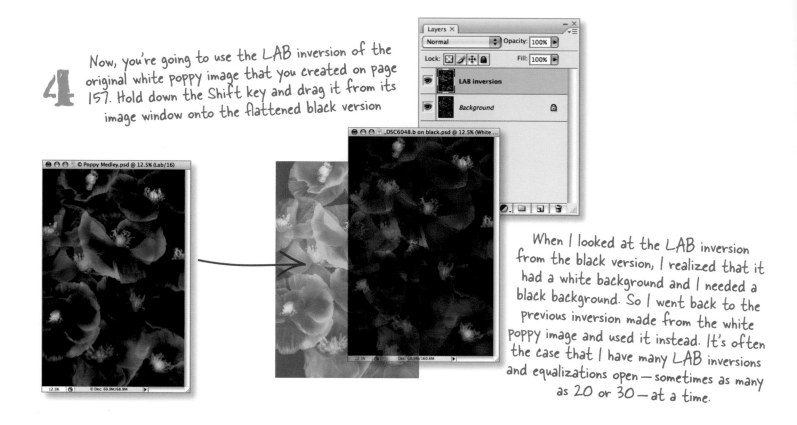

When I looked at the LAB inversion from the black version, I realized that it had a white background and I needed a black background. So I went back to the previous inversion made from the white poppy image and used it instead. It's often the case that I have many LAB inversions and equalizations open — sometimes as many as 20 or 30 — at a time.

5 Change the black version with its new LAB inversion layer from LAB mode to RGB color mode by selecting Image > Mode > RGB

Using a LAB inversion for lightening

I used this combination to add an exotic pink and lighten specific areas such as the core of the flower and some petals. If you look at the blend you'll see that this is a very distinctive kind of lightening with hints of electric blue in the shadows. I didn't paint it in very strongly anywhere and combined with this weak painting, I took the opacity down to 57%. So you can think of this as adding a touch of LAB inversion blended with Exclusion. As I note in the sidebar on page 175, you never know what you're gonna get with the Exclusion or Difference blending modes. A lot of the time they do produce a very interesting lightening effect, particularly when the blending layer is an all-channel LAB inversion.

6 In the Layers palette, change the blending mode to Exclusion

Here's what the LAB inversion layer looks like with the Exclusion blending mode applied

For more about blending modes, turn to pages 70–71

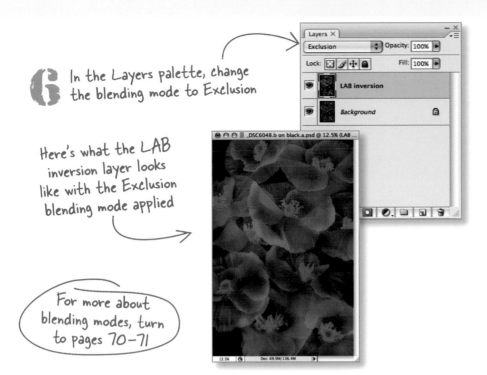

7 Gently paint in the petals on the layer mask. Finally, lower the Opacity to 57%

Here's what shows through on the layer after painting on the layer mask

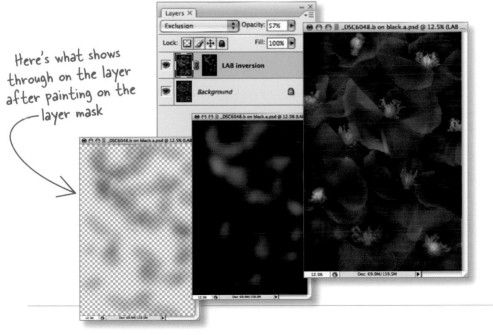

Why I use the Difference and Exclusion blending modes

I shifted to RGB because you can't use the Exclusion blending mode (or the Difference blending mode for that matter) in LAB color. Why? I don't know why. It's just a Photoshop thing.

Back on page 70, I said that the Exclusion and Difference blending modes are "weird." This was a little tongue-in-cheek as, in fact, they do have some practical uses for comparing two images.

Difference and Exclusion also play a role when you are combining LAB inversions and equalizations with an original image. These effects are unpredictable (which may be where my "weird" came from), but they also can be extremely valuable, bold at times, and subtle when you least expect it.

In this case, I used the Difference blending mode to add a really attractive pink and effectively lighten the image with high contrast.

It's really not possible, in my opinion, to pre-visualize the impact of applying Difference and Exclusion blending modes to a given LAB manipulation. Therefore, you need to try it and see.

Next Steps

Use more of the LAB color moves created on pages 172–173 with blending modes to burn specific areas and create more transparency in the petals (pages 176–177).

8 Duplicate the Background layer and drag it to the top of the layer stack in the Layers palette. Add a Hide All layer mask, and change the blending mode to Multiply. Paint on the layer mask to burn in darker areas for contrast, and then lower the Opacity to 44%.

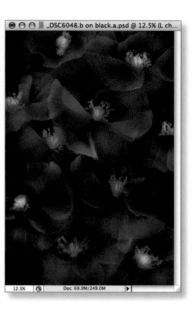

With this layer I essentially burnt some areas in (see pages 72–73 for more about burning). The point here is to create the illusion of lightness. Light only appears light when it is in contrast to something dark. Paradoxically, by darkening carefully selected target areas, the comparatively light areas of the image look brighter.

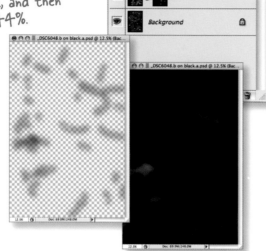

9 Drag the L channel equalization into the window that you've been working on and add a Hide All layer mask. Change to the Soft Light blending mode and paint on the layer mask to add contrast to the edges of the petals. Lower the opacity to 24%.

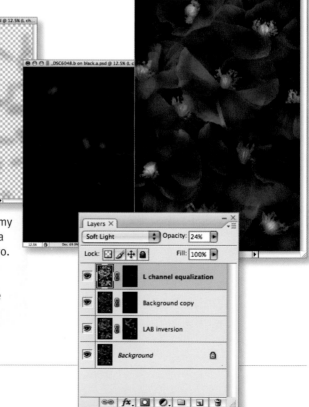

Blending an L channel equalization using Soft Light blending mode is one of my most common techniques for increasing tonal range across an image. What's a little unusual here is the 24% opacity which is higher than I would normally go. I typically do this combination at 10%–12% opacity. The other thing that's not quite typical here is that I masked the layer. My normal process would be to apply an equalization layer using a Soft Light blend at 10% opacity across the entire image. In this case, I only wanted to increase the contrast in the petals which is why I used a layer mask and selective painting.

10

Drag the L channel inversion into the image window you've been working on and add a Hide All layer mask. Paint on the layer mask to lighten the center of the flowers, and then set the Opacity to 10%

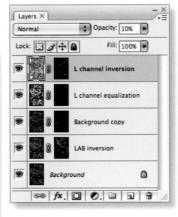

This is what shows through on the layer after painting on the layer mask

These adjustments by themselves are very subtle. And with the Opacity for the layer reduced to 10%, the adjustments become very slight indeed

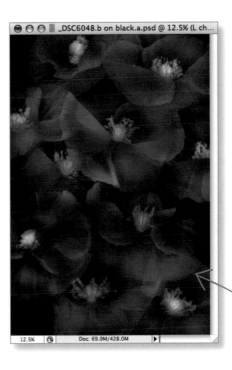

The overall image looks pretty good, but I'd like to see more transparency in the petals, particularly this area —

Just to spice things up, I used the L channel inversion of the image on black. This inversion became an image on white. However, since it's been through the LAB channel mill a few times now, it is not as pure a white as it started out. In particular, the petals have a distinctly gray cast to them. I used this channel inversion at 10% opacity to slightly lighten the interior areas of the petals.

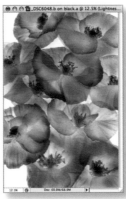

L channel inverted

Next Step

Paint on the petals using a white fill layer (pages 178–180).

›› Painting using fill layers

Creating transparent petals

Looking at the image as it stands, I am pleased with the tonal gradations in the flowers. However, I'd like to create the illusion of more transparency on the petals.

The easiest way to achieve the illusion of transparency is to "paint" on the petals in white. The most effective way to paint on the petals in white is to add a solid white layer with a Hide All layer mask. You can then carefully paint in the transparency you would like.

The same technique can be used to paint in black lines if you need them. Of course, fill the layer you are going to use with black. For that matter, you might want to paint in lines with some other color such as green or red. You can use the Eyedropper Tool to pick up the exact color you need from the image, fill a layer with the color, mask the layer, and paint.

One of the advantages of painting using a solid fill layer and a layer mask is that you can overdo things a bit without worrying. I find that I usually end up painting in lines, whether they are white or black, too heavily. To fix this once I finish painting, I take a look at the overall image and then simply reduce the opacity of the layer with the painting on it.

This is a surprisingly simple technique that can have a huge impact in the Photoshop darkroom.

Checkpoint

1 Save the image off as a checkpoint, and then flatten the layers (directions on page 54), and then save a new version of the image

See page 25 for checkpoints

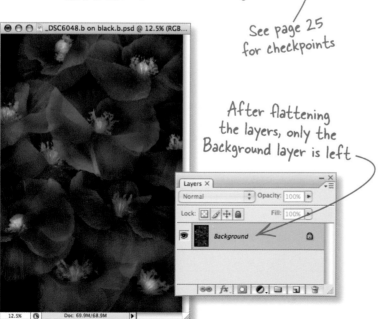

After flattening the layers, only the Background layer is left

2 Click the Create A New Layer button at the bottom of the Layers palette. A transparent layer will appear above the Background layer. Name the new layer "White fill"

Click here to create a new layer

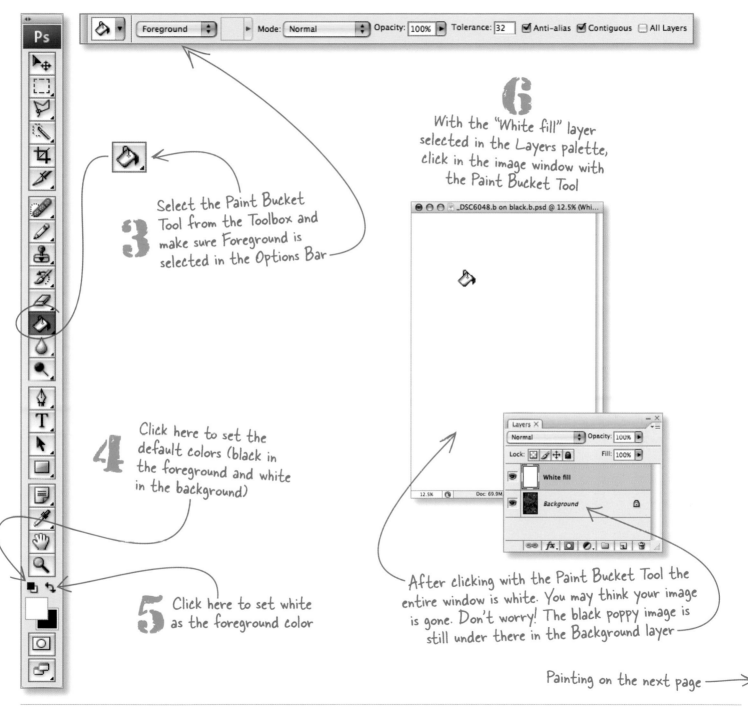

Foreground | Mode: Normal | Opacity: 100% | Tolerance: 32 | ☑ Anti-alias ☑ Contiguous ☐ All Layers

3 Select the Paint Bucket Tool from the Toolbox and make sure Foreground is selected in the Options Bar

4 Click here to set the default colors (black in the foreground and white in the background)

5 Click here to set white as the foreground color

6 With the "White fill" layer selected in the Layers palette, click in the image window with the Paint Bucket Tool

●○○ _DSC6048.b on black.b.psd @ 12.5% (Whi...

12.5% | Doc: 69.9M

Layers ×
Normal | Opacity: 100%
Lock: ☐ ✏ ✦ 🔒 | Fill: 100%
White fill
Background 🔒

After clicking with the Paint Bucket Tool the entire window is white. You may think your image is gone. Don't worry! The black poppy image is still under there in the Background layer

Painting on the next page →

7 Add a Hide All layer mask to the "White fill" layer. The white layer becomes transparent so you can see the Background layer again

8 Choose the Brush Tool from the Toolbox and select 5% Hardness, 25% Opacity, and 50% Flow in the Options bar as a starting place. With the layer mask selected on the "White fill" layer, paint in the details on the petals

9 On the Layers palette, lower the Opacity of the "White fill" layer to 46% to blend in the painting

Here's where detail was painted in on the poppy petal. It's a little obvious, so it's time to reduce the opacity of the white layer

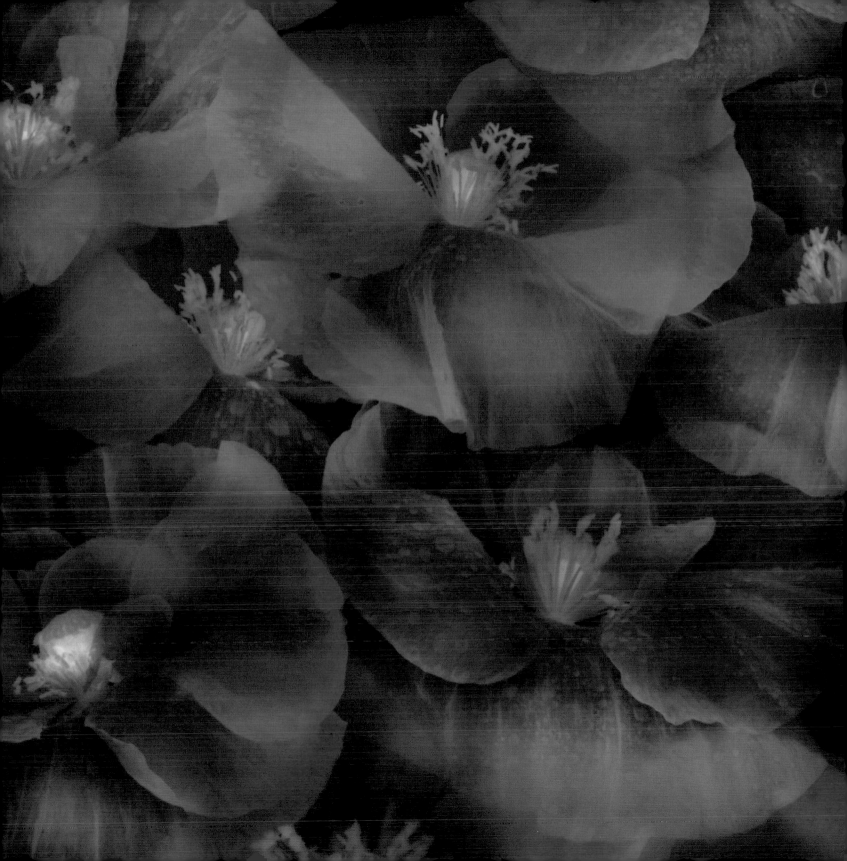

>> Filters in Photoshop

As I've become comfortable with LAB color, channels, and blending modes, I found that I use Photoshop filters less and less. However, there are many Photoshop filters and third-party filters that are worth exploring.

Here are some of the filters that I like for creative effects. It's important to use any filter on a duplicate layer so you can paint on a layer mask to control the exact areas of application of the creative effect.

NIK filters

The NIK Color Efex collection includes some spectacular filters. The ones I find myself using often are:

Color Replacement: This filter allows you to replace colors in an image with any color you want. This is very useful for changing colors in a specific area

Cross Processing: Back in the days of film photography, cross processing referred to using chemistry meant for one kind of film for another kind of film. This produced unusual shifts in color. The NIK filter simulates some of these effects and provides you with a selection of color shifts that you can add selectively into your image.

Fog: Well, I use Fog to add, ah, fog into some of my landscapes. This one should be used with a light touch. You can also use it to globally lighten an image.

Glamour Glow: This filter adds a warm saturated glow. It is best to paint it in carefully on a layer mask only where you really want it because it also softens the image and can degrade the image.

Photoshop filters

The filters that come with Photoshop itself are a mixed bag. You should know that not all Photoshop filters work with all bit-depth images, so you may have to convert your images to a lower bit-depth to use a particular filter.

One Photoshop filter that I use with almost every single image that I process is the Unsharp Mask (found under Filter ► Sharpen ► Unsharp Mask). I use the Unsharp Mask selectively in LAB color applied only to the Luminance channel as explained on pages 198–201.

Another Photoshop filter that I use frequently is Lighting Effects (found under Filter ► Render ► Lighting Effects). This one is great for either changing the direction of the light hitting the subject of an image or for emphasizing existing light and the direction of that light.

I've used the Lighting Effects filter on everything from portraits and still lifes to sunset landscapes in the mountains.

Once again, I suggest working on a layer so you can precisely control the impact of this powerful filter. You also need to carefully observe the direction, intensity, and quality of the light in the image and make sure that your use of the Lighting Effects filter compliments and does not detract from the existing light.

The Liquify filter (found under Filter ► Liquify) is great for those occasions where you need to transform a curvilinear shape. I've used this filter successfully in a number of photo composites.

In the *Butterfly* image shown on pages 186–187, I used several Photoshop filters including Glowing Edges (found under Filter ► Stylize ► Glowing Edges), Ink Outlines (found under, Filter ► Brush Strokes ► Ink Outlines) and Neon Glow (found under Filter ► Artistic ► Neon Glow).

When possible, I prefer to use channels, blending modes, and painting instead of Photoshop filters. However, there are times, as with the *Butterfly* image, that these Photoshop filters are hard to beat. They are kind of like a cheep sugar rush. You don't want to overdo them or you'll get an ice cream headache. But sometimes it's hard to pass up a brownie all-the-way with ice cream and hot fudge sauce.

To create Papaver Fireworks, *a core of a poppy gone to seed, I used approximately 24 different LAB channel inversions and equalizations.*

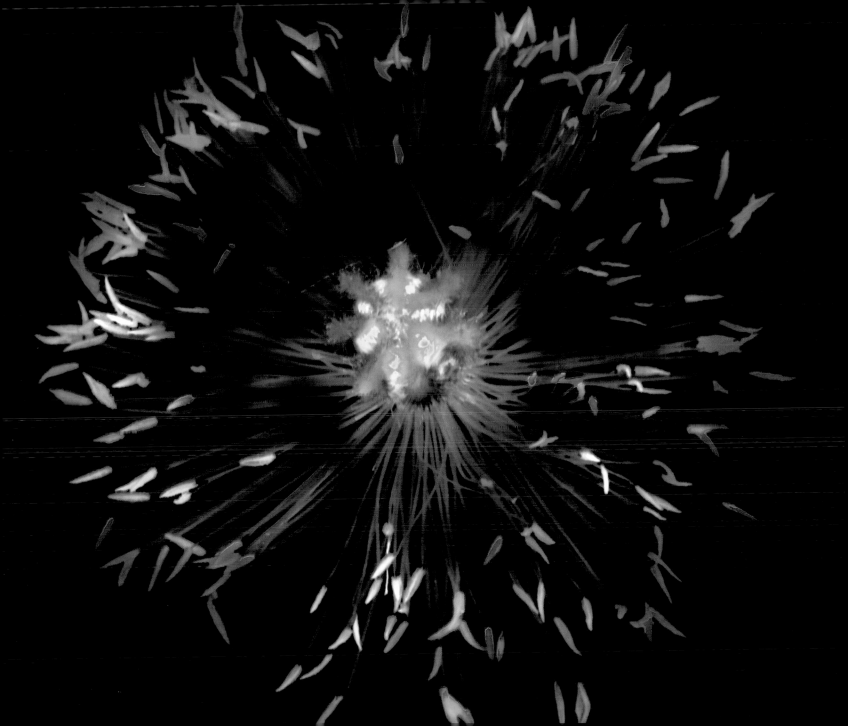

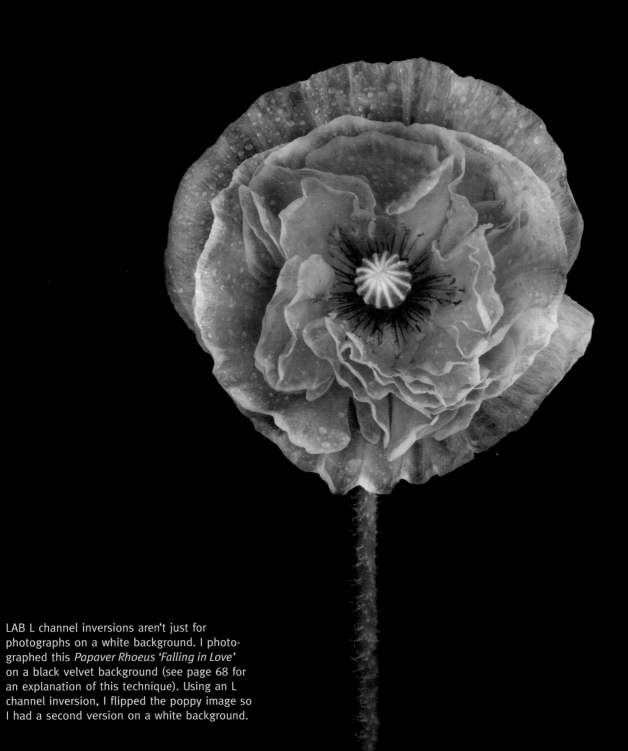

LAB L channel inversions aren't just for photographs on a white background. I photographed this *Papaver Rhoeus 'Falling in Love'* on a black velvet background (see page 68 for an explanation of this technique). Using an L channel inversion, I flipped the poppy image so I had a second version on a white background.

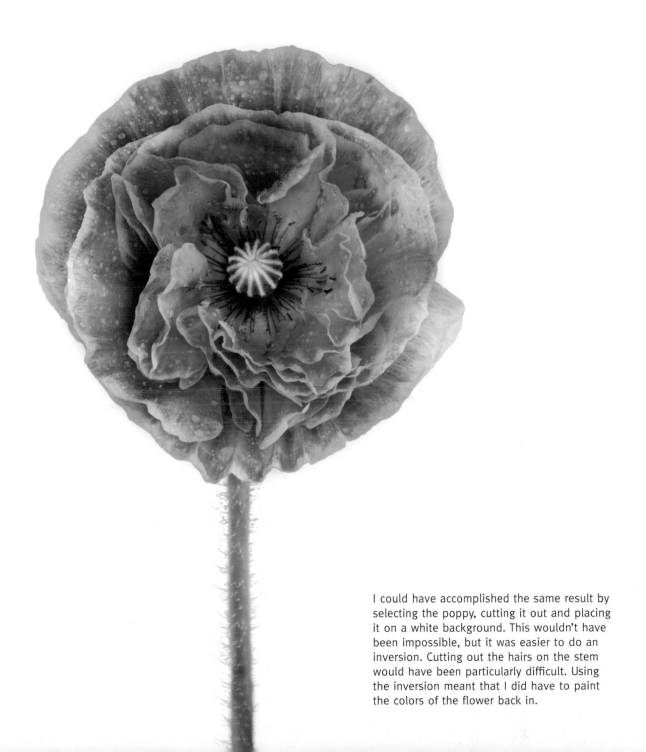

I could have accomplished the same result by selecting the poppy, cutting it out and placing it on a white background. This wouldn't have been impossible, but it was easier to do an inversion. Cutting out the hairs on the stem would have been particularly difficult. Using the inversion meant that I did have to paint the colors of the flower back in.

I PHOTOGRAPHED A BUTTERFLY specimen using a lightbox to create a transparent background as shown below. The finished image on the right was created using LAB channel operations, several Photoshop filters, and direct painting on a layer.

It's a very long way from the photo to the finished butterfly image. This process shows that you can add a great deal of color into an image that starts out fairly plain.

I think the finished image, which has been published a number of times, is as much a digital painting as it is a photograph.

›› Capturing the dragonfly

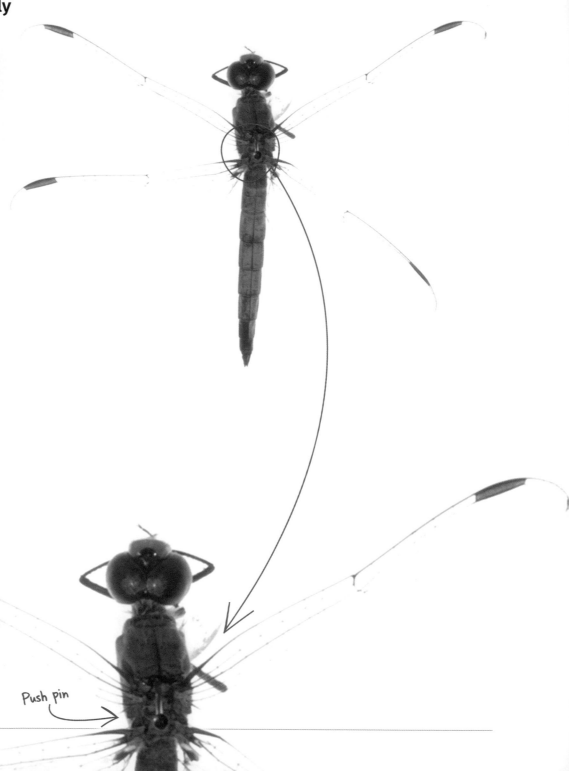

Why

As part of an assignment, I needed to create a colorful dragonfly image that looked more like a painting than a photo.

How

I looked through my library of existing dragonfly captures to find a starting place. I quickly realized they just would not do because of the position of the insects, backgrounds and lack of transparency in the wings.

I bought this dragonfly at a natural specimens store, and photographed it straight down using a lightbox as the lighting source. I used a telephoto macro lens and a tripod. I exposed the image for 2 seconds at f/32 and ISO 100.

Next Step

In some ways this capture is mundane, but I knew I could work on it and make it interesting in the Photoshop darkroom. To start with, the push pin placed by the store had to be cloned out. I didn't just pull it out because the dragonfly would have disintegrated.

Besides minor additional retouching, the image needed to be rotated and cropped.

Push pin

>> Retouch and adjust luminosity

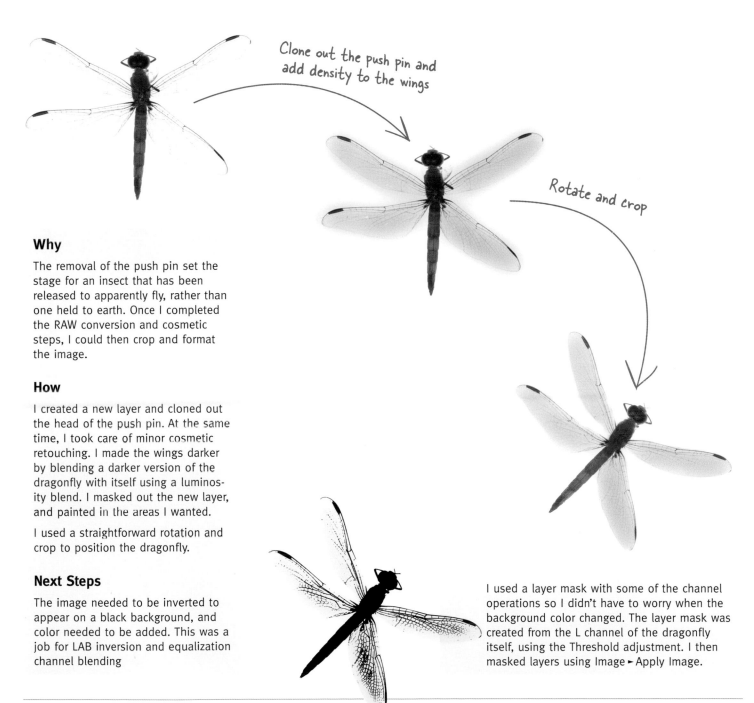

Clone out the push pin and add density to the wings

Rotate and crop

Why

The removal of the push pin set the stage for an insect that has been released to apparently fly, rather than one held to earth. Once I completed the RAW conversion and cosmetic steps, I could then crop and format the image.

How

I created a new layer and cloned out the head of the push pin. At the same time, I took care of minor cosmetic retouching. I made the wings darker by blending a darker version of the dragonfly with itself using a luminosity blend. I masked out the new layer, and painted in the areas I wanted.

I used a straightforward rotation and crop to position the dragonfly.

Next Steps

The image needed to be inverted to appear on a black background, and color needed to be added. This was a job for LAB inversion and equalization channel blending

I used a layer mask with some of the channel operations so I didn't have to worry when the background color changed. The layer mask was created from the L channel of the dragonfly itself, using the Threshold adjustment. I then masked layers using Image ► Apply Image.

LAB Inversions, equalizations, and blending modes

Top: Inversion of the image on page 189.

Second down: B channel inversion flips blue and yellow values.

Third down: Combining LAB channels using different blending modes gives a huge variety of color possibilities.

Bottom: More LAB inversions and equalizations add additional color.

Far right: Several more inversions, with colors painted in, lead to the final result approved by the client.

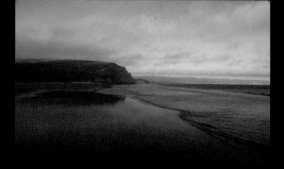

Capture as shot

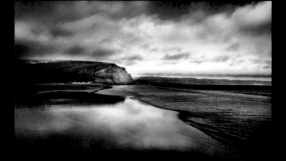

L channel equalization

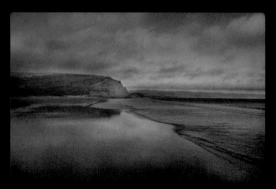

Image following multi-RAW processing

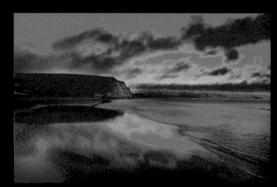

A channel equalization

Making beautiful landscapes with LAB

Don't think that the LAB channel adjustments that I showed you on pages 158–172 are only for flowers and insects! In fact, these adjustments work well to increase the color and drama of many kinds of images, including landscapes like the one shown here.

On the top left, you can see the original image of clouds and water as shot, followed by the multi-RAW processed version. I used the three equalized LAB channels shown to the right to paint in the colors and contrast you can see in the final image to the far right.

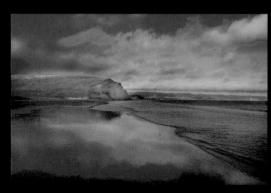

B channel equalization

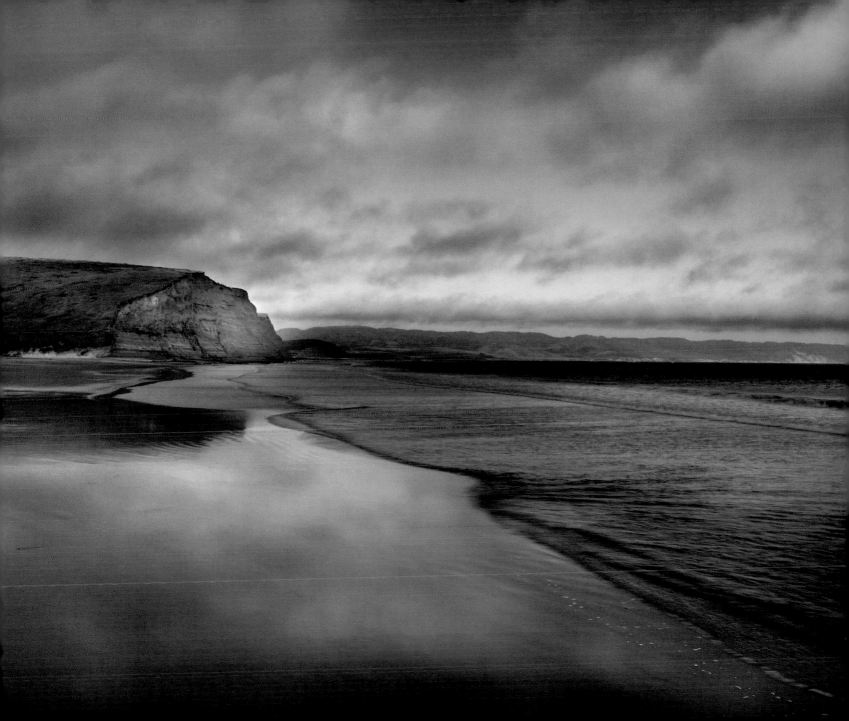

›› Setting up the Curves dialog

Using curves to improve images

As part of my workflow, when I am almost done with an image before I convert back from LAB into RGB or CMYK, I adjust the LAB curves of the image.

An L channel curve adjustment increases the contrast in an image. The A and B channel curve adjustments make the colors in an image more intense.

If done correctly, this is a subtle adjustment. If applied with brute force, a LAB curve adjustment can amount to an inversion: swapping white for black or green for magenta. I've come to recognize the shape of an appropriate LAB curve. I apply the appropriate curve to each of the three LAB channels and then verify the results visually.

Although this is a close-to-final step in my workflow, you should know that LAB curve adjustments can be done earlier in the workflow, and more than once for that matter.

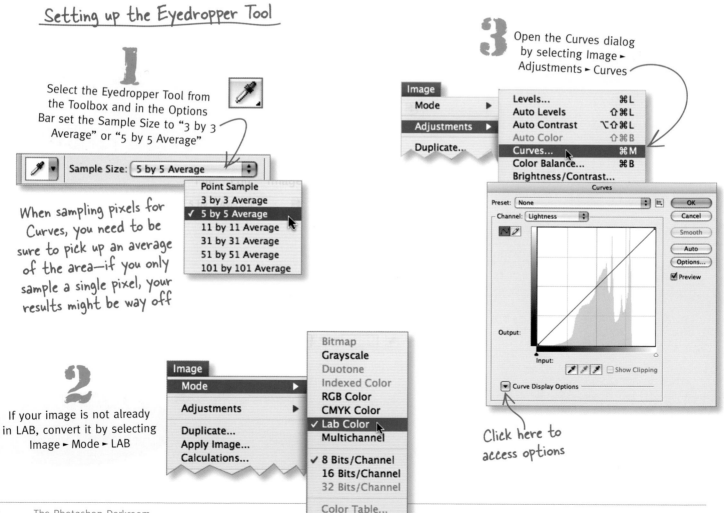

Setting up the Eyedropper Tool

1 Select the Eyedropper Tool from the Toolbox and in the Options Bar set the Sample Size to "3 by 3 Average" or "5 by 5 Average"

When sampling pixels for Curves, you need to be sure to pick up an average of the area—if you only sample a single pixel, your results might be way off

2 If your image is not already in LAB, convert it by selecting Image ▸ Mode ▸ LAB

3 Open the Curves dialog by selecting Image ▸ Adjustments ▸ Curves

Click here to access options

Setting Up the Curves Dialog

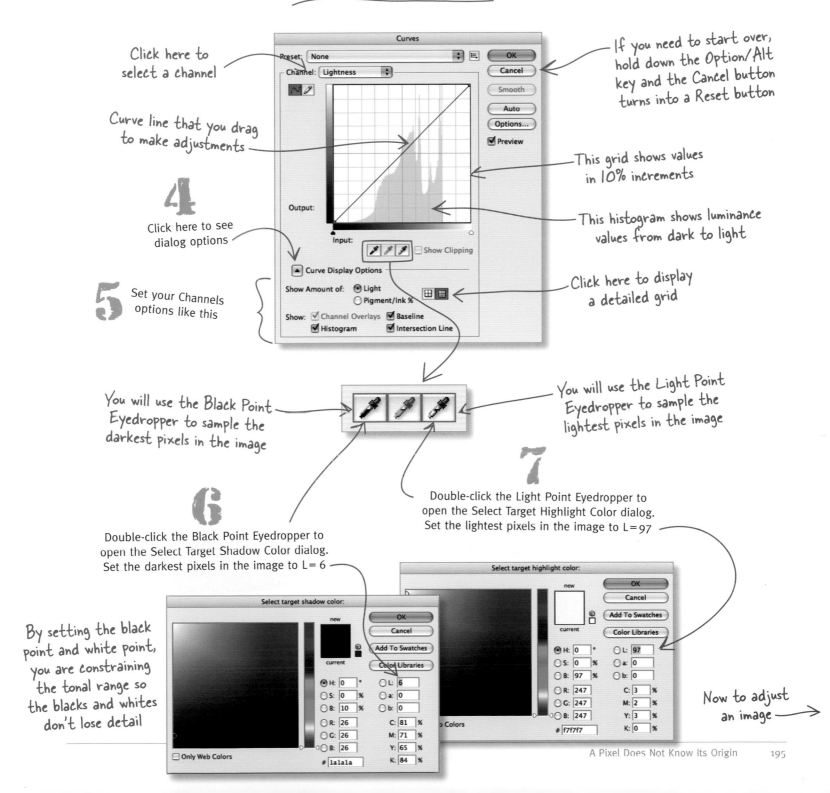

Click here to select a channel

If you need to start over, hold down the Option/Alt key and the Cancel button turns into a Reset button

Curve line that you drag to make adjustments

This grid shows values in 10% increments

This histogram shows luminance values from dark to light

4 Click here to see dialog options

5 Set your Channels options like this

Click here to display a detailed grid

You will use the Black Point Eyedropper to sample the darkest pixels in the image

You will use the Light Point Eyedropper to sample the lightest pixels in the image

7

Double-click the Light Point Eyedropper to open the Select Target Highlight Color dialog. Set the lightest pixels in the image to L= 97

6

Double-click the Black Point Eyedropper to open the Select Target Shadow Color dialog. Set the darkest pixels in the image to L= 6

By setting the black point and white point, you are constraining the tonal range so the blacks and whites don't lose detail

Now to adjust an image →

❯❯ Adjusting LAB curves

Getting down to business

Now that you have the Curves dialog configured, here's how to apply a curve adjustment to an image in LAB color. You should start with the L channel.

I spend a lot of time just fiddling with LAB curves. It's amazing what you can do with this adjustment.

1 Click the darkest area in the image with the Black Point Eyedropper

2 Click the lightest area in the image with the Light Point Eyedropper

3 Select "Lightness" from the Channel drop-down list and adjust the L channel curve

This is a nice s-shaped curve shape for a light image

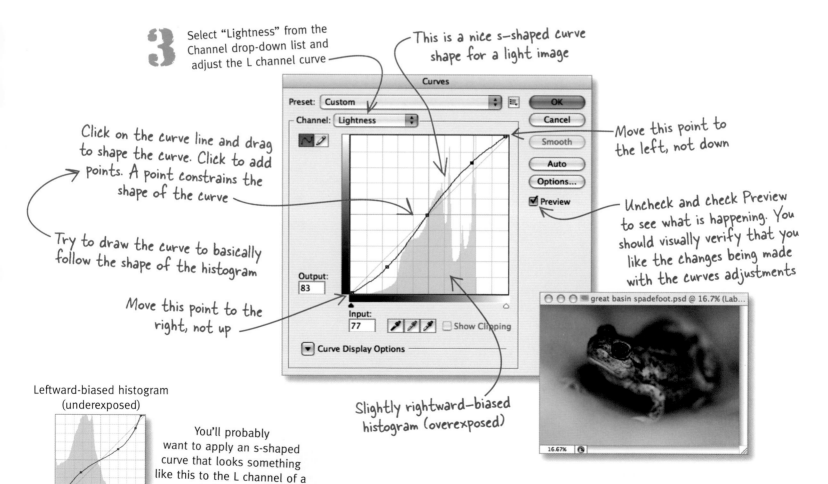

Click on the curve line and drag to shape the curve. Click to add points. A point constrains the shape of the curve

Try to draw the curve to basically follow the shape of the histogram

Move this point to the right, not up

Move this point to the left, not down

Uncheck and check Preview to see what is happening. You should visually verify that you like the changes being made with the curves adjustments

Leftward-biased histogram (underexposed)

You'll probably want to apply an s-shaped curve that looks something like this to the L channel of a darker image

Slightly rightward–biased histogram (overexposed)

4

Select "a" from the Channel drop-down list and adjust the A channel curve

I normally make these standard, but minor, A and B channel adjustments, but they are not nearly as extreme as shown here in the Curves dialogs

5

Select "b" from the Channel drop-down list and adjust the B channel curve

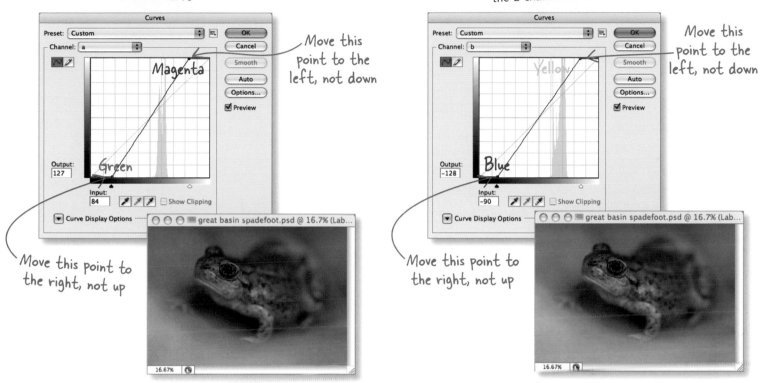

Move this point to the left, not down

Move this point to the left, not down

Move this point to the right, not up

Move this point to the right, not up

Using Threshold to find light and dark

If you have trouble using the Eyedropper Tools in the Curves dialog because you can't see the lightest and darkest areas of your image, you can use the Threshold adjustment to help. Choose Image ▸ Adjustment ▸ Threshold. In the Threshold dialog, move the slider to the left to find the darkest area and the right to find the lightest area. Click Cancel when you're done so the Threshold adjustment is not applied.

I photographed this Great Basin Spadefoot frog in the palm of an ecologist's hand at the Bureau of Land Management offices in Kanab, Utah. Collected when he was merely a tadpole in a rain puddle in the desert slickrock, this little guy was shy, so I didn't have much time to get a good shot.

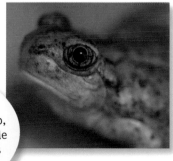

›› Selective sharpening in LAB color

Compositional sharpening

There are quite a few good ways to sharpen in Photoshop. You can sharpen in Adobe Camera RAW (ACR), use the Photoshop Smart Sharpen Filter, or sharpen with tools provided by third-parties.

However, I prefer to sharpen using LAB color and the good old-fashioned Unsharp Mask filter. My method is to apply the Unsharp Mask only to the Lightness channel. I believe that this technique produces a more attractive

sharpening effect than any of the other tools available.

But more important than the tool you use is to be *selective* about what you sharpen.

I sharpen on a duplicate layer and paint in the area I want to sharpen using a layer mask. The point of this kind of sharpening is compositional.

I'm not sharpening overall for a specific output device (which also may be necessary depending upon the situation). Rather, I am sharpening specific

areas to draw the viewer's attention to those areas of the image.

For example, consider the image of the Point Reyes Lighthouse at night on pages 142–143. In that image, I only sharpened the lighthouse.

Different kinds of images call for compositional sharpening of different areas. For example, in portraits I typically only sharpen the subject's eyes. In a photograph of a bee on a flower, I may sharpen just the bee and not the flower.

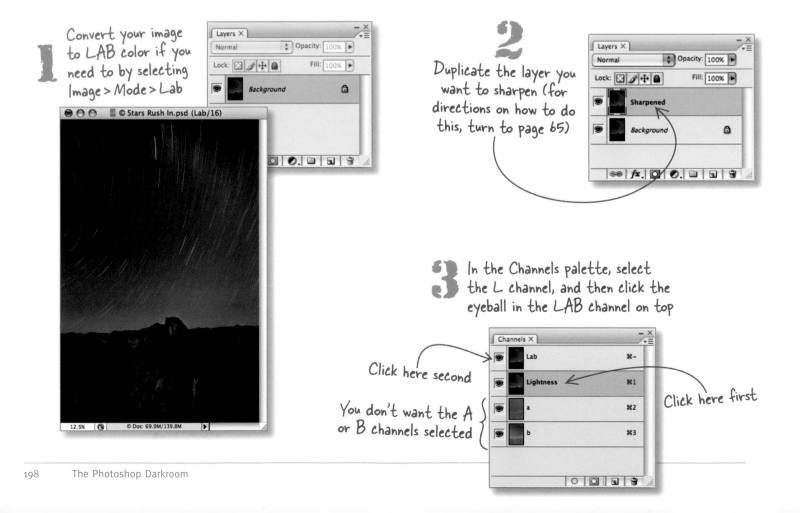

1 Convert your image to LAB color if you need to by selecting Image > Mode > Lab

2 Duplicate the layer you want to sharpen (for directions on how to do this, turn to page 65)

3 In the Channels palette, select the L channel, and then click the eyeball in the LAB channel on top

Click here second

You don't want the A or B channels selected

Click here first

4

With the layer you want to sharpen selected in the Layers palette, choose Filters > Sharpen > Unsharp Mask. In the Unsharp Mask dialog, I set the Radius to 2.7 and the Threshold to 9 as my starting place. I then use the Amount slider to sharpen the layer. Normally, I set the Amount between 50% and 120%. Experiment with these settings and find out what works for your image

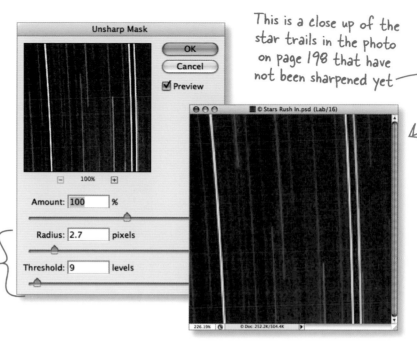

This is a close up of the star trails in the photo on page 198 that have not been sharpened yet

The higher the Radius setting, the more sharpening. The lower the Threshold setting, the sharper the image.

This is way too much sharpening. Noise looks particularly unattractive when it is over-sharpened this much

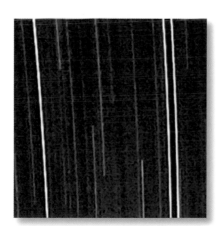

Sharpening with 100% Amount

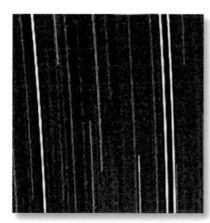

Sharpening with 200% Amount

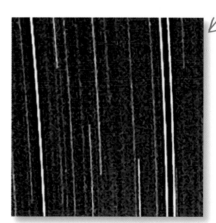

Sharpening with 300% Amount

5

After sharpening, add a Hide All layer mask to the layer, and then paint in the areas you want to selectively sharpen

Here's what shows on the layer

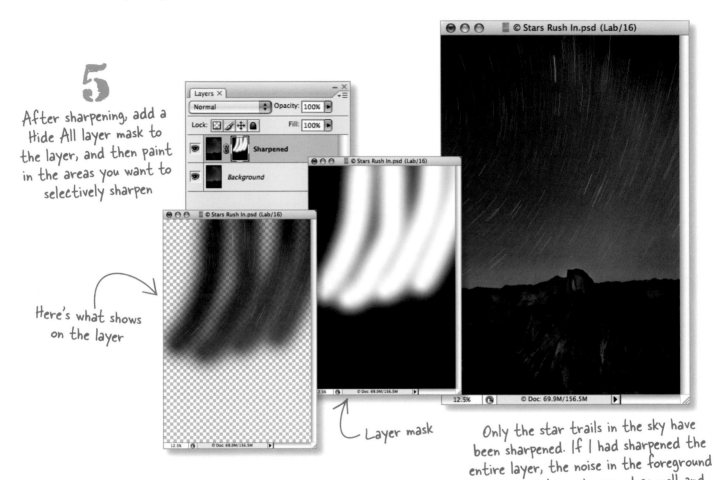

Layer mask

Only the star trails in the sky have been sharpened. If I had sharpened the entire layer, the noise in the foreground would have been sharpened as well and this would be unacceptable—who needs sharpened pixelated dots in their image?

6

After you are done sharpening in LAB, remember to change the color mode back to RGB or CMYK depending on how the image is going to be used

I photographed this 30 minute exposure of Half Dome in Yosemite Valley, California in the middle of the night from Glacier Point. When I processed the image in the Photoshop darkroom, I needed to keep the soft features of the landscape by starlight while selectively sharpening the star trails.

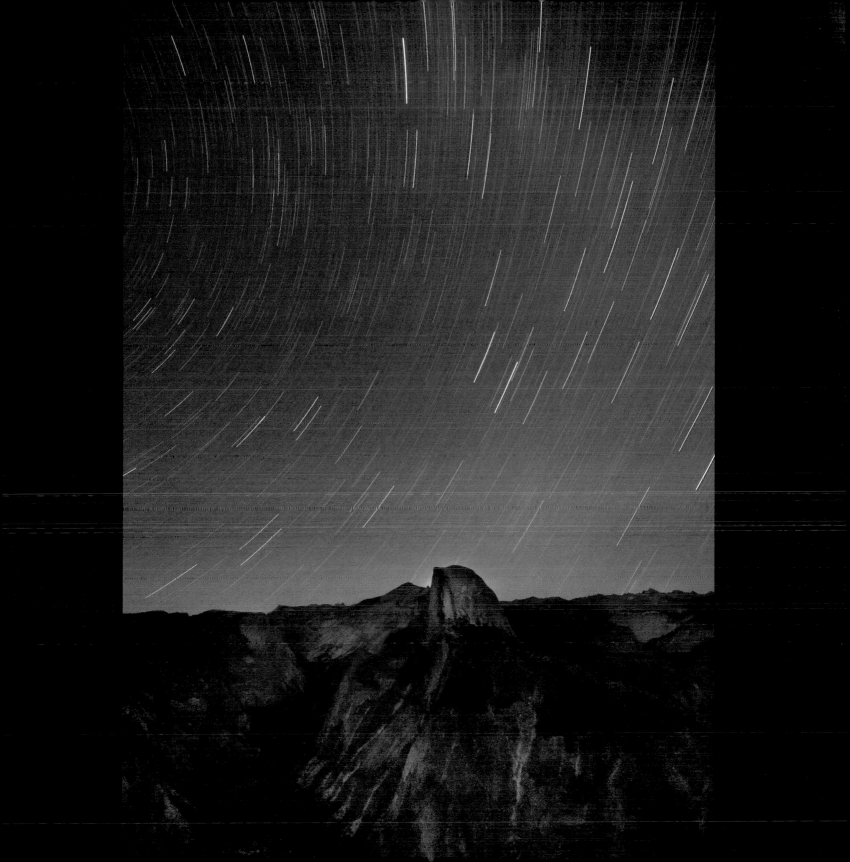

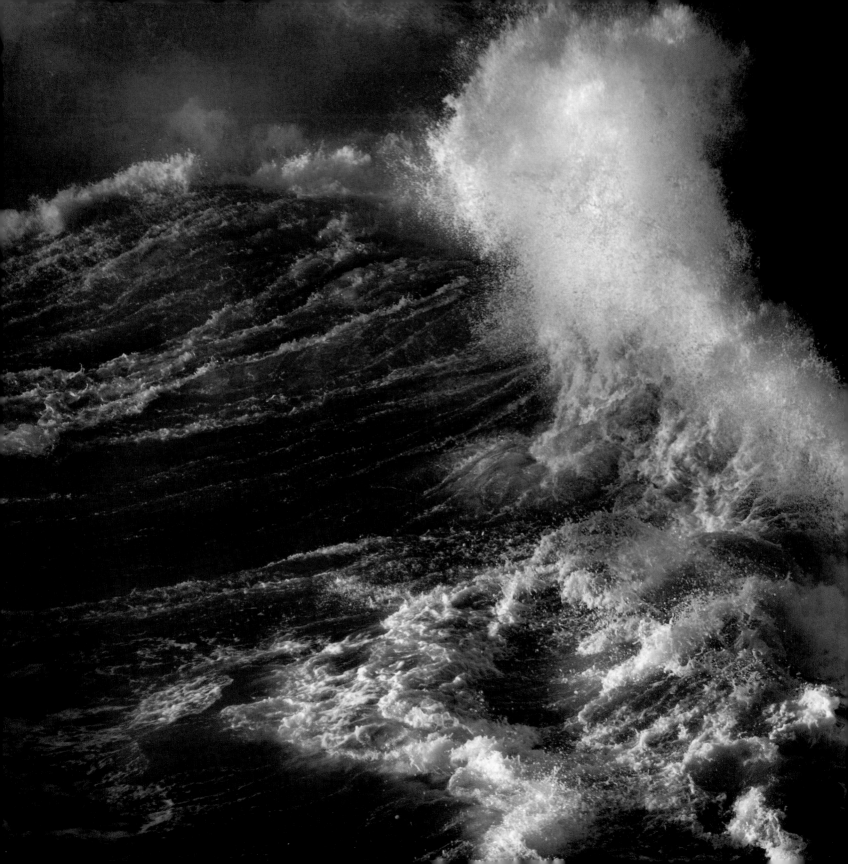

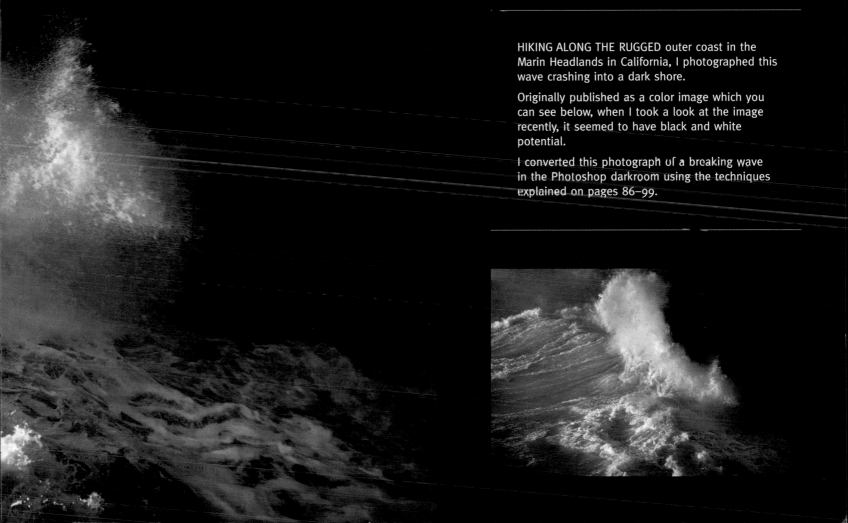

HIKING ALONG THE RUGGED outer coast in the Marin Headlands in California, I photographed this wave crashing into a dark shore.

Originally published as a color image which you can see below, when I took a look at the image recently, it seemed to have black and white potential.

I converted this photograph of a breaking wave in the Photoshop darkroom using the techniques explained on pages 86–99.

›› Glossary

Adjustment layer: A special kind of layer that holds information about the changes made to the associated layer rather than the entire layer's information.

Adobe Camera Raw (ACR): Used to convert RAW files into files that Photoshop can open.

Ambient light: The general background light in a given situation.

Aperture: The size of the opening in a camera lens.

Blending mode: Determines how two layers in Photoshop will combine.

Bracketing: Shooting many exposures at a range of settings. It is more common to bracket shutter speed than aperture.

Burn: To selectively darken an area in an image.

Channel: In Photoshop, a channel is a grayscale representation of color (or black) information. In RGB color there are three channels, red, green, and blue.

Checkpoint: A step in post-processing in which good workflow requires archiving a copy prior to continuing work.

Color temperature: The apparent warmth or coolness of a light source, as indicated in degrees Kelvin.

Compositing: See *Photo compositing*.

Curve: An adjustment used to make precise color corrections.

Depth-of-field: The distance in front and behind a subject that is apparently in focus.

Dodge: To selectively lighten an area in an image.

DSLR: Digital single lens reflex camera.

Equalization: A Photoshop adjustment that maximizes the color in a channel or channels.

Gradient: A gradual blend, often used when working with layer masks in Photoshop.

Hand HDR: The process of creating HDR images using Photoshop layers and masking without using automation to combine the images.

Histogram: A graph that represents a distribution of values; an exposure histogram is used to display the distribution of lights and darks in an image.

HDR: High Dynamic Range images combine multiple captures at bracketed exposures to have greater tonal range than conventional photos.

Inversion: A Photoshop adjustment that inverts the color in a channel or channels.

ISO: Scale used to set a camera's sensitivity to light.

LAB color: A color model consisting of three channels. The L channel contains the luminance (black and white) information, the A channel contains magenta and green, and the B channel holds blue and yellow.

Layer: Photoshop documents are comprised of layers stacked on top of each other.

Layer mask: Masks are used to selectively reveal or hide layers in Photoshop.

Multi-RAW Processing: Combining two or more different versions of the same RAW file.

Noise: Static in a digital photo that appears as unexpected, and usually unwanted, pixels.

Overexpose: An overexposed photo appears too bright; the exposure histogram is bunched towards the right side.

Photo compositing: Combining one or more photos to create an image that is often impossible or unreal.

Programmable interval timer: Used for a wide variety of tasks especially astronomical photography. With the camera on a Bulb setting, the interval timer allows you to specify an interval before an exposure starts, the length of an exposure, the length of time between exposures, and the number of exposures.

"Proper" exposure: A proper exposure is an exposure that is theoretically correct for a given subject based on overall or average light readings. With a proper exposure, the histogram is usually a bell-shaped curve in the middle of the graph. Often compared with a "creative" exposure, which is used for creative purposes but may appear too dark or bright in some or all portions of an image.

RAW: A digital RAW file is a complete record of the data captured by the sensor. The details of RAW file formats vary between camera manufacturers.

Shutter Speed: The interval of time for which the camera shutter is open.

Similars: Closely related captures from the same photo shoot.

Stacking: A process derived from astronomical imaging that displays the brightest pixels in a stack of images.

Tonal range: The range of color and light and dark values in an image.

Underexpose: An underexposed photo appears too dark; the exposure histogram is bunched towards the left side.

White Balance: The color temperature of the light source of a photo.

Workflow: The process that starts with a RAW digital capture and concludes with a finished and archived image file.

Dedication

This book is dedicated to Katie Rose, our little miracle.

Acknowledgments

Special thanks to Amy Brokering, Mark Brokering, Martin Davis, Valerie Geary, Randall Hake, Mónica Mendoza, Carlin Reagan, and Matt Wagner.

Case study images

Personally, I would prefer you to try the techniques I explain in *The Photoshop Darkroom* on your own photos. However, I know that some folks will like to follow the steps using the exact images in an example.

If you're one of these people, you'll be happy to know that I have made low resolution versions of the photos used in every case study in *The Photoshop Darkroom* available for download.

You can download the images from *www.focalpress.com/photoshopdarkroom*

Okay. Here's the legal stuff: These image files have been watermarked and are licensed to you for your use in conjunction with learning the techniques I explain in *The Photoshop Darkroom*. I maintain full copyright in these images and you are not authorized to use them for any other purpose whatsoever.

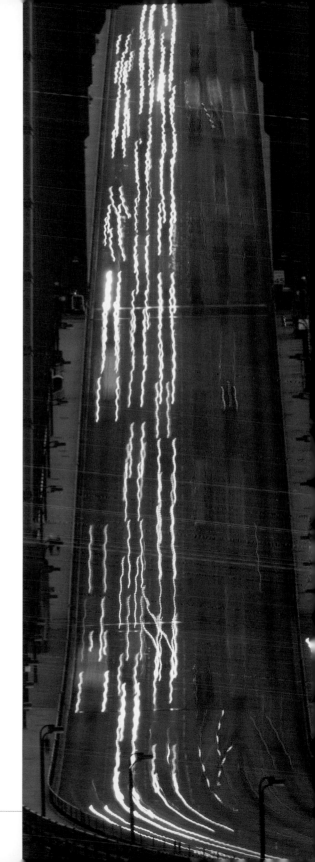

≫ Index